D1312737

Artistic Strategy
and the
Rhetoric of Power
Political Uses of Art
from Antiquity to the Present

Edited by DAVID CASTRIOTA

Southern Illinois University Press
Carbondale and Edwardsville

For Frank Capra

Copyright © 1986 by the Board of Trustees, Southern Illinois University
All rights reserved
Printed in the United States of America
Edited by Barbara E. Cohen
Designed by Quentin Fiore
90 89 88 87 86 5 4 3 2 1

Library of Congress Cataloging-in-Publication Data

Main entry under title:

Artistic strategy and the rhetoric of power.

Papers presented at a symposium held at the Heyman Center for the Humanities at Columbia University, spring 1984, and sponsored by the Society of Fellows in the Humanities of Columbia University.
Bibliography: p.
Includes index.
1. Politics in art—Addresses, essays, lectures. 2. Arts—Political aspects—Addresses, essays, lectures. 3. Arts—Themes, motives—Addresses, essays, lectures. I. Castriota, David, 1950– II. Columbia University. Society of Fellows in the Humanities.
NX650.P6A78 1986 700 85-27764
ISBN 0-8093-1289-1

Contents

Contents

Illustrations

Acknowledgments

The present collection of essays began as a symposium held at the Heyman Center for the Humanities at Columbia University in Spring of 1984 and sponsored by the Society of Fellows in the Humanities of Columbia University. I originally conceived of this project because the subject constitutes an extremely important area in the history of art, one which is potentially of interest to scholars in various other fields of the humanities, and because the society itself, where I was then a fellow, provided a marvelous forum for an interdisciplinary effort of this kind. These essays are, however, much more than a transcript of the symposium; they represent a process of discussion, interaction, and reconsideration among many of the participants as a collective effort over a period of time.

I would like to take this opportunity to express my thanks to the society for supporting the symposium, and in particular to Loretta Nassar, the director of the society, for her help in arranging and coordinating the entire project. I would also like to thank Albert Lee, the society's secretary, and Anthony Glover, the society assistant, for their logistical expertise. I would like to express my deep appreciation and gratitude to Professor Theodore DeBary, the director of the Heyman Center for the Humanities, for his constant efforts in fostering the kind of environment which made this collaborative undertaking possible. Lastly, I would like to thank my fellow contributors and colleagues for their generosity, enthusiasm, and their willingness to work together toward a common goal.

*Artistic Strategy
and the
Rhetoric of Power*

DAVID CASTRIOTA

1. Political Art and
the Rhetoric of Power
in the Historical Continuum

The present volume of essays examines the uses of art, primarily in visual media, to disseminate political messages in the Western world from the third millennium B.C. to the twentieth century. Though large in scope the collection is by necessity selective and specific in its approach. Each of the essays in its turn addresses this problem by focusing on the significant themes, issues, and monuments that exemplify the political art of a given culture and chronological period. Each offers a particular insight to the practical requirements and historical circumstances that conditioned the making of political art at a certain time and place. But these essays have a collective purpose and import as well. Together they trace the history of an important and influential phenomenon through a vast historical panorama or contiuum which Fernand Braudel has so aptly termed "la longue durée."[1] In doing this the value or usefulness of each of these essays increases geometrically, for we see what they discuss in a larger context of human cultural and intellectual development as a changing but unified process. Consequently, this first essay aims at defining the general nature and purpose of political art and the issues or features that unify and distinguish the process of political image making in the course of history, as a prelude or introduction to the various other contributions of the volume.

From earliest times works of visual art have directly served and reflected the beliefs and institutions of the societies that produced them. Often the careful interpretation of works of art can yield a wealth of cultural information that might otherwise be lost. What could we hope to know of the use of magic and ritual in the primitive hunting societies of Paleolithic Europe without the documentation of cave paintings and rock engravings? And what knowledge would we have of the essential concept of female fertility in these societies were it not for the evidence of small-scale sculptures like the "Venus" of Willendorf? But when we turn to the earliest literate societies and to works of art that deliberately address po-

litical themes or issues, such works provide us with a range of cultural information so rich and expressive that even the evidence of contemporary textual documents cannot supersede them; literary evidence can only make the message or meaning of such art clearer and more precise for the modern observer.

From the archaeological data that have accumulated over the last century, the appearance of political art would seem to coincide with the mature phase of early urbanism in Mesopotamia and Egypt during the third millennium B.C. By this period we encounter fully developed monumental architecture and closely associated works of painting and sculpture in the form of the temple and palace compounds which housed and advertised the central religious and civic authorities, and this development was decidedly political in purpose and signfcance. This is especially clear if we restrict the term *political* to its original Greek sense as relating to the affairs of the *polis* or city-state and its administration.[2] But to the Greeks as to all peoples of antiquity, the concept of a political entity naturally included the religious institutions as well, whose faithful service of the gods was considered essential to the success and well-being of the land and its people and therefore a primary responsibility of the ruling authorities. In the ancient Near East religious and civic institutions were inseparable; rulers were simultaneously priests,[3] just as the agricultural economy was directly controlled by the temple hierarchy.[4] When we recognize the importance ascribed to the aid of the gods for the success of the state and community and the focal role of the king within the ruling establishment to secure and mediate these divine blessings, we also recognize the intrinsically religious nature of the political art in such societies. This art is political in its attempt to propagate a positive belief not only in the apparatus of the state, but also in its divinely-sanctioned status. In view of its ideological breadth and effectiveness we can easily see why art of this kind is as old as the developed urban state and the ruling stratum that shaped it. Indeed, the officially sponsored media of architecture, monumental painting, and architectural sculpture may well have evolved not only for purely religious and utilitarian purposes, but also for practical religious-political reasons, as a concrete and lasting statement of the legitimacy and efficacy of the established order.

If the association of art and politics is extremely ancient, then the relation between art and literature within a political context implicit in the title of this volume is equally venerable. This too requires some explanation. It has become a commonplace, at times even a cliché, to conceive of the visual arts as a kind of language. Historians of art have no problem seeing a work metaphorically as a text whose form and content may be understood or clarified through the careful exegesis of stylistic and iconographical analysis. Such methodological precepts are largely unavoidable, for while the nature and perception of the visual arts are primarily visual, their discussion or study falls inevitably within the domain of language in verbal or literary form. But the analogy between art and

language or literature is no mere methodological expedient, particularly when we remember the basic significative function of artistic representation. No less than language, art is a medium of communication, and its narrative, symbolic, and allegorical capacities are as real and effective as those of any verbal or literary creation. Recent trends adapting the study of semiotics to the history of art and art criticism have gone far in explaining the underlying intellectual bases for these similarities, in which art and language appear as parallel manifestations of a deeper, unifying conceptual urge.[5]

But in many instances these similarities are most immediately the result of a common background of patronage and practice that deliberately fostered the production of related visual and literary representations sharing a common content and technique of imagery. This is particularly true in the case of the earliest political art and literature glorifying the tightly integrated religious, civic, and military authorities who dominated the urban societies of antiquity. In the ancient Near East the earliest texts that can be termed "literary" are essentially devoted to religious myth, to the praise and service of the gods, or to the virtues of the gods' immediate agents—the rulers and priests. The earliest works of monumental sculpture and painting almost invariably served the same purpose, and they often display a striking similarity in content and presentation to literary remains. For example, Assyrian literary texts extol the king as invincible in battle, armed, inspired, and protected by the national god Ashur.

> Roaring like a lion I put on the breastplate
> I put the helm on my head, a necessary equipment for battle
> And took in hand the bow and arrows which Ashur, king of
> the gods had bestowed upon me.[6]

Late Assyrian wall reliefs celebrate and explain the martial powers of the king in precisely the same terms.[7] In a relief from Nimrud, Ashurnasirpal II easily overpowers his helpless opponents, while the divine Ashur, in the same pose and armament, hovers above him in the winged disk to guarantee the outcome of the battle (fig. 1.1). Text and image display an identical ideology of belief and justification and use the same imagery of hyperbole and formal juxtaposition or analogy to express the protective relation of the divinity.

There can be little doubt that such visual and literary productions were intended to function analogously in relation to one another, using a common means of expression that transcends the differences of medium. If the political glorifications of ancient Near Eastern visual art can already be said to have an emphatic ideology and strategy of presentation comparable to that of contemporary literature, then they also shared its rhetoric, established rules and formats of composition that articulate the messages in a consistent, intelligible, and effective way. Through time and practice artistic and literary political representations continued to evolve

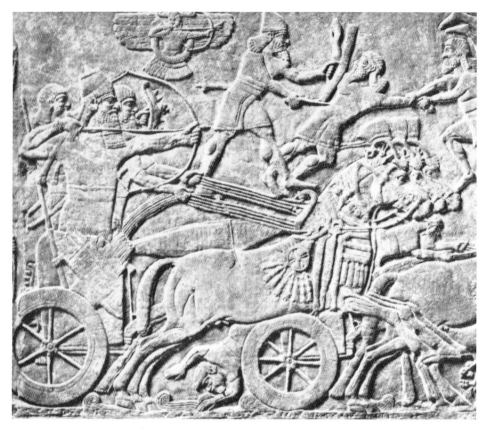

1.1. Ashurnasirpal II at war, Assyrian relief from Nimrud, in the British Museum, London (after H. Frankfort, *The Art and Architecture of the Ancient Orient* [Harmondsworth: Penguin, 1958], fig. 182).

in close association, thereby attaining a unity of purpose and expression that remained intact for the rest of antiquity and the Middle Ages into the early modern period, as the various essays in this volume will demonstrate collectively. In the context of visual political art, then, the notion of a rhetoric of power is much more than a metaphor, much more than a literary analogy.

The issue of audience is also essential to the understanding of the nature and strategy of the message itself. For whom was this rhetoric intended? Various possibilities arise from a practical point of view. There was the general population, whose confidence and support were indispensable to the maintenance of an established order, and the uppermost social stratum or aristocracy whose backing was equally important to the king or ruler. In the imperial context of Akkad, Assyria, or Rome and her successors, the triumphal imagery of war and conquest would seem inevitably to aim at the intimidation of subject peoples as well as the confidence of the home front.

But there may be other possibilities. Propaganda—the aggressive dissemination of a distinct point of view for a specific purpose—often carries a negative implication that its creators spread their messages cynically and without ideological commitment, purely as a means to an end. The evidence of premodern times suggests otherwise. In her contribution here Edith Porada has alerted us to another audience whom the modern observer might easily overlook. She suggests that in the ancient Near East political works of art were intended primarily for the gods themselves, as an earnest affirmation by the ruler of that essential relation to the divinity that assured his position and success. Such a statement may even have existed in works of political art that were clearly intended for a larger public. If so, Porada's observation also has implications for the political art of subsequent periods and cultures. Unless we are prepared to attribute a cynical impiety or atheism to rulers throughout history, then it is clear that political monuments advertising the divine support of the established order do more than foster or exploit popular religious belief in the service of the state; they are a public votive or expression by the ruler, however pompous or tendentious, in honor of the divine powers underlying his achievements.

This kind of consistency in purpose and approach also raises the issue of historical continuity in the process or tradition of political image making. To some extent the analogies between the political art of different cultures and periods are a reflection of a larger continuity in the evolution of the underlying political and religious institutions themselves. And so long as we have an urban-centered monarchy closely tied to an official cult or church, we can more or less expect monumental or public artistic statements which promulgate and glorify these institutions. But here it is essential to distinguish between the actual functions or duties of the political institution of kingship and the recurring image or theme of the king as divinely protected and inspired, as securer and disseminator of divine favor to the land and people. That the ruler should constantly appear this way in art through the centuries and millennia is hardly coincidental or inevitable. This happened because the artists of antiquity established literary and visual strategies and a rhetoric of power so widespread and effective that they transcended the boundaries of time and geography so long as the kinds of political institutions which they were intended to glorify continued to exist. The extent to which these political and religious institutions were themselves perpetuated by an effective, ongoing tradition of political imagery is well worth consideration.

There is no problem in documenting such continuity in antiquity, particularly in the ancient Near East, whose cultural features and art remained incredibly homogeneous through broad areas of time and space despite extensive local variation. The last flowering of Near Eastern culture under Achaemenid Persian rule was, moreover, an elaborate synthesis of the many traditions that preceded it. It is therefore not surprising that when the Greeks assumed the hegemony of the Near East after

the death of Alexander, they still found a wealth of political institutions, popular beliefs, and artistic iconographic formulae at their service. Like their oriental precedessors the new Hellenistic Greek rulers now strove to maintain the closest ties to religious institutions; they specifically appropriated the concept of a major deity as progenitor and protector of the royal dynasty and the king as his earthly counterpart or executive.[8] And although they substituted the Greek deities and artistic style, the adoption of various strategies from Near Eastern political art also enabled Hellenistic rulers to establish themselves over the indigenous oriental population in familiar, acceptable terms.

For practical reasons of much the same kind, many of these Hellenistic traditions then passed directly to the Romans when they assumed dominion from the Greeks. Richard Brilliant's essay unfolds the calculated display of the Roman emperor's numinous and charismatic image as a central theme of the monumental artistic celebration of the Imperium. But even if this imagery did address the cultural and ideological idiosyncracies of the Roman people, it was still long in the making. If the invincible, divinely-supported figure of Marcus Aurelius above a recumbent barbarian recalls the stele of Naram Sin or Darius I on the rock at Behistun (compare fig. 3.1 to figs. 2.5 and 2.10), and if the imperial hunt scenes on *tondi* of the Arch of Constantine remind us of the image of kingly manhood and virtue in the Assyrian reliefs of the royal lion hunt (compare fig. 1.2 and fig. 5.3), it is hardly accidental.

1.2. Ashurbanipal hunting lions, Assyrian relief from Nineveh in the British Museum, London (after A. Parrot, *The Arts of Assyria* [New York, 1961], fig. 64).

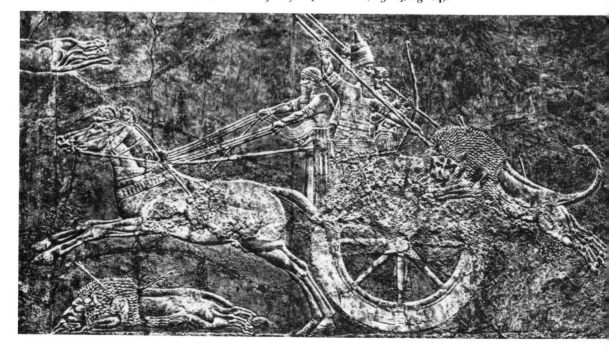

By the end of the Roman imperial period the issue of continuity in political imagery became a matter of cultural inertia; the political institutions of postantique Europe looked almost entirely to the Roman past as a model or paradigm. In the West the order and prestige of the Imperium had scarcely become a memory before the new Germanic rulers of Europe began to invoke it, claim it, and eventually to resuscitate it as a primary means of establishing legitimacy and authority in the regions which the Empire had formerly contained. Nor did the image of the Emperor himself die with the collapse of Roman power. Students of early Christian and medieval art have generally focused on the adaptation of such imperial iconography to the representation of Christ as a new supreme and thoroughly divine king. But the late Roman image of the emperor, now transformed as an earthly counterpart or representative of Christ, was still very much intact in the western Europe of late antiquity and the early Middle Ages, if not as a living presence then as a glorious memory, and a memory preserved largely by the monumental remains of Roman imperial art and architecture. It was this memory that Charlemagne and his successors sought to assimilate to their own kingship and political institutions, especially by reviving the artistic imagery of imperial authority. During the Middle Ages and the periods that followed, the restoration of a highly prestigious Roman antiquity was far more than a propagandistic tool; it eventually became a political and cultural message in its own right.

These issues emerge rather effectively in Jill Meredith's discussion of Frederick II, a medieval monarch whose remarkable familiarity and obsession with antique Roman political institutions and modes of artistic and literary expression rival the similar propensities of the Italian High Renaissance some three centuries later. Frederick's emphasis on the pre-Christian Imperium, especially his relentless efforts to portray himself as a new Augustus, already foreshadow the Renaissance and Baroque strategy of royal affiliation with specific pagan Roman rulers, which Joseph Forte examines here in his essay on Poussin's Grande Galerie at the Louvre. Frederick's revival of the Augustan theme of the renewed "Golden Age" even anticipates the later use of this theme by the papacy under Julius II and the early Bourbon rulers in France.

But the tangible continuities of artistic strategy and rhetoric cannot overshadow the extensive transformations that the artists and patrons of medieval and early modern Europe imposed upon the paradigms of ancient political imagery. In a Christian world Frederick fully exploited the intrinsically messianic implications of the restoration of the "Golden Age."[9] Not only as a new Augustus but also as a kind of new Christ, he produced an imagery that was no longer strictly Christian or Roman, but thoroughly medieval or perhaps even proto-humanistic in its perspective and cultural dialectic. As the gap progressively widened between the ancient world that had created these political paradigms and the world that now adapted them, there emerged ever greater possibilities for the conscious manipulation and transformation of antique traditions. Forte's

analysis of Poussin's Grande Galerie discloses this process of cultural dis-location as a political artistic strategy in all its richness and complexity. Poussin's Louis XIII is glorified through his affiliation with the emperor Trajan. Yet Poussin's Trajan is no longer the Trajan of antiquity, but a timeless, fictive embodiment of this emperor's role as a model of kingly strength and virtue, not only to Louis but to all rulers. For Frederick and even more for Louis, the original sense or purpose of the artistic rhetoric of Augustus or Trajan was no longer the primary issue, even if it was still generally relevant to their function as rulers. The images of the political figures of antiquity were far more useful as a source of prestige and as venerable historical mannequins that could effectively wear and advertise the changing wardrobe of artistic royal glorification. There was indeed an artistic strategy and rhetoric of power which survived and evolved continuously from the earliest city-states to the absolute monarchies of the early modern era, but it did not survive unaltered.

This is hardly surprising in view of the myriad social, economic, and religious developments taking place during the nearly four millennia separating these periods. It is in fact far more surprising that these strate-gies and rhetoric should have survived so well, or still more that many of their features would continue to find a place in the new political land-scape of the post-medieval or modern period. For in all the instances con-sidered so far, the rhetoric of power was essentially autocratic—or, to coin a more appropriate term, *regicentric*—i.e., focused entirely on the monarch as the repository of all earthly power and the essential link to divine support and benefit. The political trends of the modern period are characterized in contrast by a gradual but steady shift toward a more col-lective concept of the state as an amalgam of individual enterprise and achievement that no one man could encompass or epitomize, and a con-cept that is progressively less overt or insistent about the role of divinity as the ultimate source of the success of the state.

This shift or change is undoubtedly related to the new humanist em-phasis upon the value of the individual human intellect and its collective potential, which typified the Renaissance. But it is also not without anal-ogy in antiquity; the relatively anomalous institutions of the Athenian de-mocracy and the Roman republic immediately come to mind, as well as their use of local mythological figures in art and literature to exemplify the collective ideals of the state.[10] Nor did the propaganda of the Roman Empire from Augustus onward fail to exploit this traditional, collective national pride on the part of the citizenry, but it did so always in relation to the paternal figure of the emperor. However, with the eventual disap-pearance or weakening of monarchic power in the course of the modern period something new was needed in place of this long-familiar, unifying symbol of the power of the state. And so in its place arose the single, an-thropomorphic personification of the state itself.

David Rosand addresses an early example of this process in the hu-

manist context of the High Renaissance, the creation of the sixteenth century personifications of the state of Venice. Though republican by constitution, Venice was nevertheless imperial in her aspirations and view of herself, and so even here the old rhetoric of power is just below the surface. "Venetia" is a marvelous composite of antique pagan and medieval Christian prototypes, especially the ancient divinity Dea Roma.[11] Moreover, Venetia's incorporation of the figures of Roma, Iustitia, and the Virgin Mary with the image of the Solomonic Throne of Judgement provides a striking analogy to the iconographic repertory and strategy of Frederick II. Yet there all these figures had remained separated, unified only by their relation to the central political role of the monarch. Thus the synthesis of these figures in Venetia as an independent unity directly personifying the state demonstrates the Janus-headed aspect of this new formulation, still glancing retrospectively to the religious-political imagery and ideology of the past, but modern in its free and novel use of this imagery to articulate a new and changing political reality.

The political and artistic innovations of Venice had an enormous impact upon Europeans for centuries to come. Their effect upon England is particularly apparent in the political concept and image of Britannia, and more generally in the constant pilgrimages of Englishmen from Coryat to Ruskin, who all returned home with the praises of Venice upon their lips. After the victory of constitutional monarchy over absolutism in England, the attraction of Venice as a political and cultural ideal no doubt increased. With the emergence of England in the eighteenth century as a major European power of global imperial or colonial aspirations, the English too began to explore the new possibilities of a rhetoric of power that focused upon collective national, cultural, or intellectual achievements as a glorification of the state.

Kenneth Bendiner examines these issues in his discussion of the images of British colonial India produced in the late eighteenth century by Thomas and William Daniell. Hardly an objective view, this series of prints was intended as an advertisement of a newly-acquired imperial property, whose distinctive and exotic cultural traits serve merely as a foil to assert the superiority of British institutions and values as a justification for the domination of India. There are certainly parallels for this in the literature of antiquity: the *History* of Herodotus, especially his discussion of the Persians; Tacitus' *Germania*; or Polybius' discussion of the Gauls in Book II of his *History*. For all their description and analysis they too ultimately assert the cultural superiority and right of dominion of the Greeks and Romans over all "barbarians." But ancient representations of the foreign barbarian in the visual arts show them only as a defeated enemy; they never attempt to depict them in their own "inferior" cultural setting as a conscious form of deprecation. In contrast, the Daniells muster a wealth of ethnographic detail to create an artistic image of a foreign whipping boy that establishes a dialectic context to justify the British Em-

pire in cultural and moral terms. This is a new strategy in political image making, and it was influential in its turn upon subsequent colonialist propaganda. Soon, it would culminate in the more widespread "Orientalist" trend of 19th century European painting.[12]

Yet this new approach, however effective, could never supplant the traditional artistic strategies that glorified the state in direct, positive terms. The experience of Venice had demonstrated that the central image of the monarch was not essential to such artistic glorification, that the state and its constitution as a collective national achievement were more than sufficient and appropriate as a theme of political art. But Venetia was still visually monarchic, an enthroned image of authority conceived as a single human figure. Venice had no king, but she herself was a queen. In the nineteenth century the English carried the figuration of the state and cultural glorification a step further by exploring the more abstract possibilities of architectural iconography.

In his discussion of the rebuilding of the Houses of Parliament by Barry and Pugin, George Hersey shows us the potential of the Gothic style of architecture to embody and to enshrine the English constitutional traditions of law and government synonymous with Parliament itself. But here the use of traditional forms audaciously defies the social and political gulf between medieval and Victorian England, the same kind of cultural dislocation exploited so well in Poussin's Grande Galerie. We see the Gothic style, ultimately French in origin, and the architecture of the English aristocracy of Norman descent become a symbol of the so-called "Saxon Liberties" as the unwritten English constitution was popularly known. Here medieval architecture effectively evokes an image of pristine English social justice and equality that the Middle Ages never saw at all. This is not only the medievalism of Pugin, but also the Utopian medievalism of Morris and Ruskin. In its anticlassical emphasis of purportedly indigenous architectural traditions this medievalism also epitomizes the nationalistic striving for distinct cultural identity so typical of nineteenth century Europe. And all the while the scale and sumptuousness of the absolutist architecture of the Continent lie just below the surface of the Houses, lest this monumental glorification of the English Constitution fall short of the immediate artistic "competition." Here Hersey provides us with a striking insight into the making of artistic strategy and rhetoric in a monument which even today embodies England and her institutions despite its origin in a web of contradictions and historical anachronism.

The political art of post-medieval times was often able to exploit the dislocating effects of time and cultural change in this lively fashion. But in the course of the nineteenth and early twentieth centuries a new rift emerged that would prove detrimental to the creation of officially sponsored political art of conceptual depth and conviction. This was the rift between the main trends of modern artistic innovation or progress and

the patronage of the political and economic establishment. The rift was of course two-sided in origin. It resulted from the desire of modern artists to establish new creative bases and from their insistence upon artistic autonomy in the substance and approach of their work. But it was conditioned as well by the official rejection of new artistic precepts and modes of expression that did not conform to established academic standards. This eventually led to the mutual perception that radical artistic innovation was basically incompatible with the glorification of the established political order, a task which required a modicum of artistic continuity both to remain immediately intelligible and to serve as a message of tradition or stability in its own right.

The political and social upheavals of the First World War did, however, effect a temporary *rapprochement* between the European artistic avant-garde and the needs of the state. This occurred in early Revolutionary Russia during the twenties, when the young Soviet government gave free license and encouragement to all modes of artistic representation in the hopes of furthering its shaky new social and economic order. But the entire thrust and perspective of this development was revolutionary and radical rather than an unequivocal acclamation of the Soviet state. George Bournoutian's contribution here on the posters of Vladimir Mayakovsky demonstrates this quite clearly; they operate primarily as a critical indictment of the sins of the *ancien régime* and its supporters. Moreover, much of this Soviet art avoided an overtly propagandistic approach. Since the artistic objectives of the avant-garde were themselves "revolutionary," government-sponsored works of this kind attempted to express an ideology of political and social change through their intrinsic aesthetic and conceptual qualities rather than by any direct visual means or message.

Gail Roman's discussion of Vladimir Tatlin's *Tower* presents us with such a positive artistic metaphor in the service of the nascent Soviet state. The proposed modern design and technology of the structure were intended to house and to embody the innovative aspirations of the new regime, in a way that oddly parallels the use of traditional architectural forms to epitomize the English Constitution in Barry and Pugin's Houses of Parliament, or Frederick's Capuan Gate as a monumental symbol of his state. As Gail Roman shows, the Tower does indeed attempt to establish analogies with the monuments of the past, although as images of oppression and ignorance to be replaced by a new and better order.

But once the Soviet state was victorious and firmly in power, it was no longer served by a rhetoric of revolution and indictment of the past. It now needed a strategy based on "convincing conclusions" like those of Roman imperial imagery rather than the allusive language of radical modernity and innovation offered by the avant-garde. And the Soviet government would have such conclusions soon enough, but not from the likes of Tatlin or Mayakovsky. As the revolutionary regime became the

establishment, its association with the avant-garde ended in disaffection and repression. A few years later the artists of the Bauhaus and kindred movements would be similarly unwelcome in the new order of Hitler's Germany.[13]

But across the Atlantic this Russian experience did help spawn the ideologically related revolutionary art of Rivera and Orozco in Mexico, and it influenced modern music in the United States. Barbara Tischler's essay studies the work of the Composers' Collective, particularly that of Aaron Copland, as political invective directed against capitalist economic exploitation and the indifference of the economic establishment and government. But such work could never be official. Short of revolution or radical change the controlling political and economic forces of twentieth century Europe and America could only be the targets rather than the patrons of this ideology in music or in the visual media of sculpture, painting, and architecture.[14] If in addressing political issues modern art had gravitated toward an antiestablishment dialectic, then this could only exist as a matter of individual artistic initiative, whatever its scale or programmatic scope. As a theoretician and practitioner of large-scale political art of this kind, Bernard Aptekar provides us with a personal look at the motivation and objectives of the contemporary artist in this context.

The impact of these developments is all too apparent in the decorative program of the Rockefeller Center complex, which forms the subject of Carol Krinsky's contribution to the present volume. While the patrons and designers were eminently successful in using architecture to evoke an image of the benefits and potential of the capitalist system for Depression America comparable in scale and effectiveness to the efforts of Barry and Pugin, they were unable to extend this ideology intelligently to a program of applied sculpture and painting. Krinsky focuses on the lack of artistic discernment on the part of the patrons of the project, Rockefeller and Todd, in choosing appropriate artists and themes. This in itself exemplifies the rift between official patronage and modern artistic production. But she also emphasizes the inability of the very fashionable muralists and sculptors who received the commissions to come up with a convincing and coherent program with depth of content. Not surprisingly, when Rockefeller and Todd did turn to the talents of a forceful and committed ideologue like Rivera, the result literally subverted the basic meaning or theme of the entire architectural complex.

The attempts of Social Realist painting to glorify the strength and nobility of the worker in other commercial architectural[15] and government-sponsored projects, and in the art of the totalitarian regimes of Europe in the thirties and forties[16] were no more successful as works of artistic or conceptual sophistication than the program at Rockefeller Center. Official fascist art often deliberately echoed the aggressive rhetoric of the political art of antiquity.[17] But in contrast such art seldom displays the eloquence and richness of form and expression which the Roman monuments still impress upon the modern observer. The artistic weakness of

the official or public political art in America and Europe at this time is all the more apparent when compared to the forcefulness of contemporary political film like Riefenstahl's *Triumph of the Will,* or Frank Capra's monumental response to Riefenstahl, *Why We Fight.* As Jacqueline Austin shows in her essay here, these works transcend their immediate purpose as propaganda; they are also rich statements in their attempt to fix the major themes of national or cultural consciousness within an elaborate landscape of historical justification.

In the course of the twentieth century the ability to patronize a truly effective or profound monumental artistic imagery of power or public good gradually slipped from the hands of the political and economic establishment. But this was not due purely to the shortcomings of patronage. For even if the planners of Rockefeller Center had possessed the discernment to recognize an appropriate program of imagery and the artists capable of realizing it, it is probable that they would still have been disappointed in their efforts. By the 1930s the rhetoric of established power was no longer a part of the language of the leading exponents of painting and sculpture in Western art. At the same time the new mass media of radio, film, and eventually television were revolutionizing the process of political image making. Political statements of real depth and content in twentieth century painting and sculpture are of a very different dialectical order, primarily expressing the views of the artist himself as an independent, critical agent of protest or change, and no longer as a servant of the state.

EDITH PORADA

2. The Uses of Art to
Convey Political Meanings
in the Ancient Near East

In view of the limited application and currency of writing in the ancient Near East, official ideology was often expressed in visual form. Yet the task of discovering and interpreting examples of such visual art is not as simple as it might seem. When one thinks of politically motivated art in the ancient Near East, the images that most readily come to mind are the well-known Assyrian reliefs of Ashurnasirpal II. This powerful monarch reigned from 883–859 B.C. and built the first neo-Assyrian palace in which the throneroom was decorated in part with narrative reliefs whose battle and siege scenes are so frequently illustrated in history and art history textbooks (figs. 2.1 and 2.2). These reliefs appear to be fine examples of the message of Assyrian power for the peoples within the reach of Assyrian military might. But to assume that many of these peoples were directly influenced by the palace reliefs is a simplification of the actual situation. The reliefs are relatively small with a height between 88 and 95 cm, so that details can only be discerned from a fairly close viewing position, although some color accents probably increased the effectiveness of the designs in comparison with their present drab, undifferentiated greyish color. According to Meuszynski and Sobolewski's published plan,[1] the throneroom was ten meters wide, and the area in which people could have assembled was forty-five meters long. These are not gigantic proportions, so that one would assume that the 5,000 high officials who came as delegates from the conquered territories and as guests to the opening of the royal palace[2] would not have been received in the throneroom but would have remained outside in the courts. If Ashurnasirpal's main purpose had been to impress the surrounding peoples with his military power and to create a fear of the Assyrians so intense that tribute would be duly paid and no thought given to revolt, then a verbal account by a surviver of the hapless conquered towns would have been more effective than any pictorial representation. We have no reason to doubt the statements of Ashurnasirpal: "I conquered the towns

of Luhuti, defeating their inhabitants in many bloody battles. I destroyed them, tore down the walls and burnt the towns with fire; I caught the survivors and impaled them on stakes in front of their towns. At that time I seized the entire extent of the Lebanon mountain and reached the great sea of the Amurru country."[3]

But if the main purpose of the pictorial military narrative was not to create fear in the surrounding territories, what then was its purpose? Certainly not to impress the Assyrian inmates of the palace. Their revolts against Ashurnasirpal's son Shalmaneser III and the murder of king Sennacherib indicate that regardless of any pictorial glorification, an

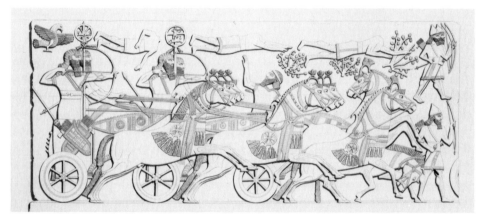

2.1. Attack of the chariotry of Ashurnasirpal II, c. 870 B.C. (from A. H. Layard, *Monuments of Nineveh* [London, 1849], pl. 14).

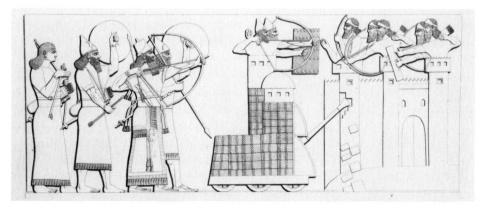

2.2. Ashurnasirpal II laying siege to a castle, using a battering ram (from Layard, *Monuments of Nineveh*, pl. 17).

Assyrian king's power was not considered irresistible among the aristocracy. The only reasonable explanation of these pictorial narratives of military victories is that, in the first place, they were intended as an accounting to the gods with whose help and in whose honor they were won, and as a means of retaining the impact of these victories in a "magical" way. Second, the narrative reliefs must have served as a satisfaction for the king's own self-esteem and as a personal reassurance of his power. I believe that only in the third place were they a means of impressing the beholder with the king's military might.

I think that we can take this view all the way back to the attack of the chariotry in the lowest register of the "standard" of Ur, dated approximately 2500 B.C. (fig. 2.3). Here the meaning of the scene appears to be primarily religious and magical rather than propagandistic. This is especially likely because we find a quotation from such full representations of chariot warfare in the single chariot engraved on a small cylinder seal of the same period, where the representation probably had a propitious significance (fig. 2.4). Even the stele of Naram Sin of Agade (c. 2200 B.C.), which is artistically one of the most effective victory monuments of antiquity, was probably intended primarily as a justification or thanksgiving for the divine protection that had made the victory possible; it was only secondarily meant to eternalize that victory (fig. 2.5). The specific emplacement of this stele at Sippar, possibly in the temple of the sun god, may confirm the religious intent of the erection of the stele.

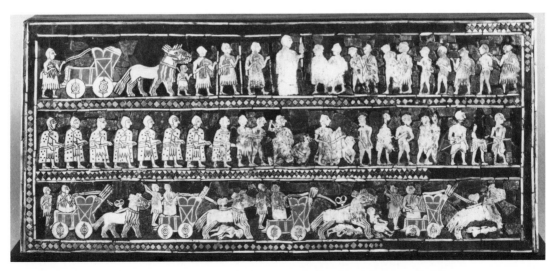

2.3. "Standard" of Ur, war panel, in the British Museum, London (photograph: The British Museum).

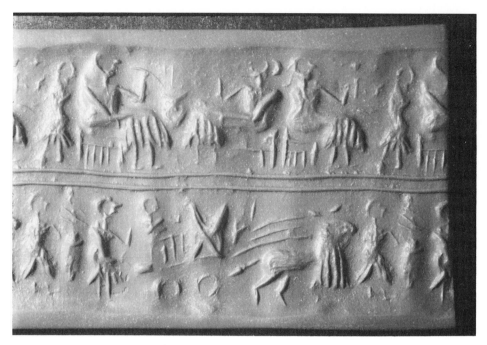

2.4. Early Dynastic cylinder seal impression, Pierpont Morgan Library No. 118, showing a chariot and booty carried behind it in the lower register and a banqueting scene in the upper register.

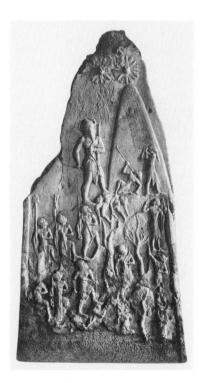

2.5. Stele of Naram Sin of Agade (c. 2253–2218 B.C.), in the Louvre, Paris (from W. Orthmann, *Der Alte Orient* [Berlin, 1975], pl. 104).

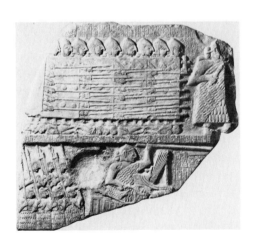

2.6. Stele of Eannatum from
Tello (Girsu) in ancient Sumer,
two major fragments, in the
Louvre, Paris (from E. Strom-
menger, *5000 Years of the Art of
Mesopotamia* [New York, 1964],
pls. 66–67).

The stele of Eannatum which was erected to commemorate the vic-
tory over the neighboring state of Umma in a war over water rights may
present a different case (fig. 2.6). Although its height is a little less than
that of the stele of Naram Sin, it leaves the impression of a more powerful
monument. Perhaps the impenetrable wall of Sumerian soldiers is re-
sponsible, or the great figure of the god Ningirsu fighting for his pro-
tégés, the king of Lagash and his army. Here a primary purpose may well
have been a statement of power.

But certainly in all the other examples shown, the immediate impression that the representation was directed toward the viewer to impress him or her with the legitimacy of the king's role as a militarist, and implicitly as protector of the people, seems to have been less important than the king's relationship with *his* protectors, his gods, and his personal desire for the permanence of victory. Of course, the security of the inhabitants and their ordered existence depended on the king's ability to defend them, hence the numerous representations in the Old Babylonian period of the king as a warrior. But there the actual destruction of enemies is left to the gods, whereas in representations of the north, Assyria, and the west, North Syria, kings appear as victors.[4]

Thus, upon closer examination, monuments that seem at first sight to have been overt visual propagandistic statements probably had a more propitious intent. But there were other examples of ancient Near Eastern visual art that were indeed directed toward the viewer for political reasons. We return to a neo-Assyrian monument, the obelisk of Shalmaneser III, the son of Ashurnasirpal II, who reigned from 858–824 B.C. The obelisk was standing in the open, apparently visible and accessible from every side (fig. 2.7), though its precise position was not recorded. On the principal side there are two scenes below the ziggurat-shaped top (figs. 2.8 and 2.9). In each a foreign prince kneels before an Assyrian king with his hands and beard touching the ground in the posture of the greatest humility. The lower scene is often reproduced alone, because the foreign ruler is Jehu of Israel, whose biblical association is of general interest. The similarity of the two scenes is unique and has always puzzled me. Fortunately the identity of the other foreign ruler is indicated as well.[5] The man in the top register is Sua (or Asu) of the land of Gilzanu, which was located in the vicinity of Lake Urmia in modern Iranian Azerbaijan.[6] Gilzanu appears to have been the easternmost area of Shalmaneser's campaigns. Equally far in the opposite direction from Shalmaneser's residence at Kalhu or Nimrud, was the land of Jehu of Israel. Now the meaning of the two scenes one above the other becomes obvious. Portraying the tribute of these two countries effectively demonstrates the gigantic extent of the area covered by Shalmaneser's campaigns and of his sphere of influence. While this is the first such pictorial indication of a geographical distance, the suggestion of territorial expanse by naming two or more well-known points, far from each other, was common in historical inscriptions. There remains the question of the intent of the differences that appear between the two scenes, a military attire for the persons in the scene at Gilzanu, and a court ceremony in the one involving Jehu (figs. 2.8 and 2.9). This may imply a different political situation of which there is no evidence in the texts, but it is also possible that the differences were merely intended to vary the image and to show the king in two different roles, both as a military leader and as a benign overlord in peacetime.

Shalmaneser's pictorial language was probably better understood in his own time. The meaning or sense of the juxtaposition of the two scenes would have been entirely clear to the ancient observer, and we are still not certain about all the details, which would have been evident to a visitor to the royal enclave at Kalhu in the ninth century B.C. But its impact was certainly not as direct or immediate as the visual statement of victory of the Persian king Darius I (522–486 B.C.), who places his foot on the body of the fallen Gaumata in the rock relief at Behistun (fig. 2.10). The motif here is said to have been derived ultimately from the stele of Naram Sin, but there is a basic difference in the context of the motif. The indication of the resistence that had to be overcome by Naram Sin is no longer present in the relief of Darius, where instead the opponents appear

2.7. Obelisk of Shalmaneser III (858–825 B.C.) (from Layard, *Monuments of Nineveh*).

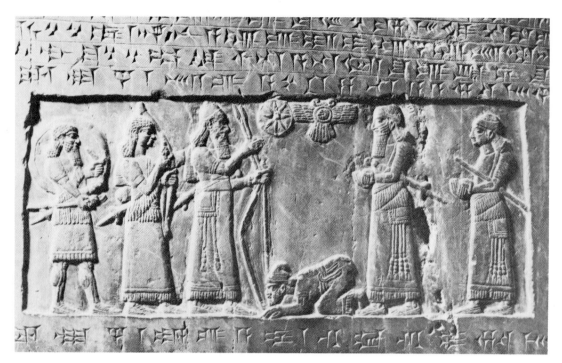

2.8. Shalmaneser III receiving tribute of Asu of Gilzanu (photograph: The British Museum).

merely as roped prisoners in a row (compare figs. 2.5 and 2.10). Yet anyone who has actually seen the relief knows how small it appears from the ancient road from Iran to the west that runs through the valley at the foot of the rock bearing the relief. So as long as only that relief was known, it could be considered another work not directed primarily at human viewers, but rather to the gods. But the relief is not unique, as we shall see; it had only a supporting role in relation to its text, which was carved in three languages: Akkadian (the language spoken and written by the Assyrians and Babylonians), Elamite (the language of Iran before the Persians), and Old Persian, for which the cuneiform equivalents may have been invented for this inscription. The cursive Aramean, which was actually the languge of the Persian chancelleries,[7] was not used. The text contains the justification of Darius to rule the Persian Empire: he gives his genealogy; the account of the secret murder by Cambyses, son of Cyrus, of his own brother Bardiya; Cambyses' death; the rise of a false Bardiya, a magus called Gaumata whom the inhabitants of the empire accepted as ruler, and whom the mother and wife of Bardiya accepted as the person they had known; the defeat and subsequent death of the false Bardiya-Gaumata at the hands of Darius and six of his coconspirators; and finally the rebuilding of the temples destroyed by Gaumata, the return of cattle

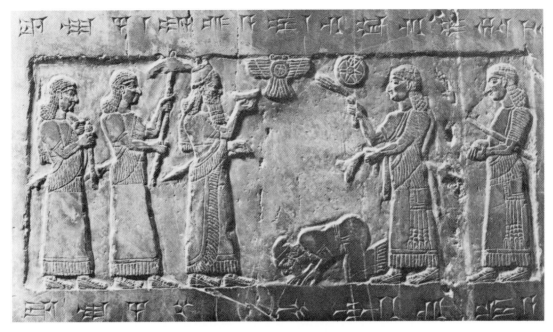

2.9. Shalmaneser III receiving tribute of Jehu of Israel (photograph: The British Museum).

herds and peasants that Gaumata had seized, and in short, the reestablishment of the *status quo* before the false Bardiya had seized power.[8] The text appears to have been sent throughout the empire,[9] for there were fragments discovered in Egypt and also in Babylon. The importance of disseminating the story of Darius' rise to power lay especially in the question of the death of Cambyses' younger brother. Herodotus and Ctesias accepted Darius' version, but recently Ilya Gershevitch, the great Iranologist, worked out a very complicated explanation for the guilt of Cambyses. Yet the very desire to promulgate the story speaks for its spuriousness. In addition to fragments of the text, there were also fragments of the central motif of the Behistun representation found at Babylon on either side of the outer procession street which led up to the Ishtar Gate from the north. A visitor in the time of Darius would have seen the victory monument of the Persian king before he entered the town gate. Ursula Seidl, who discussed the fragments,[10] reconstructs a freestanding monument with at least three sides. Recently J. V. Canby[11] discovered a glazed brick from Susa among the tiles lent for an exhibition of Achaemenid Persian art by the Louvre, which may derive from another copy of the Behistun relief, although she considers the possibility that the tile may belong to a different motif. Assuming that Susa did indeed have a copy of the

Behistun relief, which is all the more likely since it was Darius' principal residence, we then have in these replicas works of art that were clearly intended to legitimize the role and function of Darius at the head of the greatest empire that the world was to see.

Finally I would like to turn to a Persian cylinder seal probably made by a Greek engraver in Anatolia (in modern Turkey) several decades after Behistun (fig. 2.11). Despite a similarity of motif, I think that the seal differs fundamentally from the relief. In the seal the king appears as the defender of the order of the country and of the security of the inhabitants, protecting them against foreign intrusion; thus he kills a Greek soldier or hoplite. This is an amulet in the traditional sense, expressing the wearer's belief in the indisputable role and power of the king as his protector. The Behistun relief in contrast was an attempt to justify the role of Darius to his subjects in rational terms. Such a deliberate attempt to control or affect public opinion in the empire may have been the result of Darius' genius for government. Or it may have resulted from his Persian origins in a tribal society where people of more or less equal status had to be convinced to accept the leader's policy. At any rate this type of propaganda constituted a new departure in the art of antiquity.

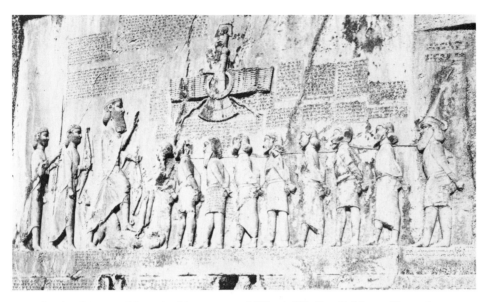

2.10. Darius I (522–486 B.C.) with conquered "king of lies" at Behistun (from *Archaeologische Mitteilungen aus Iran* 1 [1968], pl. 26).

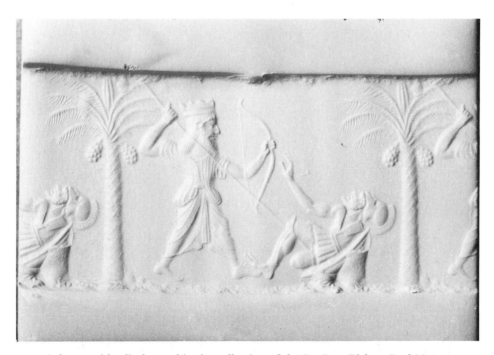

2.11. Achaemenid cylinder seal in the collection of the Rt. Rev. Bishop Paul Moore: a Persian king defeats a Greek hoplite.

RICHARD BRILLIANT

3. *"I Come to You as Your Lord": Late Roman Imperial Art*

At te imperii summam, et, cum omnium rerum tum etiam tui potestatem, di
 transtulerunt.
 —Pliny, *Panegyric to Trajan* 56.3

The Romans of the Empire were masters in creating visual, pub-
lic images of power, translating the verbal and nonverbal fabric of social
and political relations and of historical events into the symbolic forms of a
monumental art. Gilded bronze equestrian statues, greater than life, such
as that of Marcus Aurelius on the Campidoglio in Rome (fig. 3.1), served
to present the image of the charismatic leader to the Romans, asserting
the lofty qualities of the emperor in the guise of the triumphant man-
on-horseback, a crouching submissive barbarian (now lost) once placed
emblematically beneath the stallion's raised front hoof. Victorious in war,
a ruler of distinguished lineage and of noble character, Marcus Aurelius'
statue projected an aura of magnificent authority, especially when the en-
tire artwork flashed golden in the sun.

Yet for the statue to do its work, to present the overwhelming image
of the emperor as master (*dominus*), an audience was required, respond-
ing to the rhetorical qualities of the artwork, to the manner of its imposi-
tion on their consciousness. Roman Imperial art had long developed an
extensive repertory of programmatic types and motifs, charged with the
exaltation of the emperor and his deeds. Equestrian monuments, colossal
statues of the cuirassed leader, elaborate large-scale reliefs and paintings
depicting his exploits in war and peace, triumphal arches and honorific
columns, as well as a steady flow of imperial portraits, coins, and medal-
lions constantly advertized the reality of the emperor's power and occupied
the Romans' mental and physical space with his images. Such constant
reiteration, a technique of Roman rhetoric, had already been employed in
the political propaganda of the Late Republic and its use was progres-
sively intensified during the course of the empire. The omnipresent im-

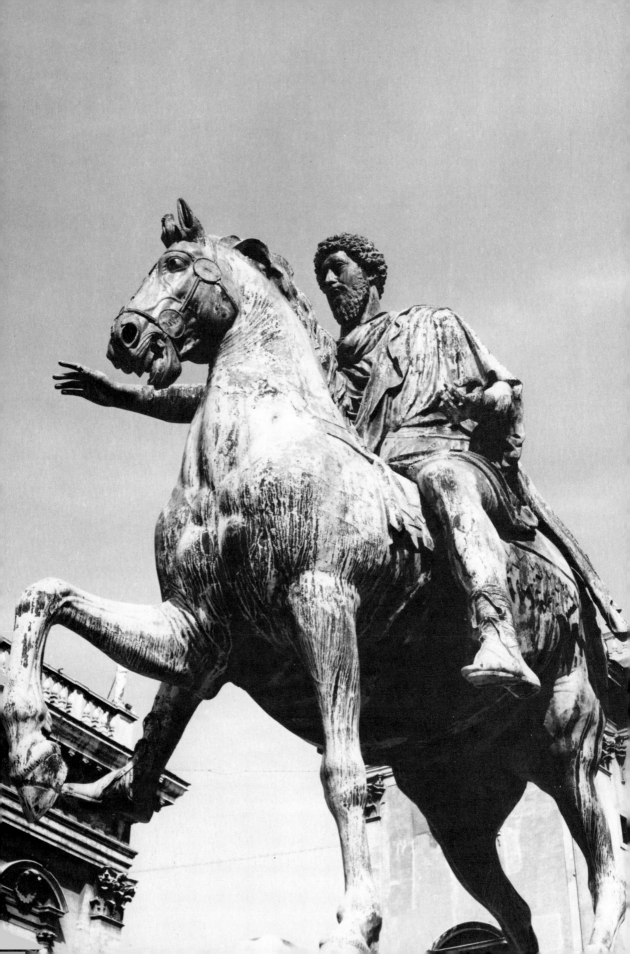

ages forced themselves into the mind of the Roman public; by precluding alternative interpretations they shaped the dialectic between image and spectator, between presentation and respondent so that convincing conclusions rather than historical or factual justification became paramount.

Thus, the triumphant Marcus Aurelius, victor in the German wars of the 170s, gives no hint of the difficulty of that victory, nor should that be expected given the transcendent nature of his image and of the values it represents. There is, however, a connection between historical fact, the defeat of the Germans, and the puissant image of the emperor available to the enemy on the battlefield and to the Roman citizens at home, that is the gesture of his right arm. For the submissive enemy below, the gesture demonstrates the imperial authority, but it is also a conventional symbol of *clementia*, that virtuous act of mercy extended to a defeated foe, to anyone in trouble needing to be restored to well-being. But that gesture applies as well to the members of the Roman public, standing beneath the lofty statue, and it reminds them of his power over them and of his efforts on their behalf. In effect, then Marcus Aurelius is their lord and protector and his statue bears open witness to that truth.

Even earlier the Arch of Trajan at Benevento (A.D. 114–117) had made the classic imperial exposition of this message: his domestic program was revealed in the richly allegorical relief panels on the side facing Benevento and Rome beyond, while Trajan's conduct of foreign affairs and war appeared in the panels on the country facade, turned southeast toward the port of Brindisi and the planned campaign against the Parthians in Mesopotamia. On both facades the emperor's success and his numinous authority were manifest, supported by the gods and by the apparatus of ceremony developed by the Romans to mark the superiority of the imperial person and the respectful response offered to him by the people of the empire.

The repertory of such official ceremonies includes the imperial arrival (*adventus*) and departure (*profectio*), formal addresses to the troops (*adlocutio*), the submission (*submissio*) of the defeated enemy and the clemency (*clementia*) extended to them, the triumphal procession through the Roman Forum to the Capitol (*pompa triumphalis*), investiture, acclamation (*acclamatio*), and the donation of money and food to the soldiers or to the Roman people (*congiarium, largitio*); to these were added in the Late Empire the ceremonial opening of the games in the hippodrome with its donative (*sparsio*) and the elaborate court rituals about the person of the emperor, involving *proskynesis* and other forms of self-abasement. Such ceremonies involve the imperial protagonist and the public in a highly structured relationship that frames political action, expresses its ideology, and offers a rich spectacle, combining visual splendor, verbal formulae,

Opposite. 3.1. Equestrian statue of Marcus Aurelius, Campidoglio, Rome, c. 175 (photograph: Richard Brilliant).

often repeated rhythmically, and even music, all within an elaborate, formal setting.[1] And it is ceremony that separated Roman rulers from the ruled, creating awe and fear in their subjects so that they were more prepared to acknowledge their lord's supremacy.[2]

Works of art and the motifs developed to represent these ceremonies commemorated the historical occasions in a permanent form; they could express the ideology of the ceremony symbolically in categorical images of authority; or they could recreate the intimidating, awe-inspiring effect of the ceremony through highly structured compositions or generic types. Processions and parades, especially of a triumphant nature, provided artists with an excellent opportunity to manifest the glory of the triumphator as well as the response of others to him. The Roman *pompa triumphalis* was such a spectacle and its effective transformation into an artistic motif can be seen in an Etrusco-Roman cinerary urn of the late second century B.C. (fig. 3.2). The ceremony has been adapted to the funereal program, suggesting the triumph of the heroic deceased over death, but the elements are consistent with the ceremonial procession of triumph: the triumphator rides in a chariot, accompanied by officials; the quadriga is preceded by lictors and by trumpeters who announce his presence and clear the way before him, while a young horseman raises his right hand in a salute (of greeting or farewell). The small panel combines the ceremonial situations of parade and reception; the supporting mechanisms of the triumphal chariot, the presence of deferential officials, of annunciatory musicians, and of an acclaiming equestrian, together with the focused composition express the special position of the deceased, his dominating status.

Departure and arrival are both parts of the ceremonial procession, anticipating the elaboration of the *pompa*, the *adventus*, and the *acclamatio* in later Roman monuments such as the Domitianic reliefs from the Cancelleria in Rome, the arches of Trajan at Benevento, of Galerius at Salonika, of Constantine in Rome, and the columns of Trajan and Marcus Aurelius. All these monuments are mute; what is lacking is the sound of trumpet flourishes and the rhythmic recitations of praise of the participants, responding to the presence of their leader and patron with "spontaneous" salutations:

The theater is filling up, and all the people are sitting aloft presenting a splendid sight and composed of numberless faces, so that many times the rafters and roof above are hidden by human bodies. You can see neither tiles nor stones, but all is men's bodies and faces. Then, as the ambitious man who has brought them together enters in the sight of all, they stand up and as from a single mouth cry out. All with one voice call him protector and ruler of their common city and stretch out their hands in salutation. Next, betweenwhiles, they liken him to the greatest of rivers, comparing his grand and lavish munificence to the copiuous waters of the Nile; and they call him the Nile of gifts. Others, flattering him still more and thinking the simile of the Nile too mean, reject rivers and seas; they

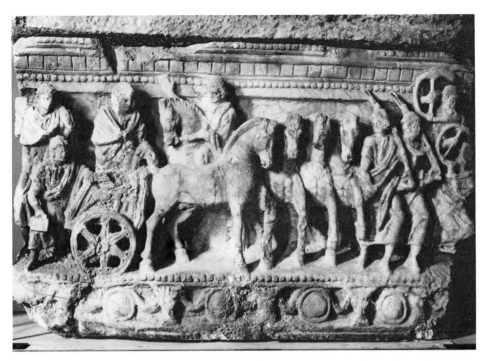

3.2. Late second century B.C. Etrusco-Roman cinerary urn: procession of a magistrate to the underworld, in the Museo Guarnacci, Volterra (photograph: Tivizzoli).

instance the Ocean and say that he in his lavish gifts is what Ocean is among the waters, and they leave not a word of praise unsaid.[3]

If praise for a private benefactor can be so extravagant, it reaches a greater intensity when the recipient of such acclamations is the emperor, when the very reiteration of acclamatory expressions takes on a ritualistic, even liturgical character. Thus, the Roman Senate acclaimed the new emperor Tacitus in 275 A.D.: "'We are choosing you as an emperor, not as a soldier.' This they said twenty times. 'Do you but give commands and let the soldiers fight.' This they said thirty times. 'You have both wisdom and an excellent brother.' This they said ten times. . . . 'It is your mind and not your body that we are choosing.' This they said twenty times. 'Tacitus Augustus, may the gods keep you.'"[4] The manner may be obsequious, the expressions simply hortatory, the concept self-gratifying, all coming together in a difficult political environment when the Senate is ready to turn over all power to a single individual, because the senators have been accustomed to the absolute rule of the state by one. In the late third century, the Latin panegyric developed as a major rhetorical form to be delivered as the public *laudatio* of a great man, and especially of the emperor, and formed part of important imperial ceremonies, especially the *adventus* and on anniversaries of accession or great victories. These panegyrics were rhetorical in conception in that they sought to present a

convincing image of legitimate power; they were elaborately allegorical, even splendid in anecdote to demonstrate the character of the perfect prince; they were largely ahistorical because truth lay in the reality of power rather than in the record of events; and they were primarily ideological, providing the audience with an image of splendid majesty.[5] The most complete representation of the *maiestas augustorum* surviving in Roman Imperial art is to be found in the reliefs of the Arch of Galerius at Salonika (fig. 3.3), a panegyric in stone of the early fourth century.[6]

The arch was situated at a major crossroad, one of whose streets led directly to the mausoleum of Galerius, the Tetrarch who had completed a successful campaign against the Persians and celebrated his victory in the erection of a four-bayed arch. Only half of the original monument still stands, but the remaining bands of relief appear to have much more to do with the celebration of the majesty of the Tetrarchs than with the ostensible cause of celebration. The reliefs on the north side of the south pier from top to bottom represent: (a) the triumphant *adventus* of the Tetrarch into a city, acclaimed by its citizens; (b) the victorious charge of the Roman forces led by the Tetrarch on his great horse, supported by the presence of *virtus*, the personification of his validating spirit; (c) the assembly of all the Tetrarchs, enthroned and frontal, flanked by the gods, especially Mars, personifications of the bounties of nature, and symbolic representations of the powers of the heavens and of the earth; and (d) at the bottom, in seven niches, images of Victory bearing trophies, probably emblematic of continuous victory at all times and places. Event has been transformed by ceremony that manifests the invincible power of these associated rulers, embodying a singular concept of majesty that gives order to the Roman world and rises above it.

The composition of these Tetrarchic reliefs exploits the distinction between the developed imagery of power as a collection of iconographic motifs, such as advent and triumph, and the patterns or schemes that underlie the affairs of the Roman state and its people. Given the protective frontality of the state portrait in the third register, placed slightly above the spectator's eye-level, this incorporated image of absolute power defines the iconic nature of the tableau, thus created, and frames it in ceremony. And it is in an elaborately tendentious ceremony, whose function is to force its conception of the absolute state and of the ordered cosmos on the mind of the implied but unseen audience, that late antique society achieves its most impressive artwork.[7]

The ceremonialization of all official acts with its concomitant ornamentation of imperial behavior led to the individuation, separation, and elevation of the emperor, to his distancing from all others:

Opposite. 3.3. Arch of Galerius, Salonika, south pier, north side, early fourth century (photograph: D.A.I. 52.3).

A high platform was set up and it was surrounded by a crowd of hoplites, javelin-men, and archers and cavalry equipped with their horses and the standards of the legions. Then the Emperor, accompanied by . . . his colleague, mounted the platform, carrying no sword or shield or helmet, but wearing his usual dress. And not even one of his bodyguard followed him, but there he stood alone on the platform, trusting to the speech which was so impressively appropriate.[8]

The emperor, as man and Lord, is alone, purposefully alienated from society even as he is the master of it. Such is the dominating pattern of the reliefs that adorn the obelisk of Theodosius I, erected on the spina of the Hippodrome at Constantinople in 390.[9] The base of the obelisk holds four large relief panels, very formally and schematically composed, representing Theodosius at court, Theodosius receiving an embassy of barbarians, Theodosius in state, and Theodosius at the Hippodrome awarding the wreath of victory to an unseen, unrendered winner of the chariot races (fig. 3.4). All the panels exhibit a symmetrical, frontal composition around the central, elevated, frontal, and colossal figure of the emperor, whose very eminence is hieratically charged, revealing the abstract, ideological structure of the concept. Since the victor is not shown and Theodosius directly affronts the spectator, the program of the relief implies that all victors—victory itself—are dependent on the numinous person of the emperor, now and forevermore. It is he who brings felicity (*felicitas*), security (*securitas*), and the possibility of enjoying them (*libertas*) to the empire.[10] This concentration of effects on the rigid, iconic image of the imperial master in late antiquity not only develops the preeminence of Theodosius but renders him superhuman, a magical figure, unique in the world and most worthy of reverence.

Accordingly, being saluted as Augustus with favoring shouts, while hills and shores thundered out the roar, he [Constantius II] never stirred, but showed himself as calm and imperturable as he was commonly seen in the provinces. For he both stooped when passing through lofty gates (although he was very short), and as if his neck were in a vice, he kept the gaze of his eyes straight ahead, and turned his face neither to right or to left, but . . . neither did he nod when the wheel jolted nor was he ever seen to spit, or to wipe or rub his face or nose, or move his hands about. Furthermore, that during the entire period of his reign he neither took up anyone to sit beside him in his car, nor admitted any private person to be his colleague in the insignia of the consulship, as other annointed princes did, and many like habits which in his pride of lofty conceit he observed as they were most just laws. . . .

So Constantius . . . signed himself 'My Eternity', and in writing with his own hand called himself lord of the whole world (*orbis totius se dominum appellaret*).[11]

Such an extraordinary being required an extraordinary environment, the domain of the Lord, which provided a fitting setting for the expression of his splendid majesty. Late Roman architecture created a variety of symbolic types to mark the magnificent presence of the Lord, among them specially planned spaces and specific motifs.[12] The arcuated

lintel, a form derived from Hellenistic-Roman religious architecture in Syria and the Levant, informs the facade of Diocletian's audience hall in his palace at Split (fig. 3.5).[13] This symbolic framing device signifies the numinous presence of the great emperor, resplendent in all his glory within while receiving those very few fortunate to be admitted to his majesty. The arch of glory, set within the angular gable, identifies the cosmic hall of the enthroned king, sitting in state; it could be used as a detached symbol to represent the emperor in state, as on the Missorium of Theodosius in Madrid, probably sent from Constantinople to the West in 387/388, thereby signalling his claim to power over the whole empire.[14]

The unlimited nature of this claim, indeed the very concept of unboundedness as the proper frame of reference for the late Roman emperor, already shaped the art of Constantine who appeared at the Council of Nicaea in 325 like some heavenly messenger, his costume glowing with brilliant splendor (Eusebius, *Vita Constantini* 3.10).[15] This solar imagery, an aspect of the iconography of Sol Invictus, fused with the persona of Constantine in his coinage following the victory over Maxentius at the Battle of the Milvian Bridge, and in the program of his Roman arch that celebrates the same victory.[16] Inscriptions in the central passageway of the arch refer to Constantine as *fundatori quietis* (*pacator*) and *liberatori urbis*

3.4. Base of the Theodosian obelisk, Hippodrome, Istanbul, c. 390 (photograph: Richard Brilliant).

(*benefactor*)—victor, bearer of peace, and liberator of the citizenry—while the inscription in the attic uses the unprecedented phrase *instinctu divinitatis*, proclaiming God's favor and support. By these means, Constantine must be seen as *dominus* but not as *deus, vicarius Christi* as Eusebius states in his Tricennial Oration,[17] but on earth he remains alone in his power. No other interpretation would appear to suit the great statue of Constantine, placed in his basilica at the edge of the Roman Forum.[18] Only the colossal head (fig. 3.6) and some fragments survive, but the original sculpture was about six times life-size. This was more than sufficient to overwhelm the spectator for whom Constantine's image had little regard, as the great eyes stared heavenward to that other greater Being with whom only he can be compared. God may rule over the cosmos and through his vicar, but the Roman emperor rules below on earth, and his glory is commensurate with that power. The composition of that imagery, whether vicarious or conclusive, was comprehended most completely by the Romans of the Late Empire, but they are not the only ones.

When Licinius, Constantine's associate in the East, faced Daia near Hadrianople in April 313, his army repeated the following prayer before their enemy:

> Supreme God, we beseech You,
> Holy God, we beseech You,
> We entrust our justice to You,
> We entrust our safety to You,
> We entrust our Emperor to You.
> Through You we live,
> Through You we are victorious and successful.
> Supreme Holy God, hear our prayers;
> We stretch our arms out to You.
> Hear, Holy Supreme God.[19]

Recently, two thousand young Iranian prisoners kneeled in rows, striking their breasts in unison beneath a giant painting of Khomeini, arms raised like Michelangelo's risen Christ, and roaring out the following litany:

> Khomeini is our leader.
> Death to America.
> Death to the USSR.
> Death to our former leaders.
> Death to Bani-Sadr.
> Death to Rajavi.
> This is not a prison it is a university.
> We are happy to be here.
> We want to go to the front to fight.
> We want to die for the Islamic Republic.[20]

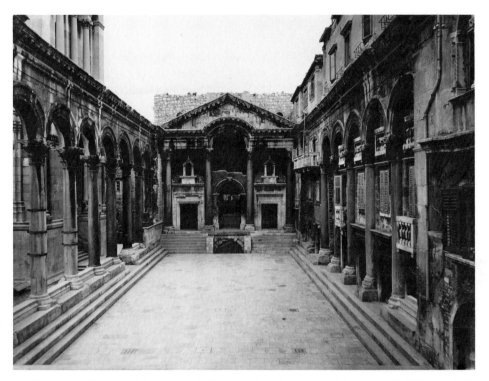

3.5. Peristyle, Palace of Diocletian, Split, early fourth century (photograph: Urbanisticki Biro-Split).

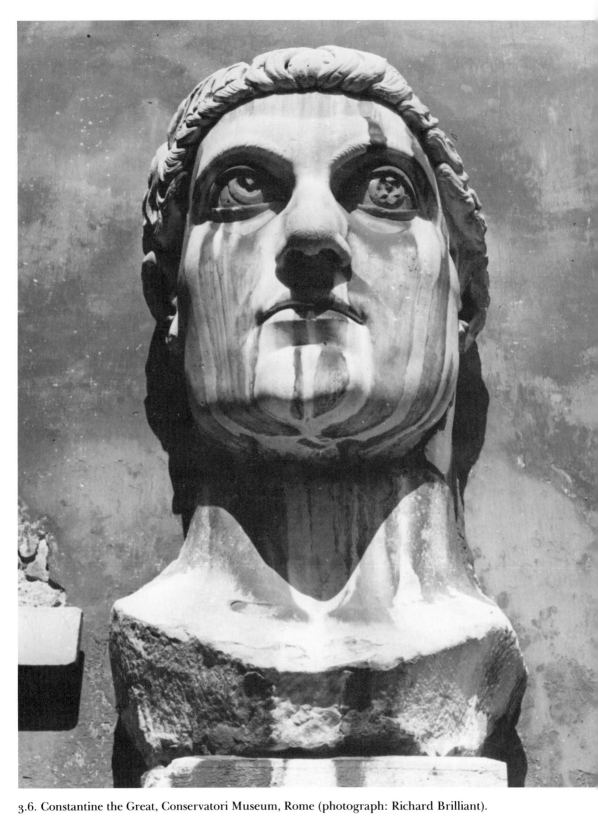

3.6. Constantine the Great, Conservatori Museum, Rome (photograph: Richard Brilliant).

JILL MEREDITH

4. The Revival of the Augustan Age in the Court Art of Emperor Frederick II

The Hohenstaufen emperor, Frederick II (1194–1250) (fig. 4.1) is unique among the secular or ecclesiastic rulers of the High Middle Ages.[1] His interests and aspirations reflect an unprecedented fascination with classical antiquity that foreshadows the Renaissance. A man of many talents and pursuits, he mastered half a dozen languages. He conversed and corresponded with experts in zoology, medicine, mathematics, and astrology. He established the University of Naples as a center for rhetoric and jurisprudence to rival Bologna. He wrote poetry and a treatise on ornithology. He personally directed military campaigns and architectural projects that yielded castles and fortifications throughout southern Italy, including the gate at Capua whose design and sculpture will be considered here. Frederick also patronized the literary and visual arts. He collected exotic animals that traveled with his peripatetic court, and he collected antiquities as well.

To become world ruler, his abiding personal ambition or "destiny," Frederick had to assume the characteristics of all manner of kings and princes. He may have lived in opulent style like an Arab prince, complete with harem, but his rulership was modeled partly on Carolingian and Ottonian prototypes, the Norman Sicilian king, the Roman emperor, and biblical messianic kingship. He achieved his extensive dominions by diplomatic and military skills, but equally through his own charisma, and the effective advertisement of his accomplishments and personal qualities through literary and visual media. Nor is there any question that he was the chief architect of the propagandistic activities which were refined and executed by his brilliant retinue.

The most common and potent of his public images was Frederick as Roman emperor, an appropriate model following the long-established precedent of his German forebears going back to Charlemagne. Roman

imperial tradition underlies many of his actions and words generally, but he associated himself particularly with one Caesar, Augustus. He did not seek to imitate Augustus but rather believed himself to be Augustus incarnate—the embodiment of a prophecy dating back to the time of his grandfather Frederick I, Barbarossa.[2] This literary and artistic association with Augustus actually began with his father, Henry VI, German emperor and king of Sicily in the 1190s, but it was the birth of his only son, Frederick, that finally fulfilled this dynastic prophecy.

The association of a German emperor with Augustus was also important in Christian terms since the Age of Augustus coincided with the time of mankind's redemption by Christ. Furthermore, these beliefs coincided with the late twelfth century "end of the world" prophecies. Writers such as Abbot Joachim of Flora foretold the end of time, to be preceded by a final epoch of peace, expected to occur in the thirteenth century. This dawning Third Age would correspond to and resemble the preceding ones, that is, the Age of Creation and the Age of Redemption which began at Christ's birth in the reign of Augustus. This Third Age would be once again a Golden Age of peace.

These beliefs and prophecies are reflected in an early thirteenth century manuscript illumination of the World Chronicle of Otto of Freising that specifically links Augustus and Christ.[3] Here Augustus, portrayed in conventional, familiar terms (i.e., like a German emperor), is shown enthroned and surrounded by his councillors, while the birth of Christ occurs simultaneously in the horizontal register just below.

A new messianic age was predicted for the thirteenth century that would resemble the first century A.D.; and Frederick was born, propitiously, on December 26, 1194. Henry VI's court poets explained this as the fulfillment of prophecy; a new savior, chosen by God to renew the peace and order of the world had now arrived. To celebrate Frederick's birth and his father's coronation as king of Sicily on the preceding day, Christmas 1194, the court poet Petrus de Ebulo compiled and had illustrated a series of poems, the *Liber ad honorem Augusti* (Bern, Burgerbibliothek Cod. 120).[4] These recount Henry's recent military achievements in Sicily and foretell future greatness for his son in a manner reminiscent of the illustrious father and messianic child of Vergil's *Fourth Eclogue* or the more developed image of Augustus as triumphant restorer of the Golden Age in the *Aeneid* (4. 58). And the connection with Christ is also suggested in an accompanying illustration which depicts the newborn Frederick and his mother, Constance, in a composition usually reserved for representations of the flight of the Virgin and Christ into Egypt.[5] Frederick reiterated the Nativity analogy himself in a 1240 letter to his birthplace, Jesi "noble town of the March, place of our illustrious birth where our Divine Mother brought us into the world, where our radiant cradle stood . . . our Bethlehem, birthplace of the Caesar."[6] Here Frederick clearly presents himself as a messianic prince of peace resembling both Christ and Augustus.

Frederick first actively asserted his renewal of the Augustan Age with his coronation as Holy Roman Emperor in Rome on November 22, 1220. Although this followed the practice of German emperors since Charlemagne, he was more deliberate about reviving ancient ceremonies such as following the route of the *Via Triumphalis* and the distribution of largesse.[7] He then left for his Sicilian kingdom where he immediately held a Diet at Capua, also an important site in his father's campaigns. At Capua Frederick formulated the basis for the new order in the kingdom, the Law of Privileges, again following Roman imperial role models as law-giver and bringer of order and peace.[8]

In the late 1220s Frederick led a successful Crusade to the Holy Land. There he celebrated an Eastern Triumph and self-coronation as king of Jerusalem in March of 1229—ostensibly as a fulfillment of the Sibylline prophecies foretelling a messianic ruler of the West who would liberate Jerusalem.[9] He proclaimed himself Emperor of Peace to the assembled pilgrims. Here the resemblances to Augustus, Christ, and Christ's forebear the Old Testment King David converge in a new image as Frederick showed himself *imperator* of Christendom.

4.1. Head of Frederick II, cast of So-lari copy, in the Museo Provinciale Campano, Capua (Max Hutzel).

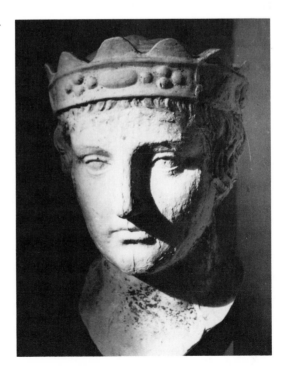

By 1231 he had become Emperor Frederick II, "ever Caesar Augustus of the Romans Fortunate, Victor and Conqueror of Italy, Sicily, Jerusalem and Arles," as he is styled in his 1231 law compilation *The Constitutions of Melfi*, also known as the *Liber Augustalis*.[10] A new coin type first issued by Frederick in 1231 was similarly called an *Augustalis* (fig. 4.2)[11] and can be considered the numismatic counterpart to the law book. Each depends formally on Roman imperial prototypes. The Justinianic law codes inspired Frederick's constitutions as Augustan coinage and cameo portraiture provided the formal exemplars for Frederick's gold *Augustales*.[12] But more recent precedents also influenced the format and meaning of each. The *Liber Augustalis* incorporates laws promulgated by his predecessors, the Norman kings of Sicily, together with new statutes based on Frederick's current needs to ensure order and peace in the Sicilian kingdom. Similarly, Carolingian precedent underlies Frederick's revival of an ancient coin type. In a coin issued after his coronation in 800, Charlemagne linked himself to the Roman imperial past as "Karolus Imperator Augustus."[13] But motifs on the reverse, including an altar with crosses, modify Charlemagne's rulership as Christian Roman emperor. Frederick has eliminated any Christian reference and has restored the Roman imperial eagle to the reverse. The *Augustalis* obverse inscription is even more to the point, accompanying the laureate imperial portrait: "Imperator Romanorum Caesar Augustus." He omitted his own name deliberately, not just to liken himself to a Roman caesar but to identify himself *as* one, Augustus, Emperor of Peace. The reverse inscription, "Fridericus," is subdivided to stress the etymology of his German name:

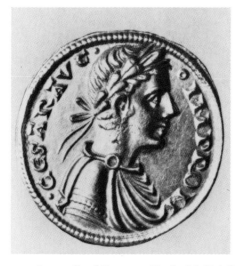

4.2. *Augustalis* of Emperor Frederick II (after Württembergisches Landesmuseum, Stuttgart, *Die Zeit der Staufer. Geschichte Kunst, Kultur, Katalog der Austellung*, vol. 2 [Stuttgart, 1977], pl. 633.

fried=peace, *ric/reich*=rule. By duplicating an antique coin with slight but potent modification Frederick had not simply revived the Christian or Constantinian Roman *imperium*, as did Charlemagne; Frederick, instead, had renewed the Augustan Age.

The Capua gateway (figs. 4.3 and 4.4),[14] built between 1234 and 1240, can be seen as the monumental architectural and sculptural counterpart to this gold coinage and the *Liber Augustalis*. It stood as the formal, concrete expression of royal authority not only as stated in the 1220 Capuan Law of Privileges, but also in the expanded version, the *Liber Augustalis*. This gateway not only celebrated Frederick's personal triumphs, it epitomized his doctrines of statecraft as well. As a unique and heterogeneous monument, it parallels the diverse components of his rulership and his law code. In addition, the Capuan gateway expressed the fulfillment of promise as foretold by Petrus de Ebulo, Henry's (and later Frederick's) court poet. Significantly, these many statements and allusions are couched in the visual language of architectural sculpture in antique style, prefiguring the works of Nicola and Giovanni Pisano later in the thirteenth century, as well as the later classicizing Renaissance sculpture.

Certainly the historical and strategic significance of Capua in Henry's campaigns must have contributed to Frederick's choice of this location for a unique, heavily fortified and richly decorated towered gateway to his kingdom. And a monumental arch would clearly denote the end of the papal state and the beginning of Frederick's kingdom of Sicily. Thus the Capua gateway stands at the head of the ancient Roman bridge where the Via Appia from Rome crosses the Volturno River at Capua, guarding the only entrance to the city, which is bounded on three sides by the river. Appreciating the strategic importance of the bridge, Frederick ordered the surrounding suburbs cleared in August of 1233.[15] In February of 1234, while his court was based at Capua, he ordered the construction of a gateway and castle at the bridgehead, following his own design. Subsequent textual references mainly concern the accounting of expenses, although the construction supervisor, a *protomagister* Liphantis, is mentioned. Progress can be inferred by references in 1239 and 1240 to the roofing of the towers and related marble supplies. A final revision of accounts in April of 1240 suggests that work was complete or nearly so. Although partially demolished and refortified under the Spanish viceroys in 1557, its original appearance is discernable in earlier sixteenth century drawings (figs. 4.5 and 4.6).[16]

The architectural design and sculptural decoration of the Capua arch served several propagandistic functions. Inherent were multiple complementary messages that addressed different classes of viewers. Yet these statements were not made to influence opinion, but to compel behavior and to proclaim fact: Frederick is the supreme authority in the kingdom; he establishes law and promotes justice; compliance with his law results in order, peace, and prosperity for all; a Golden Age is at hand. The calculated visual effect of opulence and inpenetrability made

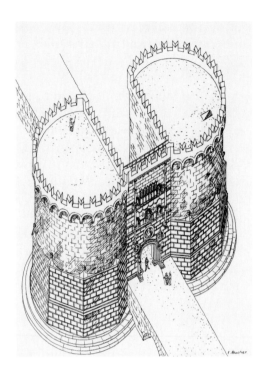

4.3. Capua Gate, reconstructed aerial view of entrance facade (after C. A. Willemsen, *Kaiser Friedrichs II. Triumphtor zu Capua* [Wiesbaden, 1953], fig. 105).

4.4. Capua Gate tower bases, viewed from Capua (Sam Gruber).

an immediate impact on all viewers, but especially upon travellers arriving in the Sicilian kingdom from Rome. It was an impression of wondrous beauty and strength, the very words of a contemporary chronicler who spread the fame of this monument and its message to other courts and to posterity.[17]

Frederick's court chronicles only mentioned the structure generically as bridge towers (*turris, turris pontis*) or castle (*castrum, castellum*). But its Renaissance name, Porta di Capua, as well as its design relate to gateways in the ancient city walls of Rome, such as the Porta Ostiensis, a similar three-story structure comprised of cylindrical projecting towers that flank and protect the archway. The Capua Gate presented the traveller from Rome with a familiar architectural image and it suggested that Capua, and by extension Frederick's kingdom, was analogous to ancient Rome, if not its reincarnation. In addition, the polygonal tower bases and the royal chamber or *regium cubiculum* above the archway followed German imperial precedents. The west facade of the eleventh century Essen Cathedral displays similar polygonal stair turrets which flank the multistory *Westwerk*. The *Westwerk*, typical of medieval German religious architecture, precedes the church proper; it rises over the church entrance and contains a royal chamber or chapel in an upper story. In a sense this gateway was also Frederick's *Westwerk*, since an enthroned statue of him was originally placed in the middle story.

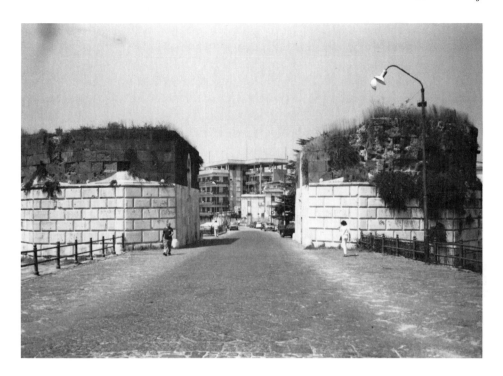

The heavy fortifications of the gateway provided an added comfort to Frederick's subjects as protection from further assault by forces of Pope Gregory IX, who harried the town while Frederick was absent on crusade. And to Frederick's Sicilian subjects, nobles and commoners alike, the gateway visually expressed Book III, Title 33 (12) of the *Liber Augustalis* regarding the king's role in providing for the common security of his subjects: "For we believe that our fortifications, and what is more secure, the fortification of our protection, is sufficient for the protection of all *fideles* [subjects] of our kingdom,"[18] a passage based on the 1220 Law of Privileges of the Diet of Capua. It goes on to forbid privately sponsored towers and gates either by individual nobles or the town. Frederick observed that the private wars among the nobility were a major cause of civil disturbance. The confiscation and demolition of privately held towers and gates, stated in Book III, Title 32 (11), were therefore necessary to enforce internal peace. By supplanting and surpassing previous towers and gates, Frederick's gate informed the nobility of the king's prerogative and the exercise of that right by its very presence as the largest, most substantial, and most luxurious towered gate in the realm.

The decorative enrichment of the gateway enhanced its practical and ideological functions. As seen in the tower bases, the lower portions were faced with white travertine dressed in a rusticated chamfer and filletwork design. Shearer, in noting evidence of reused masonry, concluded that it

originally faced the Roman amphitheatre at Capua. Reusing dressed masonry was not only convenient and economical, but also visually referred the viewer to Roman imperial Capua. Like the *Augustalis* coin, Frederick in effect created a new Roman imperial architectural monument, although unlike any single precedent. Here, for example, rustication is used to excess throughout the ground story and intimidates the viewer with the effect of great mass. This aggressive statement of strength underpinning royal authority is complemented and clarified by the details of the sculptural program above.

An incomplete sixteenth century drawing (fig. 4.5) along with verbal descriptions and some sculptural remains provide the basis for reconstructing the original appearance of the sculptural decoration. The most detailed account, in the sixteenth century Capuan annals compiled by Sannelli, notes that the uppermost story contained "various statues taken from ruins of ancient Capua."[19] These appear on the Vienna drawing (fig. 4.6) but not on the more reliable Uffizi drawing (fig. 4.5), unless they were already removed when it was made. Nevertheless, their use reflects Frederick's antiquarian interests as well as another calculated reference to ancient Capua. Perhaps like the rusticated masonry these too were spoils, Roman cult statues taken from the Capuan amphitheatre and installed in

4.5. Drawing of Capua Gate entrance facade, c. 1550, in the Uffizi, Gabinetto dei disegni, no. 333A recto, Florence (after Willemsen, *Triumphtor*, pl. 99).

4.6. Drawing of Capua Gate entrance facade, c. 1500. in the Oesterreichische Nationalbibliothek, Cod. 3528, f. 51v, Vienna (after Willemsen, *Triumphtor*, pl. 98).

the upper register, Fredrick's architectural Olympus. Their use would then be analogous to the frequent invocation of Roman gods in Petrus de Ebulo's "Vergilian" account of Henry's Sicilian campaign in the *Liber ad honorem Augusti*.

The middle register, referred to in Campano's mid-fifteenth century description as a royal chamber or *regium cubiculum*, was partitioned externally into three arcuated niches.[20] Frederick surpassed his father and forebears and associated himself with the Roman imperial past by including a lifesize statue of himself. This is the earliest extant medieval work where a living secular ruler appeared as a three-dimensional enthroned statue personifying the principle of royal authority. This central figure of Frederick (fig. 4.7) survives today in severely damaged condition at the Museo Provinciale Campano, Capua. The original appearance of this slightly larger than lifesize, free-standing statue is suggested by a drawing published by Seroux d'Agincourt (fig. 4.8) shortly before it was further vandalized by French soldiers at the end of the eighteenth century.[21] The slightly later statue of Charles of Anjou by Arnolfo di Cambio, modelled on Frederick's statue, suggests its original appearace and indicates contemporary esteem.[22] Andrew of Hungary, a panegyrist of Charles of Anjou, writing c. 1265, described the gesture of the Frederick statue as having the arm and two fingers extended as though pronouncing the verses inscribed on the arch overhead, which run: "How wretched I make those whom I know to vary."[23] The statue informed the approaching visitor that disloyalty would be punished. Frederick's role as omniscient judge is implied here and confirmed by the lion armrests of the throne, visible on the Uffizi drawing, which allude to biblical descriptions of King Solomon's throne.

The statue may be compared also to the *Augustalis* coinage since here too for the first time since antiquity the ruler's portrait displays no Christian emblem. This secular outlook is paralleled in the literature produced at Frederick's court.[24] And like the coinage, the classical aspects are exceptional. Here the revival of the sculpture types of the Roman emperor is underscored by the three-dimensionality, classicizing drapery, and a portraitlike head. The eighteenth century sculptural copies of the head (fig. 4.1) suggest the extent of the classical naturalism.[25] Yet this is no more a photographic likeness than the portrait on the *Augustalis*. A factual likeness has been transformed by informative but fictitious details. His youthful appearance has been exaggerated; he is not a forty-five-year-old man but *puer apuliae*, eternally a triumphant boy king. His coiffure combines the Frederician neck-length golden curls with the stereotypical Augustan forehead locks that protrude below the edge of Frederick's crown. And instead of the floriated crown, this gemmed band culminates in raylike projections, a radiate or sun crown analogous to the image of the deified Augustus with the radiate crown of the sun god Apollo on Tiberian coins.[26] The literary counterparts include the Horatian ode in which Augustus is likened to the sun, and Petrus de Ebulo's ode to Henry VI

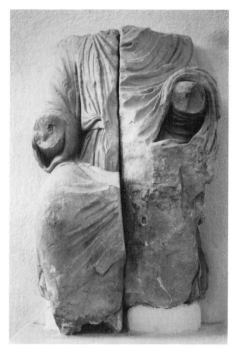

4.7. Torso of the Emperor statue, in the Museo Provinciale Campano, Capua (Sam Gruber).

4.8. Drawing of the Emperor statue (after Seroux d'Agincourt, *Histoire de l'art par les monuments. IV. Sculpture, IIe Partie* [Paris, 1823]. pl. XXVII, 4).

invoking "Sol Augustorum."[27] In this portrait statue, Frederick displays himself as the fulfillment of the Augustan promise of his father, but he also associates himself directly with Augustus.[28] And Frederick is the Sun King, as his contemporaries hailed him.[29]

The two figures that flank Frederick in the sixteenth century Vienna drawing seem to have been reused Roman statues. Not only do they allude generally to the Roman imperial past, they also enhance the presentation of Frederick as man among men, Roman emperor, judge and cosmocrator. In the Uffizi drawing the figure at Frederick's right (viewer's left) appears to be a classically-garbed female with seated dog whom Scaglia has convincingly identified as the goddess Diana.[30] Furthermore, Scaglia has located what seems to be the surviving torso fragment of this Roman statue, now in the Museo Provinciale Campano, which closely resembles the drawn version. In antiquity Diana was venerated locally, so this would represent another instance of Frederick referring specifically to Roman imperial Capua in his use of local *spolia*. Diana would be an appropriate patron deity since Frederick advocated the hunt as a courtly activity. Skillful himself, he wrote a treatise on the art of hunting with falcons.[31] And hunting lodges, such as Gravina di Puglia, figured in his vast architectural enterprises throughout southern Italy.[32] Frederick ap-

4.9. Arch of Constantine: details of medallions from the east side arches. *Left*, south facade medallion with statue of Diana. *Right*, north facade medallion with statue of Apollo (after H. P. L'Orange and A. von Gerkan, *Der spätantike Bildschmuck des Konstantinsbogens* [Berlin, 1939], pls. 40, 41).

parently invoked the mistress of the hunt on other occasions. This Diana statue is the antique and architectural counterpart to the medieval "hunting maiden" with hawk and dog who appears on a Frederician cameo from southern Italy, dated circa 1220–40.[33] But by including a Roman statue of Diana on his triumphal gateway, Frederick has linked himself more directly to the Roman imperial past. Undoubtedly he knew the Arch of Constantine in Rome with its unusual hunting images in the reused Hadrianic *tondi* installed above the lateral arches.[34] The medallion at the eastern entrance of the arch's south side in fact depicts the Emperor before a statue of Diana (fig. 4.9, left). Perhaps, like Hadrian and Constantine before him, Frederick appreciated and wished to evoke the Emperor's virtue or *virtus*, expressed through the image of the hunt and its patron deity.

The figure to Frederick's left has been omitted in the Uffizi drawing although it has been indicated vaguely on the more complete Vienna drawing. The description of the gateway contained in the late 13th century *Gesta Romanorum* provides a clue to its identity.[35] The medieval author accurately described much of the Capua gate and transcribed its inscriptions, evidently well aware of what was depicted. But he interpreted the middle zone allegorically as Christ [Frederick] flanked by his mother

the Virgin [Diana] and young St. John the evangelist. If we take this account as basically factual, though moralizing, then Diana's counterpart at Frederick's left was a youthful male figure, and most probably a reused statue of her brother Apollo with whom she was frequently paired in Roman art and Latin literature. In Augustan poetry such as Horace's *Carmen Saeculare*, Diana and Apollo are invoked repeatedly to protect and prolong the strength and prosperity of Augustan Rome.[36] Apollo also appears on the Arch of Constantine in another of the reused Hadrianic *tondi*, the right medallion of the eastern entrance of the north side (fig. 4.9, right), installed to complement the Diana medallion on the south side.[37] By completing the Hadrianic pieces with two newly-commissioned medallions of *Sol* and *Luna* for the short east and west sides, the designers of the Arch of Constantine distinguished Diana and Apollo from their companion hunt deities, Hercules and Silvanus, by underscoring the cosmological association of the former deities with the sun and moon respectively.[38] In this context, then, Frederick's portrait head with sun crown refers not only to Augustus but also to his patron deity, Apollo. Thus Frederick's direct association with Diana and Apollo on the gateway enhances his imperial as well his divine aspects.

Although he modelled himself extensively on Augustan prototypes, Frederick was certainly familiar with the Arch of Constantine, a well-known marvel of medieval Rome, and he clearly intended the Capua Gate to be understood in the context of this prestigious earlier monument. In the middle zone of his gateway, Frederick has extrapolated and reworked significant details of the middle zone of Constantine's triumphal arch in order to impress and arouse the citizens of Rome, his own subjects, and other medieval travelers who knew the wonders of Rome. He has made his statement all the more effective by emphasizing specific information, reducing the detail, changing the scale, and by reusing actual Roman antiquities. Frederick's own statue, in which he is shown enthroned as emperor and judge refers to, in fact epitomizes, the Constantinian friezes below the *tondi* which depict the Emperor in military triumphs and as judge and authority figure. These are all Roman imperial aspects that Frederick emulated in his military and legal activities. Because of these unmistakable allusions to Constantine's triumphal arch, the Capua Gate thoroughly deserves Willemsen's appellation, *Triumphtor*. Clearly Frederick intended the "Porta di Capua" not only as a towered gateway to his kingdom, but also as a triumphal arch to celebrate his military and diplomatic victories in the manner of Roman Caesars.

The most prominent image of the ground story sculpture is the female bust, three times lifesize, set in a roundel (figs. 4.3 and 4.10). It was located directly over the arch and just below the statue of Frederick. Also virtually a free-standing sculpture, it displays the formal details and attributes of a Roman deity. The border inscription clarifies her association with Frederick: "By command of Caesar I am *custodia* [the protection or guardianship] of the kingdom."[39] According to Sannelli's annals, she was

traditionally identified as Capua personified.[40] Kantorowicz, interpreting a modest allusion in the *Prooemium* of the *Liber Augustalis*, called her *"Iustitia."*[41] He thought the program proclaimed a secular cult of Justice and Peace on the analogy of medieval church facade sculptures. However, the inscription indicates that she was the tutelary deity of the State, thereby justifying and qualifying her more popular identification as "Capua."

The idea of this guardian divinity undoubtedly stems from classical goddesses personifying cities or states. Works such as the famous cameo showing Dea Roma seated with the Emperor Augustus probably inspired Frederick's visual and literary association with *Custodia* in this fashion. *Custodia*/Capua not only protected the realm but also brought prosperity as symbolized by her ivy-grape leaf wreath. In this sense the iconography of the architecture, the antique sculptural style, and the position on the facade all contribute to her significance here. She stands as a counterpart to the personification of Dea Roma, just as Frederick now fulfills the promise of his forebears and becomes the new Caesar Augustus.

The sculpture of the arch spandrels also has Roman precedents. Each spandrel contained a bust-length portrait of a bearded man (fig. 4.11). The novel tectonic motif revived the monumental antique *clipeus* format as it was used for imperial as well as aristocratic portraiture. The verses inscribed on the roundels' borders issued a rhyming welcome and a warning to the approaching visitor: "They enter secure who seek to live pure" and "Let the unfaithful fear to be excluded or even to be cast into prison."[42] Two possibilities of behavior were stated but only one would be

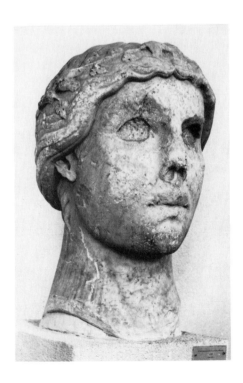

4.10. Head of a female, *Custodia*/Capua, in the Museo Provinciale Campano, Capua (Max Hutzel).

tolerated. Local Capua tradition and chronicles identify the two men as members of Frederick's court circle, Petrus della Vigna of Capua and Thaddeus Suessa, both lawyers, rhetoricians, high court judges, and poets.[43] Petrus compiled the *Liber Augustalis* at the order of Frederick, as stated in the closing lines of the text.[44] Despite the portraitlike detail, these should not be taken as accurate individual likenesses either, but rather as types. Allowing for the damage of the Suessa head, they look alike, in fact nearly like twins. This resemblance plus their architectural position, balancing one another in the arch spandrels, imply a fraternal relationship with regard to one another at the imperial court as well as in Frederick's judicial system. Such a portrayal of equal status depends on Roman sculptural precedents, like the statue of the Tetrarchs at Piazza San Marco in Venice, which depicts four corulers of the Late Empire with identical, stereotyped faces. Frederick's court officials were cleanshaven, as he was, so the prominent beards are highly significant details. These were undoubtedly intended to recall the recognizable philosopher type

4.11. Bust of Petrus della Vigna, head of *Custodia*/Capua, bust of Thaddeus Suessa, in the Museo Provinciale Campano, Capua (Max Hutzel).

well established in Greek and Roman art as well as its Christian adaptations in the depictions of saints Peter and Paul. Here this portrayal appeared as a hint of reciprocal flattery for Petrus and Thaddeus, who were largely responsible for the extravagant rhetoric of imperial speeches and chancery correspondence in praise of Frederick.

Other figures indicated on the Uffizi drawing have been lost, but perhaps their contribution to the program can still be inferred. Waist-length male figures supported engaged colonnettes which visually linked the lower and upper stories into a unified whole. A Hohenstaufen portrait, either Frederick or one of his sons, from Barletta, displays a similar torso form and turned posture.[45] Perhaps by analogy and tectonic context these male figures represented two of Frederick's sons as loyal supporters of his regime. The archway also contained two more male busts at the arch springings alongside projecting half figures of lions. Perhaps two local judges or notaries were depicted here. The lions, with the connotations of imperial wisdom and Solomonic judgment, lend credence to such an interpretation and parallel their use and Solomonic references in the text and illustrations of Petrus de Ebulo's *Liber ad honorem Augusti* (such as folio 53, in fig. 4.12)[46] which depicts Henry seated on a throne preceded by lion heads and accompanied by a female personification (here, *Sapientia* or wisdom). This illustration may have inspired the ruler-tutelary deity formula used on the gateway facade, above. In addition the architectural use of lions in this way also follows contemporary practices in ecclesiastic architecture elsewhere in Campania and Apulia.[47] And if the tectonic context is symbolically expressive, then they were incorporated here just as Sicilian common law was incorporated into the *Liber Augustalis* that is, as a local ongoing practice used where necessary.[48] Their application with Solomonic overtones expresses the judicial authority that Frederick delegated to his hierarchy of judges. The repetition of lions on the throne and facade also challenged their similar use in early thirteenth century Rome on papal thrones. Clearly Frederick has directed this reference to the supporters of Pope Gregory IX, his adversary during this decade.

A novel feature of the Capua towers are the terminal heads installed in the tower angles just above the rusticated masonry. Many have been preserved at the Museo Provinciale Campano, including male and female examples.[49] Although they have induced little more than stylistic comments, their inclusion is highly important to the meaning of the program. They personify the obediant subjects whom Frederick addresses as *fideles* (faithful) throughout the *Liber Augustalis* and for whom he codified and expanded the law. They are his subjects to whom he demonstrates his majesty, protection, and justice in the form of the gateway itself. And they are the very foundation of his kingdom as their architectural position indicates. Once we recognize their identity the gateway can be understood metaphorically as a tangible image of the entire spectrum of the State, with whose lower portions the visitor or faithful subjects themselves could identify.

Programmatically and technically the Capua gateway was unique in its day, without equal or progeny until the Renaissance.[50] And within the context of medieval sculpture Frederick's use of classically inspired naturalism here is most extraordinary. Nor is this just an allusion to the renewal of Roman antiquity; it is also a primary means of "setting forth the things which are as they are."[51] Frederick's architectural and sculptural display was not intended to convince the viewer just through rational justification, but to present a political message as a self-evident fact. It was more than an architectural billboard advertising imperial justice. It addressed the medieval viewer on many levels simultaneously. The contemporary writer of the *Gesta Romanorum* described the monument in terms of Christian allegory. With familiar sculptural images of the Last Judgement in mind the medieval author read the sculptures on the Capua Gate facade as Christ presiding at the Last Judgement accompanied by his Divine Mother and St. John. This conflation was intended. Frederick *was* effectively presented here as forerunner of the Last Day in terms normally reserved for the Savior. But simultaneously Frederick was the fulfillment of the prophecy associated with his fathers—the renewer of the Augustan Age of Peace in this kingdom of Sicily, and by extension, the world. This type of statement could best be articulated by the classicizing

4.12. Henry VI enthroned and accompanied by *Sapientia*, Petrus de Ebulo, *Liber ad honorem Augusti*, Bern, Burgerbibliothek, Cod. 120, f. 54 (after G. B. Siragusa, *Liber ad honorem Augusti di Pietro da Eboli secondo il Codice 120 della Biblioteca Civica di Berna, Fonti per la Storia d'Italia* [Rome, 1905–6], pl. 54).

detail of the sculptural program. His classicism was prompted, moreover, by events between 1230 and 1240.

Frederick's Roman imperial allusions were especially potent to the aristocratic citizens of the thirteenth century Rome, whom he wooed in letters dating from the late 1230s to join him in his dispute with Pope Gregory IX.[52] In the rhetoric of his speeches, letters, and the display of victory trophies following the manner of ancient Caesars, he sought to arouse their local familial and national spirit. The gateway program presented him in much the sames terms as revivifier of the ancient Roman empire—Augustus reincarnate who would restore Rome to her former glory. So his statement also addressed the Roman nobility in a visual language familiar not only in its broad outlines but in its stylistic detail.

The gateway program spoke as well to the Lombards against whom Frederick fought in campaigns between c. 1236 and 1239, which he termed the "Execution of Justice."[53] The warring Lombard towns had disturbed his World Empire of Peace—order, as it existed in Sicily, had to be established. This required military strength as well as his physical presence. As "Augustus the Avenger" Frederick displayed himself. He believed that "upon seeing his face the Lombards shall not be able to look on it unmoved, from fear before our justice," the same strategy that was effected by the Capua Gate. Frederick established peace in Lombardy temporarily after his victory at Cortenuova on November 27, 1237 with a new Roman battlecry "Miles Roma! Miles Imperator!"[54] He entered Cremona a few days later with the Milanese *carroccio* with its civic standards as a trophy in a traditional Roman triumphal ceremony. The trophy was then sent to Rome for display on the Capitoline accompanied by a letter from Frederick "Caesar Augustus the Just." By these actions he became Caesar. They were a statement of the realization of his destiny— a destiny that was immortalized in the imagery and antique style of the gateway program.

He capped his military achievement with subsequent northern diplomatic victories culminating in Pisa with Christmas and birthday celebrations in December of 1239. There he addressed the populace from the Pisa Cathedral pulpit and promised a reign of peace. The completion of the gateway coincided with his entry, early in 1240, into the Marches, Ancona, and Duchy of Spoleto, all papal territories that had peacably come over to his side against the pope, who had just excommunicated Frederick for a second time. During the spring of 1240 he camped near Capua and kept up correspondence with the Romans, promising future festivals and triumphs in the ancient style and calling himself their benefactor and father in the manner of Augustus.[55] He even imitated Augustus's characteristic magnanimity by sparing Sutri in an effort to compel them to admit him bloodlessly into Rome as Prince of Peace.

Against the immediate background of these events the Capuan archway rose to completion, "a wonder of size, strength and beauty" costing 20,000 ounces of pure gold, before the Sicilian kingdom—the ideal State

of Peace, guaranteed by royal authority. Sicily was the ideal, the prototype for the World Empire as expressed in his 1240 statement "Sicily shall be the envy of princes, the pattern of monarchies." In August of 1240, with Frederick nine miles from Rome, his longtime adversary, the aged Gregory, died, cheating Frederick of a final confrontation and glorious triumph but leaving him, for the two years in which the papal throne went unoccupied, as Lord of the World.

JOSEPH FORTE

5. Deconstruction and Reconstruction
in Poussin's Decoration
of the Grande Galerie
of the Louvre

In December of 1640, Nicolas Poussin arrived in Paris to begin decoration of the immense corridor, the Grande Galerie, that once ran from the Louvre to the Tuileries Palace.[1] This 1400 foot passageway had been built in 1588, and a commission to decorate the upper level of the gallery had been given to the chief architect of the Louvre, Jacques Lemercier, and the Flemish landscape painter, Jacques Foucquières, in 1626.[2] Little had been done on the decoration when Poussin arrived from Rome, and he spent the next two years trying to complete a basically impossible task.[3]

The formal disposition of Poussin's decoration is known from a miniature replica on a snuffbox made in the 1770s;[4] while the subject matter is clarified in nearly contemporary accounts by Henri Sauval (1648), Roland Fréart de Chambray (1651), and Giovanni Pietro Bellori (1672) (fig. 5.1).[5] On the snuffbox, the lower walls are decorated with paneling, having large tabernaclelike frames. From Sauval, we know that the frames were to contain depictions of the most important towns and cities of France retained from the earlier scheme of Lemercier and Foucquières.[6] Resting on the cornice above the paneling were alternating round and rectangular scenes, painted in fresco, depicting the Life of Hercules.[7] Drawings for over sixty of these scenes are preserved at Windsor Castle, the Louvre, and the Hermitage (fig. 5.2).[8]

On the snuffbox the vault decoration is unclear, but from the literary sources we know that it consisted of plaster casts of reliefs from Roman triumphal monuments. Fréart de Chambray tells us that the ceiling was decorated with "two medallions of eleven palms taken from the Arch of Constantine and seventy reliefs from the Column of Trajan" (figs. 5.3 and 5.4).[9] From Bellori we learn that the two tondi of the arch were then thought to be "taken from other buildings of Trajan."[10] The tondi are

5.1. Choiseul snuffbox (after F. Watson, *The Choiseul Box* [Oxford and London, 1963], pl. 1.

now known from evidence too extensive to discuss here, to be reused sculptures of Hadrianic date, but it is clear that in the seventeenth century all the reliefs on the Arch of Constantine that were not obviously made for the monument in the early fourth century were considered to be Trajanic in origin.[11]

Poussin's use of the casts on the ceiling had certain practical advantages. It was far easier, cheaper, and less time consuming than painting a vault over 1400 feet long with an illusionistic decoration, as Pietro da Cortona had done on the Barberini ceiling.[12] But spanning more than 1400 feet, the vault of the Grande Galerie required more reliefs than any classical monument could provide except the two historiated columns of Trajan and Antoninus Pius. The choice of reliefs from Trajan's column is most intelligible here as a conscious act of affiliation between the emperor and the king of France, Louis XIII, who commissioned the decoration of the Grande Galerie. Since the Middle Ages, Trajan had been seen as an exemplar of the virtue of Justice and of the ideal prince.[13] Since Louis XIII also strove to associate himself with Justice (his sobriquet was La Juste), the affiliation with Trajan was natural.[14] Court panegyrists took these ideas even further. For example, in *Éloges et discours sur la triomphante réception du roi en sa ville de Paris après la réduction de Rochelle*, the livret states that "France has such riches in the person of Louis as formerly the empire had in that of Trajan who was praised by Pliny."[15] The reference is to Pliny the Younger's famed *Panegyric to Trajan*, a work extensively quoted throughout the pamphlet. From the model of the panegyrists of Trajan, the ideal prince, the authors of the triumphal program and livret claimed to develop a language of praise that no longer equivocated over Louis's virtue, but praised him as an ideal monarch in the mould of his imperial predecessor.

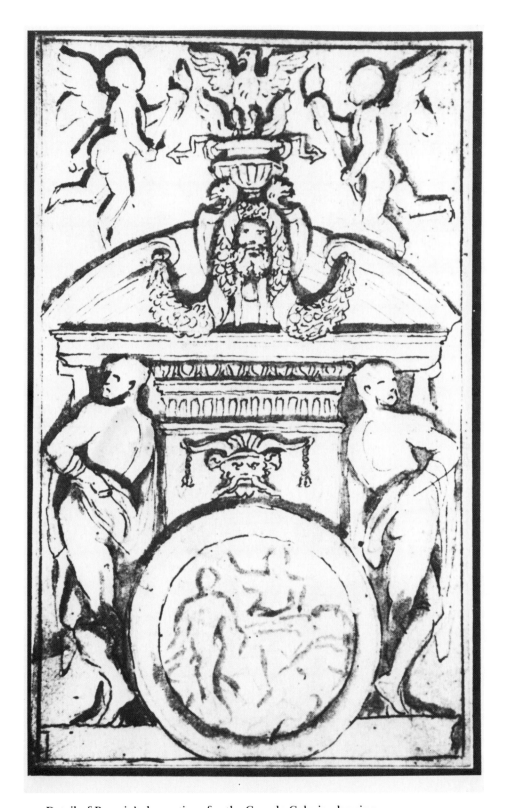

5.2. Detail of Poussin's decorations for the Grande Galerie, drawing.

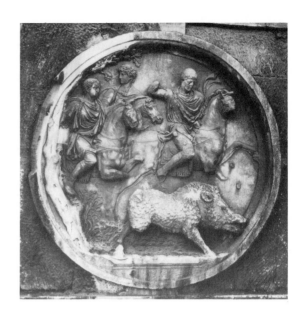

5.3. *Tondo*, boar hunt from Arch of Constantine, Rome (after L'Orange and von Gerkan, *Der spätantike Bildschmuck des Konstantinsbogen* [Berlin, 1939], pl. 41).

5.4. Detail from Column of Trajan, Rome (after K. Lehmann-Hartleben, *Die Trajanssäule* [Berlin ad Leipzig, 1926], pl. 9).

The imperial aspirations of the kings of France may provide yet another reason for the use of casts from Roman reliefs on the ceiling. Since Charlemagne, French monarchs had associated themselves with the office of the Roman emperor. And like the Holy Roman emperors, who were also descended from Charlemagne, French kings utilized their propaganda to assert other imperial themes, such as the return of the Golden Age of Justice under royal fiat, the search for world unity through empire, and a particularly Christian theme, the New Crusade.[16] In the sixteenth and seventeenth centuries, imperial images increased in importance not only because of the humanist's interest in the revival of pagan antiquity, but through the direct influence of the Hapsburg monarch Charles V whose political program was infused with references to the *translatio imperii* or translation of the empires, a notion of the return of the Roman empire as a precondition for the revival of world peace and of unity.[17] By adopting these imperial images from ancient and contemporary sources, both the Valois and Bourbon monarchs sought to compete with their great rivals, the Hapsburgs.

Poussin may have used imperial and specifically Trajanic imagery for the decoration of the vault for any of these reasons, but this does not explain why he added the *tondi*.

Contemporary evidence suggests that the *tondi* were considered illustrations of the virtues of the Emperor Trajan manifested in adolescence. In a series of inscriptions composed to accompany engravings in François Perrier's *Icones et segmenta illustrium e marmore tabularum quae Romae adhuc extant*, Bellori, a friend and the first biographer of Poussin, explained the *tondi* with quotes from Pliny's *Panegyric to Trajan*, thereby creating a relationship between the scenes depicted and specific moral virtues. Below the engraving of *The Departure for the Hunt*, Bellori used lines from section 81 of Pliny's *Panegyric*: "Instar reflectionis existimas mutationem laboris . . . lustrare saltus, excutere cubilibus feras, . . . pia mente adire lucos et occursare numinibus" (fig. 5.5)[18] Here Pliny coupled the emperor's prowess in hunting and by extension his greatness in battle, (both illustrating his *fortitudo*,) with Trajanic piety or *pietas*, his respect both for the gods and for the traditions of the Roman state.[19] In his panegyric, Pliny characterized Trajan's hunting as reflecting both his virtuous adolescence and his embodiment of the Roman tradition of manly self-reliance. Hunting fostered the qualities of fortitude, later made manifest in imperial conquests.

No textual evidence identifies either the subject or the placement of the two *tondi* used by Poussin, but they probably consisted of one hunt scene and one sacrifice scene demonstrating as they had in antiquity the emperor's fortitude and piety.[20] Probably located at the entrance to the gallery, these *tondi* would have served as a preface to the reliefs from the column that expressed Trajan's virtues by depicting his victories over the Dacians.[21]

Poussin's decoration, however, suggests other problems that cannot

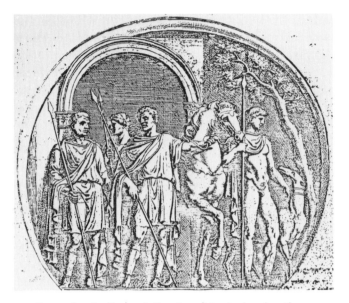

5.5. Engraving by François Perrier of *tondo* showing the departure for the hunt from the Arch of Constantine (after Perrier, *Icones et segmenta*, pl. 35).

be resolved by historical analysis: for example, the question of the presence of both subject and author in the work. In most decorations of a political nature the image of the monarch being praised actually appears in the work. Although the image of the Roman emperor Septimius Severus is miniscule in the reliefs from his triumphal arch, certain visual and textual cues leave no doubt as to whom the monument glorifies.[22] And seventeenth century works like Rubens' Medici cycle and Le Brun's decoration of the Galerie des Glaces for Louis XIV leave little doubt of the identity of the patron.[23]

Sensitive as he was to questions of the nature of content as well as its particular usage, Poussin chose a more difficult strategy, but one that is arguably closer to the reality of the synthesis of historical and of ahistorical concepts upon which his work depended.[24] The imagery of imperial morality, power, and affiliation enshrined in his work turns on a dialectic. The emperor Trajan is both an historical personage and an ahistorical ideal, his inclusion in the decoration is founded both on particular contemporary associations and upon general metaphysical premises. Consequently, his utility—as a symbol—functioned not only in relation to a specific French king but to all French kings who followed. Most historians of political art do not see these various premises as contradictions. I would like to suggest, however, that in this case Poussin sought to point out the differences and thus to state the problems rather than to offer a synthetic solution.

In recognition of the dichotomies in political art, historical vs. ahistorical, personal vs. dynastic, Poussin refused to close symbolically the

process of eternal return implied by concepts like the *translatio imperii*, but to enshrine its variability. For to fix somewhere in the decor the image of Louis XIII is to limit the imperial revival to a precise historical personage. Louis XIII and indeed subsequent Bourbon monarchs used the Grande Galerie to exercise the *touche sacré*, an allegedly divinely-endowed power that allowed French monarchs to cure scrofula.[25] Only then, when dispensing a cure that reasserted his semidivine powers, would the monarch be present and thus complete the cycle. Normally, however, the king would be absent, a vital yet variable missing piece of the puzzle.

Thus Poussin simultaneously invoked a process of imperial dislocation and historical realization. For the whole premise of the links between Roman emperors and French kings is based on the fall of real empires, the subsequent transfer of their abstract political reality from one geographical site to another, and the recognition of their presence in another place and time. The carving up and transportation—in a literal sense—of the Column of Trajan and the Arch of Constantine makes that reality tangible, but to delete a representation of Louis XIII is to cast doubt on the possibility of empirical revitalization as a contemporary political certainty. In the decoration of the Grande Galerie, the casts themselves most effectively convey the image of the great empires of the past. And as part of an ensemble, these relics of the past imperial glory were coupled with the image of the hero depicted in the Life of Hercules, that Bourbon emblem, and with the image of the realm depicted by the town and the cityscapes.[26] All these elements can only vaguely invoke the ideal of the concrete revival of the imperium. But they delineate elements of a new political reality, whether we call it absolutist monarchy or the nation-state, and we must be aware of Poussin's insistence on the abstract nature of political ideals that resists realization in a single form.

And again this may be paradoxical. To consider the components as an abstract ideal is to deny that at least two of them, the Life of Hercules and the reused Roman reliefs are biographical, i.e. they may be read as indications of singular presence or of individuality as a theme in the decor.[27] The biographical content of the Hercules cycle is self-evident, but the use of the *tondi* as illustrations of the virtues of Trajan gives the reliefs from the column a personal dimension, and together they show the organic development of the emperor's moral qualities from his adolescence to his maturity. The creation of these heroic and imperial biographies is consistent with theoretical admonitions beginning in Book 9 of Alberti's *De re aedificatoria* and appearing in numerous sixteenth century treatises on painting. According to Alberti, Armenini, and others, painters should decorate the halls of princes with the lives of heroes and other rulers so as to praise the patron and to induce virtue in onlookers.[28]

If the assumption about the placement of the *tondi* is correct, then they may be viewed as a "preface" to the deeds of the mature Trajan, depicted in the "text" of the reliefs of the column. Indeed, to understand the prefatory function of the *tondi*, it is useful to turn to Spivak's com-

ments on the preface in her introduction to Jacques Derrida's *On Grammatology*.[29] Though placed first, prefaces are inevitably written last as a gesture of authorical command. The summarizing function of the preface attempts to deny the free process of thought; it implies a specific solution to the text while revealing some of the mechanics of the creation of that text. And lastly in trying to delimit the free play of meaning, it implies the possibility of other meanings, other messages that the text may generate.

First the issue of authorial command. The reuse of monuments like the Column of Trajan implies a direct challenge to modern notions of creativity or originality central to current standards of artistic activity. It is true that Poussin's view of originality preserved in Bellori's *Life* of 1672 differs from ours.[30] For him, novelty lay not in ignoring traditional subjects, but in giving them a new disposition. Logically one could reuse not only antique motifs but entire antique monuments if they were given a different form in a new setting. In order to adopt the continuous band of the column to the format of discrete scenes framed in coffers on the ceiling, it had to be divided into parts. Thus the column is transformed into a series of distinct scenes or narratives, framing and emphasizing specific events in the Dacian wars and providing each episode with its own spatial and temporal unity.[31] The division of the column into discrete parts transforms its overall narrative structure into something more analogous to the formal and thematic unity of the tondi.

As well, we might expect the focus on the imperial presence in the *tondi* to be carried over into the column reliefs. But such an imperial focus is difficult in the context of the column's style, with its wealth of incidence and of detail and its only occasional depiction of Trajan. Therefore the preface of the *tondi* creates the possible expectation that the newly revised compositions of the column reliefs will follow principles of legibility and clarity typical of seventeenth century *istorie*, an expectation that in reality is not fulfilled.

The act of dividing the column, that is adapting its form to a new disposition, is an act of Poussin's authority that asserts his own presence through the act of recomposition.[32] Regardless of the attempts to integrate the casts from the Column with the tondi, their differences in format and in style make such an assimilation impossible. By juxtaposing their incongruity, Poussin imparted his own guiding sensibility to the program. The competent audience knew that the anonymous Roman sculptures could never have been seen together *in situ*, that is, in Rome.[33] But by being presented together and in altered form the works are lifted from anonymity and given authorship; the author is not physically present nor is he represented by any self-portrait or signature but only through the strategy of the manipulation of borrowed form.

The disruption caused by the *tondi* forces the viewer not only to be aware of the authorial presence behind the work, but also of the process of creation now demonstrated by the work. The problem of reading is implied in the function of the two different forms of reliefs. Questions

naturally arise when viewing the work: How do these fit? What values of one are reflected in the other? What theme do they treat either in isolation or in unison? The message of the *tondi*, at least as understood in the seventeenth century, was to inflect the reading of the column toward a particular end, the location of the virtues of *pietas* and *fortitudo* in the activities of Trajan in the Dacian wars. All these events are then portrayed as readable, as having moral significance.

In indicating the possibility of legibility, Poussin is creating the expectation of comprehension. But as we analyze the actual circumstances of the work we realize that this is a fiction. Given the distance from floor to ceiling—over 24 feet—and the style of the column with its richness or overabundance of detail, the reliefs would have been barely legible, but the *tondi* with their larger scale and clearer composition could be more easily grasped.[34] Yet the promise of legibility implied by the *tondi* situated above is never fulfilled. We cannot really see the reliefs of the column, and we cannot study them except in terms of a preconditioned response.

If the inclusion of the *tondi* posits a specific interpretation, then like a preface it reveals as well the decoration's guiding aesthetic, the act of reuse as a valid artistic strategy. Significantly, the original *tondi* themselves, although now on the Arch of Constantine, were originally taken from another work.[35] Thus as Poussin employed casts from famous Roman monuments, and thus was thought to have reused them in a new context, Poussin and his contemporaries believed that Constantine's architect reused original *tondi* from a destroyed Trajanic monument to depict imperial virtues and to associate his patron with his illustrious predecessors. By incorporating casts of the *tondi* already reused in antiquity, Poussin claimed a traditional sanction and authority for his seemingly expedient shortcut. Such justification was important to Poussin both to deflect criticism and more importantly to preserve the notion of the authority of antiquity as a structuring principle in expressing present day realities. For the process of artistic affiliation implied by the reuse of ancient works is ultimately subsumed in an earlier political message—the eternal reality of the Roman imperium reappearing in changing historical form. Again, what is implied is not the present incorporation of that eternal reality, but its constant subjection to change and to reuse in every political and artistic context.

The changing form of the imperium implies a variability in the work which is again asserted by the addition of the *tondi* as a preface. It is perhaps instructive to look at another more obvious instance of this potential of variability, Rubens' Medici cycle.[36] At the west wall of the gallery of the Luxembourg Palace, Rubens placed a portrait of Maria de Medici as Athena-Minerva. This was the opening scene of the Medici cycle, indicating the range of interests and moral virtues that will appear in the narratives that follow. But on the west wall, the portrait can also be considered as the end of the narrative scenes. Considering the subjects of the last five *istorie*, the portrait may have taken on a specific function. The last five scenes of the Medici cycle outline Maria's problems with her son, her

flight from imprisonment at Blois, and other scenes. These conflicts were open to varying interpretation: Maria de Medici's unlawful meddling as a foreigner in French affairs, her willful conduct that led France to the brink of civil war.[37] The closing portrait presents these activities, however, as the consequence of the martial and intellectual capacities of Athena-Minerva-Maria. Thus, in trying to forestall variant readings, the portrait ultimately suggests their possibility.

The same is, I believe, true for the *tondi*. In attempting to manipulate the meaning of the reliefs from the column, they suggest the possibility of variant readings. Since the work lacks specific reference to the achievements of Louis XIII, the tales of heroic valor on the ceiling could be read either as an apotheoisis or an admonition. To insist on the moral dimension of imperial conquest through the *tondi* is to imply their possible immoral aspects. We need only remember Callot's illustrations of the *Miseries of War* where human suffering and pain are reported in terms of the realities of war, and the largely anonymous and degrading circumstances of the soldiers and the victims. In the column, the virtues of Trajan are juxtaposed with the mass movements of armies, the despair of peoples, and the drudgery of camp life. The sense of individual dignity evolving in the seventeenth century could possibly have suggested to the viewer an unflattering analogy between a Roman war and the hunt depicted in the *tondi*; thus battle could be seen as a sport where human life appears sacrificed to no particular end but personal glory. And in the mass of detail, the emphasis on camp life and on the valor of troops from all over the empire, do we not perhaps have a subtle reminder of the anonymity of the emperor, particularly in the context of the Grande Galerie where the column was transformed into a series of narratives without the large statue of Trajan at the top and the inscription at the bottom that assert his eternal identity and fame. How far are we from that wonderful scene in Tolstoy's *War and Peace* where the image of a sniffling, red-nosed Napoleon debunks every heroic myth of the omnipotence of the imperial conqueror.[38]

Poussin was no partisan of the people, but in the context of seventeenth century politics with the emergence of political forms responsive to the demands of a new class, the *bourgeoisie*, the individual took on a value not held when the column was originally fashioned.[39] Thus, a reading about the valor and piety of the emperor that would have come more naturally to the Roman viewer needed both to be underlined and to be changed in Poussin's handling of the theme.

The *tondi*, therefore, demonstrate Poussin's command of the precepts of seventeenth century political art. They articulated a range of conceptual contradictions—anonymous authorship, illegible legility, reused usage—which are really central to the process of political image making. Moreover, his desire to fix meaning so clearly in the work causes us to question that very meaning, so that we see this work not as an unchanging fact, but as a variable and open text, subject to the interpretation and the vagaries of history and context.

DAVID ROSAND

6. *"Venetia":*
The Figuration of
the State

Venetia, Venetia, chi non ti vede non ti pretia

More than any other political entity of the early modern period, the republic of Venice shaped the visual imagination of political thought. Just as she instructed Europe—and, ultimately, America—in the idea of statehood, so she taught how to give that idea eloquent pictorial form. Perhaps as much as her famed constitution, the actual figure of *Venetia*, Venice personified, carried the reputation of the republic; its icon embodied what has come to be known as the "myth of Venice." Like the city itself, set wondrously upon the waves, the beautiful persona of the queen of the Adriatic delighted the vision of foreign observers as a perpetual declaration of the extraordinary, visible proof of divine intervention in the political affairs of men.

Out of the facts and fictions of its history, the Most Serene Republic (Serenissima) wove that fabric of propaganda that is the myth of itself: the ideally formed state, miraculously uniting in its exemplary structure the best of all governmental types—monarchy, oligarchy, and democracy—and institutionalizing this harmonic structure in a constitution that was to inspire other nations for centuries. Venice came to stand for the very idea of the state, the ideal abstraction concretely embodied and functioning on earth. The survival of Venice for more than a millennium seemed proof of its privileged status among nations. Declaring its own immutability, Venice remained secure in its lagoon fortress and in the righteousness of its institutions, the guaranteed and absolute rule of law that made it the paragon of justice in the eyes of the world.

Central to the historic-political elements constituting the myth were the events of 1177, when the republic mediated peace between Pope Alexander III and Emperor Frederick Barbarossa; from that moment on, according to the local historical vision, Venice stood on the political stage of Europe as a third sword, an equal to the Roman Catholic Church

and the Holy Roman Empire.[1] By the middle of the fourteenth century the myth was further refined, as Venice added a new, humanistic resonance to its public self-assertion—voiced by none other than Petrarch himself, who had traded his library for the intellectual liberty offered by the Serenissima. In 1364 the Florentine poet celebrated Venice's swift conquest of Crete:

The most august city of Venice rejoices, today the single home of liberty, peace, and justice, the one refuge of honorable men, haven for those who, battered on all sides by the storms of tyranny and war, seek to live in tranquility. Venice, rich in gold but richer in fame, built on solid marble but standing more solid on a foundation of civic concord, surrounded by salt waters but more secure with the salt of good council. . . . Venice rejoices at the outcome, which is as it should be— the victory not of arms but of justice.

The rhetoric of revived Latin had been reharnessed to the celebration of state. "Even in our age," Petrarch continued, "fraud yields . . . readily to fortitude, vice succumbs to virtue, and God still watches over and fosters the affairs of men."[2]

Exalting the uniqueness of the city, its marvelous site and more marvelous liberty, acclaiming its identity with divine justice, Petrarch's letter further established basic tenets of the myth of Venice and quite naturally became a scriptural text in Venetian apologetic literature of the Renaissance. In all its aspects, physical as well as constitutional, according to Gasparo Contarini, her most influential apologist, Venice seemed "framed rather by the hands of the immortal gods, than in any way by the art, industry, or invention of men," a miracle left on earth to be discovered by mortals.[3] The very vision of its wondrous self was indeed part of the powerful image of Venice: *Venetia, Venetia, chi non ti vede non ti pretia* ("Venice, he that doth not see thee doth not esteeme thee"). By the mid-sixteenth century the old proverb had made its way to England, where it would continue to echo the fame of the city on the lagoon—repeated by Shakespeare's Holofernes in *Love's Labour's Lost* (IV, ii) as well as in later, more overtly political texts, like that of James Howell's *S. P. Q. V.*, which concludes "the Eye is the best Judg of Venice."[4]

Foreign observers like Howell—a prime audience of Venetian propaganda—responded to all aspects of the splendid spectacle of Venice, including the persona that epitomized in a single figure the virtues of the Serenissima. The personified Venetia does indeed offer in microcosm the qualities that define the larger image of the state. By focusing on this particular aspect of the iconography of the myth of Venice, the pictorial form of her self-presentation, exploring the complexity of its genesis and the referential range inherent in the form, we may come to a clearer understanding of the myth itself, as well as of some larger questions concerning the nature and operations of such imagery. After we have isolated the individual elements that constitute such an image, we will consider the degree to which they continue to resonate separately, recalling their origins even as they participate in the formulation of a new visual construct. We

will test the subsequent reception of the figure and ask to what extent such later response and commentary offer a legitimate reflection of original or intended meaning. Such questions take us to the heart of the matter: the ways in which an image signifies and the levels on which it means—in particular, an image of the state.

Four basic elements contributed to the compound of *Venetia figurata*, each of them drawing upon an independent tradition of its own; each contributed a particular dimension to the new construct, a set of values as well as of visual possibilities. These four constituents of the image were: the personification of Justice, the figure of Dea Roma, the Virgin Mary, and Venus. Collectively they served to realize the personified Venice, but that realization, we must not forget, was possible only because of an essential precondition: the abstract concept of the republic.

> *. . . la nostra Città, che volendosi figurare, figura vna santissima Giustitia.*

In Francesco Sansovino's dialogue *Delle cose notabili che sono in Venetia* the Venetiano is explicating to the Forestiero the reliefs by Jacopo Sansovino on the Loggetta (fig. 6.1). "La figura, ch'é nel mezo," he explains, "é vna Venetia, quantunque stia in atto d'vna Giustitia, perche tale à la nostra Città, che volendosi figurare, figura vna santissima Giustitia."[5] The equation of Venice with Justice boasts a venerable tradition, one that was given new impetus and rhetorical power, as we have seen, by Petrarch. That identification of the cardinal virtue with the state was a fairly standard topos in the world of the medieval commune—and we need look

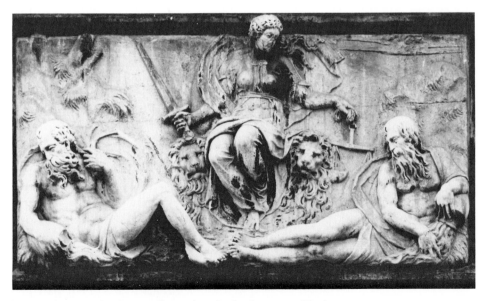

6.1. *Venice as Justice*, Jacopo Sansovino, in the Loggetta, Venice.

no further than Ambrogio Lorenzetti's fresco in the Palazzo Pubblico of Siena for monumental testimony of this.[6] In Venice, however, the identification became literal, as the traditional representation of Iustitia became the prime model for the figure of Venetia herself.

Throughout most of her early history Venice imaged herself through the person of her patron saint, Mark, or metonymically by the symbol of the evangelist's winged lion. By the middle of the trecento, however, a new figural emblem of Venice began to emerge, a *Venetia* that was more complex and elliptical in its evolution and composition and ultimately more subtle and effective in its political function. This personification attained its maturest and most splendid form in Paolo Veronese's triumphant canvas on the ceiling of the Sala del Maggior Consiglio (fig. 6.2), part of the redecoration of the room following the destructive fire of 1577. Its earliest full monumental and official manifestation is probably the relief in the roundel on the Piazzetta façade of the Ducal Palace (fig. 6.3), which may have been in place as early as the mid-fourteenth century.[7]

Venice is imagined as a regal matron, enthroned and triumphant. In the Ducal Palace roundel she is seated above the waves upon a leonine throne and two vanquished prisoners writhe beneath her feet, their gestures suggesting the vices of Ira and Superbia. In her right hand she holds a sword, in her left a scroll that declares her triumph over the "furies," whose costumes in turn suggest civil discord and military threat: "FORTIS/IUSTA/TRONO/FURIAS/MARE/SUB PEDE/PONO." An inscription behind her explicitly identifies this imposing female: "VENECIA."

Despite her prominent location on the façade of the Ducal Palace, the inscribed label is indeed necessary to distinguish this figure from her older prototype, Iustitia. Visually, only the absence of scales signals this distinction, their absence according still greater weight to the sword: Justice here is retributive.[8] The Justice of Jacobello del Fiore's triptych (fig. 6.4), painted in 1421 for the Magistrato del Proprio, or that atop the Porta della Carta, commissioned of the Bon workshop in 1438 and installed in 1441, recall the basic reference: the crowned figure with sword and scales upon a Solomonic throne of double lions.[9]

In the Ducal Palace *Venecia*, the basic formal construct and figural type of the personified virtue have been inflected to make a new statement; but the originating construct and type remain very much in evidence, and their continuing presence guarantees that their significance inheres in the new image. The transformation is an interesting one, for its visual operation reveals the Venetian political imagination at work, capitalizing upon the possibilities latent in its own propaganda.

Opposite. 6.2. *Apotheosis of Venice*, Paolo Veronese, in the Sala del Maggior Consiglio, Ducal Palace, Venice.

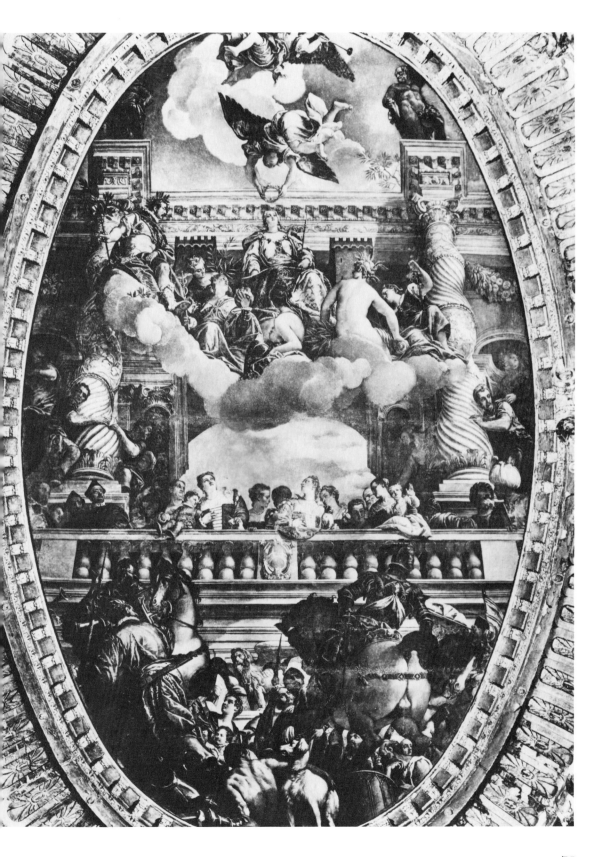

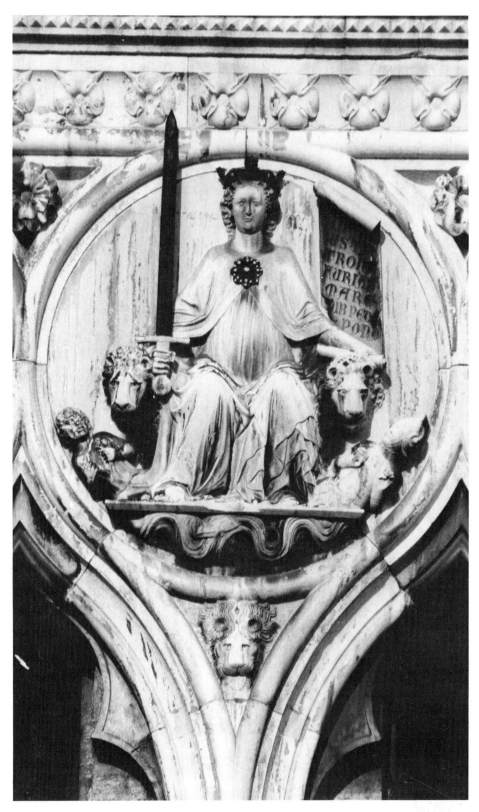

6.3. *Venecia*, Ducal Palace, Venice.

Justice was, understandably, the chief virtue claimed by the state, and the iconography of Justice dominates the public façades of the Ducal Palace, which was explicitly defined as a palace of justice (*ad jus reddendum*). At the corner of the new western wing on the Piazzetta, flanking the main public entrance (the Porta della Carta), the sculpted group of the *Judgment of Solomon* establishes the basic theme: in the Ducal Palace of Venice, the Palace of Solomon—the archetypal seat of justice—is reincarnate in the modern era.[10] And the throne of Solomon the wise judge, with its two flanking lions (1 Kings 10:17–19)—the natural seat of Justice and, as *Sedes Sapientiae*, identified with the Virgin (a theme of some Venetian relevance to which we shall return)—is inherited by Venice herself. Here too, the convenient coincidence with the beast of St. Mark offered to Venetian iconography a special set of possibilities, or correspondences and cross-references, and a new range of resonance.

Once established—in the course of the trecento, presumably—the figure of Venetia/Iustitia assumed canonic status; its individual components, however, always retained something of their original, distinctive significance, never being totally subsumed into a new entity. The image itself remained most usefully ambivalent; it functioned quite deliberately and fluently as a composite. Most often, in fact, the scales were restored to Venetia, thus diminishing the distinction attempted in the Ducal Palace roundel and consequently strengthening the identity of virtue and state. Thus, the central figure in the attic reliefs of Sansovino's Loggetta is quite naturally described by his son as "una Venetia in forma di Giustitia" (fig. 6.1). And the many figures articulating the surfaces and silhouettes of the Ducal Palace itself, culminating in Alessandro Vittoria's crowning contribution to the two façades, appear as a dominant theme of design and of significance; only their inscriptions distinguish them as IVSTITIA or VENETIA.[11] The public statement, however, unambiguously depends upon the ambivalence.

> . . . *vn'altra Vinegia . . . ad imitatione della Roma.*

The program for the new pictorial cycles in the Ducal Palace following the fire of 1577 was published a decade later by Girolamo Bardi, advisor to the patrician inventors.[12] Climaxing Bardi's *dichiaratione* of the ceiling of the Sala del Maggior Consiglio, and the climax of the entire program, is Veronese's canvas of the apotheosis of Venice (fig. 6.2). The ceiling presents a sequence of three great paintings, a central rectangular composition designed by Tintoretto and two ovals by Palma il Giovane and Veronese. Each is centered on a figure of Venetia, and Bardi makes clear that a definite progression is intended, culminating in Veronese's painting, which is located "sopra il Tribunale doue si riduce la Signoria." The sequence moves from the militant triumph of Palma's Venice victorious through the stately piety of Tintoretto's apparition of Venice to

doge and senators before the church of San Marco, to the joyous celebration of virtue in Veronese's canvas, the just rewards of Venetian rule: "dalla forza & dall'armi figurate nel primo quadro, & dall'amore & dalla deditione volontaria espresse nel secondo è proceduto quello effetto di allegrezza, & di giubilo vniuersale de i popoli domati da questa gloriosa Republica."[13]

The victorious object of this spontaneous adulation is the sceptered figure of Venetia, very much a regal Juno in an Olympian setting but, according to Bardi, inspired by a somewhat different yet related source. He describes this final Venetia in the sequence as "risedendo sopra diuerse Torri & Città, ad imitatione della Roma, che si vede nelle medaglie sedere sopra i Mondo; ha di sopra della testa vna Vittoria alata, che la incorona di alloro."[14]

It was perhaps inevitable that a state in search of the personification of itself should look to the great example of antiquity, that a Venice refining her mode of *figurarsi* should turn to the model of Dea Roma. Offering the essential standard for any subsequent imperial aspiration or constitutional pretension, Rome also supplied the basic code for the insignia of state.[15]

Built into the mythography of Venetian history, and in a very special way, was the notion of succession: only Venice, born free and Christian, could lay proper claim to that privilege, for only Venice of the major states of Italy owed its foundation not to pagan Rome but to the true God himself. And she had already proved the legitimacy of her claim by the unprecedented example of her long survival as an independent state. The ideally proportioned structure of her constitution, tuned to the har-

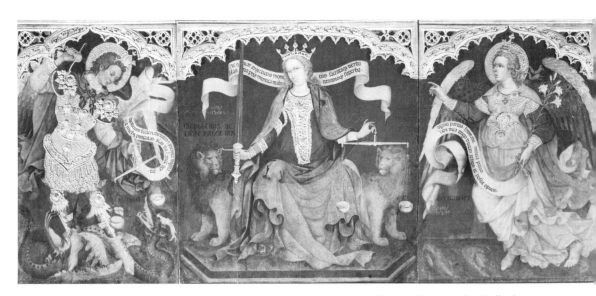

6.4. *Justice with the Archangels Michael and Gabriel,* Jacobello del Fiore, in the Gallerie dell'Accademia, Venice.

monies of the divine order, guaranteed her eternal existence, "inviolate and immaculate." And that, in the words of the apologists, was glory truly unique to this unique city, a glory that none of the celebrated states of the ancient world could claim—not Carthage, not Athens, not Rome itself.[16]

It seemed most proper for Venice to appropriate the imagery of Rome, to transform the ancient goddess Roma into a Venetia. About this the program for the Sala del Maggior Consiglio ceiling was quite clear.

What may well be the earliest effort to personify Venice in this mode occurs in 1393, on a pseudo-antique medal designed and struck by Marco Sesto in imitation of a sestertius of the emperor Galba. The reverse depicts a female figure with the vexillum of St. Mark; she stands upon a wheel of Fortune. The inscription reads, "PAX TIBI VENETIA." [17] That modification of the heavenly salutation to Mark realizes, as it were, the proleptic significance of the original utterance—at least according to traditional Venetian interpretation of Christ's words to Mark. Ancient Roman and medieval Christian imagery are thus crossed in this numismatic invention of early humanism. And we must recall just how central to the new humanist movement was the celebration of the idea of state; in Venice Petrarch himself had shown the way.

That the celebration of state should develop especially at particular moments in the history of a political community, whether monuments of confident assertion or of chastened pride, is not surprising. Venetian expansion onto the terraferma in the early quattrocento is accompanied by just such developments of official ceremony and iconography, most notably of the monumental manifestation of *Venetia figurata*. That expansive policy was pursued with aggressive vigor under Doge Francesco Foscari, during whose reign (1423–1457) the western borders of the dominion were pushed well into Lombardy. By the middle of the fifteenth century Venice had become a genuinely imperial power. And it is precisely on a medal of Foscari that we can trace the further articulation of its evolving iconography.[18] Adapting the type of the roundel on the Ducal Palace (fig. 6.3) and the antique numismatic medium, the image on the reverse of the medal gives it a more fully Renaissance stamp; because of her shield, the figure appears rather more *all'antica*, and the inscription "VENETIA MAGNA" more deliberately proclaims her new imperial ambitions.

Such appropriation of antique numismatic models was hardly unique to Venice. But when compared to the medallic claims of other Italian states and *principi*, the elaboration of a *Venetia figurata* appears significantly more legitimate and natural, certainly less forced.[19] The fundamental distinction derives from the idea of the state. For however exaggerated the dimensions of its mythography, Venice represented above all the concept of the legitimate state and was universally so recognized. Dependent upon no single ruler but rather founded on immutable law, Venice could indeed assert the independent idea of itself, a republic of and yet existing above men. And that idea could sustain with convic-

tion the figural embodiment of itself, for those visual symbols, and especially the personified Venetia, shared that ideal realm of existence—even as they participated in the affairs of men. Seventeenth and eighteenth century admiration for the constitutional republic acknowledged and adapted its figuration as well. Venetia stands as the critical mediator between ancient Roma and, for example, modern Britannia.

. . . Venetia Vergine . . . con la sua incorrotta purità.

Guariento's fresco of the *Coronation of the Virgin*, which dominated the tribune wall of the Sala del Maggior Consiglio, was executed shortly after 1365, that is, in the years immediately following Petrarch's epistolary celebration of the republic.[20] With this commission, the government of Venice placed itself, quite literally, under the protection of the Virgin Mary. Such an invocation was hardly unique to Venice; the special patronage of the Virgin was claimed by most Italian communes, and her image graced many a council hall—such as the Palazzo Pubblico of Siena, with Simone Martini's *Maestà*. Guariento's fresco assumes a particular complexity, however, for flanking the heavenly architecture of the community of saints were two aediculae that housed the protagonists of the An-

6.5. *Annunciation* triptych, Bonifazio de'Pitati, in the Gallerie dell'Accademia, Venice.

nunciation. In similar fashion, across the upper reaches of the church of San Marco the Archangel Gabriel addresses the humble Annunciate, and that holy dialogue continues to reverberate in the piazza. The feast that Venice thus perpetually celebrated in her great council hall and in her public square—and, we might add, from the late sixteenth century on, across the arch of the Rialto Bridge—acquired an obvious importance, and its special significance related to the origins of the city itself. According to standard legend, Venice was founded in the year 421 on the date of the Annunciation, March twenty-fifth.

On that day, with the dedication of the church of San Giacomo al Rialto, supposedly the first in the lagoon, Venice was born—upon the ruins of the fallen empire of Rome and in Christian liberty. Summing up that tradition and giving it new, humanistic sanction, Bernardo Giustiniani wrote in his *De origine urbis Venetiarum* (which was published in 1493):

the sacrosanct day was chosen on which the divine message was brought by the Archangel to the most glorious Virgin with the indescribable bending of the celestial highness to the abyss of humility. It was then that the highest and eternal wisdom, the Word of God, descended into the womb of the most chaste Virgin so that man, lying in the depths of pitiable darkness, might be raised to the most joyful society of celestial spirits. But indeed, there is no measure to the divine wisdom. For He Who, on that day, in choosing the Virgin for the redemption of

the whole human race, looked especially towards her humility, . . . wished also that on the same day, in a most humble place and from most humble men, a start should be made toward the raising of this present Empire, a beginning of so great a work.[21]

The Roman Empire had been destroyed by the barbarian tribes; pagan might was fallen, and God in his infinite wisdom saw to a proper, Christian succession: on 25 March began as well the new era of political grace. No image makes the point as succinctly as the triptych from the studio of Bonifacio de' Pitati (fig. 6.5), painted for the Camera degli Imprestidi of the Ducal Palace before 1540.[22] Its central field depicts God the Father and the Holy Spirit soaring above Piazza San Marco: Venice participates directly in the theological mechanics of salvation, simultaneously hosting and sharing in the moment of the Incarnation and thereby receiving its own peculiar divine sanction.

Such imagery must perforce have remained somewhat elliptical in its claims, allusive and analogical in its operation; its meanings fitted into a complex exchange of mythic history and theology and required the precise evocation of that congruence to become manifest. Nonetheless, although its means of communication may have remained rather indirect, the political density of its message had a sure resonance. Venice declared the miracle of its own birth and the divinity of its mission by coopting, as it were, the Annunciation.

And that message could hardly help but deepen and further complicate the meanings of Venice personified. Just as the easy transition from Iustitia to Venetia enriched the referential value of such imagery and the evocation of Dea Roma lent political and historical sanction to it, so did the identification of Venice with the Virgin permit a still more daring reach. That system of iconographic intercalation we have been observing, the visual exchange and deliberate conceptual ambivalence, is manifestly at work in Jacobello del Fiore's triptych (fig. 6.4). The implications of the *Sedes Sapientiae*, linking the Solomonic throne and Mary as the bearer of the Word of God, are more than reinforced by the larger compositional context.[23] The central personification is bracketed by the archangels Michael and Gabriel, and the inscription behind her declares that she "abides by the angels' admonitions and holy words." Michael, traditional guardian of divine (and ultimate) justice, urges her to reward or punish according to merit and to "commend the purged souls to the benign scales." Gabriel, explicitly identified as the "announcer of the virgin birth of peace among men," begs the virgin to lead humanity through the darkness.[24]

It is Gabriel's presence in this particular context that calls for comment. This heavenly messenger, accompanier of the Holy Spirit, announcer of the Incarnation, is, of course, traditionally associated with the Virgin Mary. And .that association is pointedly acknowledged in Jacobello's painting, where the archangel, carrying the lily that becomes his attribute through his role in the Annunciation, assumes a pose of direct

address that intentionally evokes that role. His addressee, however, is ostensibly a different virgin, the virgin goddess of justice—and here, to recall the full resonance of that figure, we need no more than adduce the Virgo Astraea of Vergil's messianic Fourth Eclogue.[25] Yet Gabriel's position in the picture and the allusions of his text encourage that ambivalence we are beginning to discern as central to the Venetian iconographic imagination. The annunciation scene played out in Jacobello's panel automatically conflates those earlier events of March twenty-fifth: the theological Incarnation that initiated the new era of Christian grace and that historical incarnation in the four-hundred-and-twenty-first year of that era, the foundation of Venice.

The calendary parallel quite naturally invited—as was surely its intention—analogies of a vaguer and yet ultimately more effective kind. Venice was increasingly likened to the Virgin Mary, and the doctrine of the Immaculate Conception afforded a convenient rhetorical base for this. In a prayer for the doge, dating back evidently to the twelfth century, we find the declaration that God himself had wonderfully arranged the Venetian republic *ab eterno*: "qui dominium venetum ab eterno mirabilitur disposuiti."[26] Hyperbole bordering on blasphemy, ostentatiously developed on the basis of the Marian liturgy—and of the Old Testament Wisdom texts that underlay that liturgy—such rhetoric would become standard in Venetian panegyric literature.

The divine origins of the city of Venice were well known. Only divine intervention in the troubled affairs of men could account for the ideal perfection of her constitution, which was itself an imitation on earth of the celestial harmonies. Envoys of the subject cities of the *dominio* (as Staale Sinding-Larsen has shown) especially embroidered this imagery of the "divine republic" in their formal orations before the Signoria, acknowledging Venice as "a worthy image of the divinity that one never invokes in vain, and revered by everyone as a sacred thing on earth to be worshipped, were this permissible."[27] The printing presses of Venice assured the broadcast of such texts.

More explicitly historical, we might say, was the assertion of the virginity of Venice. "Venetia Vergine" became another common topos, for "with her uncorrupted purity she defends herself against the insolence of others," as Francesco Sansovino explained.[28] Indeed, one of the true marvels of Venice, as we have observed, was her long survival intact, the sheer duration of her independence, her freedom from foreign domination; and that phenomenon, an understandable source of pride to the Venetians, did not fail genuinely to impress the rest of Europe. In 1497, for example, the German knight Arnold von Harff was in Venice for the Festa della Sensa, and he recorded in his diary the following description of the ceremony and the Bucintoro:

Item on Ascension Day the Doge celebrates a festival each year before the haven on the high sea. He then throws a golden finger-ring into the wild sea, as a sign that he takes the sea to wife, as one who intends to be lord over the whole sea.

Item the ship in which he celebrates is a small stately galley, very splendidly fitted out. In front of this ship is a gilt maiden: in one hand she holds a naked sword and in the other golden scales, a sign that as the virgin is still a maid, so the government is still virgin and was never taken by force. The sword in the right hand signifies that she will do justice: for the same reason the maiden holds the scales in the left hand.[29]

Here we have clear testimony to the effectiveness of Venetian propaganda, visual as well as literary. The message has been well comprehended by those to whom it was addressed.

Thomas Coryat, an English traveller who published his account in 1611, begins his extensive commentary on Venice with the following title: "My observations of the most glorious, peerelesse, and mayden citie of Venice: I call it mayden because it was neuer conquered."[30] Coryat later returns to the theme: "It is a matter very worthy of consideration," he notes,

to thinke how this noble citie hath like a pure Virgin and incontaminated mayde . . . kept her virginity vntouched these thousand two hundred and twelue yeares . . . though Emperours, Kings, Princes and mighty Potentates, being allured with her glorious beauty, haue attempted to deflowre her, euery one receiuing the repulse: a thing most wonderfull and strange. In which respect she hath beene euer priuiledged aboue all other cities. For there is no principall citie of all Christendome but hath beene . . . at some time or other conquered by the hostile force: onely Venice, thrise-fortunate and thrise-blessed Venice, as if she had beene founded by the very Gods themselues, and daily receiued some diuine and sacred influence from heauen for her safer protection, hath euer preserved selfe *intactam, illibatam, sartam tectam*, free from all forraine inuasions to this day.[31]

Coryat's concluding lines offer final testimony to the incredible persuasive power of the Venetian propaganda machine of the Renaissance: "and so at length I finish the treatise of this incomparable city, this most beautifull Queene, this vntainted virgine, this Paradise, this Tempe, this rich Diademe and most flourishing garland of Christendome."[32]

Throughout the seventeenth century—and on into the nineteenth, in fact—the English would carry the banner of St. Mark, especially as they sought to define and defend political positions during their own historical crises.[33] The very title chosen for a treatise by James Howell in 1651 bears witness to the continuing impact of Contarini (who had been translated into English as early as 1599) and the tradition of Venetian apologetics: Howell called his book *S. P. Q. V. A Survay of the Signorie of Venice, of Her Admired Policy, and Method of Government, &c.* And his opening lines summarize the basic tenets of the myth of Venice: "Were it within the reach of humane brain to prescribe Rules for fixing a Society and Succession of people . . . the Republic of Venice were the fittest pattern on Earth both for direction and imitation: This Maiden City . . . had the prerogative to be born a Christian, and Independent . . . and hath continued above a thousand hot Sommers an intemerat Virgin."[34]

The degree to which Venice herself could exploit such celebratory metaphor in its own political imagery is fully demonstrated in a votive painting by Domenico Tintoretto in the Avogaria of the Ducal Palace.[35] It depicts the portraits of the Avogadori and notary of this magistracy; above them, atop a globe, presented by an angel and accompanied by a figure identifiable as an ecclesiastical virtue (or prerogative) and triumphant over figures of strife and envy, a regal Venice receives the blood from Christ's side. Through this direct rapport with the Eucharist, the political figure of Venetia usurps the role traditionally assumed by Ecclesia or Fides, whose standard attribute is the chalice. Domenico's painting is generally, if rather casually, dated circa 1600. But, as has been observed by Father Richard Lamoureux, the clearly antipapal connotations of this image make certain a more exact dating, between May 1606 and April 1607: the year of the excommunication of the Venetian government and the interdiction of the entire Venetian domain.[36] Without rehearsing the complicated background to this most consequential interdict, we need only observe that the government of Venice decreed that despite the papal ban all churches remain open and all religious offices continue to be celebrated. The substitution of Venetia for Ecclesia in Domenico Tintoretto's composition becomes, then, the clear pictorial affirmation of the ecclesiastical policy of the state.[37]

Venetian defiance of Rome found its most eloquent spokesman in Paolo Sarpi, and the public conflict between church and state excited all Europe—most especially the Protestant centers of the north.[38] It was still a burning issue when Thomas Coryat embarked upon his grand tour in 1608. And we can continue to gauge the effectiveness of Venetian political iconography and propaganda by accompanying this curious Englishman on his visit to the Sala del Maggior Consiglio, which was, he confessed, "the sumptuousest of all, exceeding spacious, and the fairest that euer I saw in my life. . . . Neither do I thinke that any roome of all Christendome doth excel it in beauty."[39] Coryat naturally lavished special praise upon the "wonderfull richly gilt" ceiling and its pictorial fields, making the obligatory comparison with the art of the ancients: "the curiousest painting that euer I saw done with such peerelesse singularity and quintessence of arte, that were *Apelles* aliue I thinke it is impossible for him to excell it."[40] The spectacle of the room was working its intended effect upon the visitor; Venice was showing itself off, and the forestiero was indeed properly impressed.

Focusing on the three central canvases of the ceiling, those that "especially are passing glorious," Coryat describes first Veronese's *Apotheosis of Venice* (fig. 6.2): "In the first of these borders . . . is painted the picture of the Virgin *Mary* in marueilous rich ornaments, with an Angell crowning of her."[41]

The system of transference and interpolation that had produced the figure of Venetia personified conditions as well the expectations of the

interpreter. Among the individual constituents of the image, the most sacred one emerges as dominant in Coryat's reading; however naïve, though, his interpretation is nonetheless grounded in an essentially accurate, if partial, perception. Without the guidance or context of experience, faced with a fundamentally novel kind of image, the visiting Englishman reaches out to other, more familiar categories to aid in comprehension. A beautiful woman enthroned in heaven, crowned by a winged creature, and surrounded below by a host of adorers: any Christian might be forgiven for seeing the Coronation of the Virgin.

Similar expectations, inspired by a certain kind of compositional structure, govern Coryat's description of the central canvas on the ceiling. In the elaborate design by Tintoretto, Venice herself descends from the empyrean, surrounded by Cybele, Thetis, and other nymphs, symbolizing Venetian dominion over land and sea; she and the lion present the doge (Nicolò da Ponte) with palm and laurel, signs of victory and honor. The doge is accompanied by members of the Collegio, and collectively they represent the Venetian state. Below, subject cities of the *dominio* render spontaneous submission to the Signoria. This is the basic reading of the iconographic program published by Girolamo Bardi in 1587 and reprinted in 1606.[42] The publication itself represented a deliberate effort to disseminate the program as such, to offer to a wider audience of visitors, actual and potential, the scenario of Venetian imperial display. One visitor, as we have just seen, evidently failed to consult this little book. Here is Coryat's description of the picture painted by the Tintoretto studio: "In the next border . . . is represented the Duke in his Ducal maiesty, accompanied with the greatest Senators and Patricians. . . . A little aboue the Duke is painted the Virgin *Mary* againe with a crowne on her head, attended with two Angels: shee feedes the winged Lyon with a branch of the Oliue tree, by which is signified peace."[43]

Once again, Coryat assumes, and not inappropriately, that a regal woman in the clouds must be divine. He recognizes in the basic structure of the composition, in its distinction of heaven and earth and the possibility of mediation between the two realms, the visual semiotics (as we might say) of salvation. The images he surely had in mind are altarpieces and, more immediately to hand, votive pictures such as those in the Sala del Collegio and elsewhere in the Ducal Palace.

When the figure of Venetia personified is brought down from the clouds and enthroned on earth, a quite different element in her constitution becomes dominant. In Palma il Giovane's canvas of Venice enthroned, set above her conquered provinces and crowned by a winged Victory, the more secular imperial triumph is appreciated by Coryat. He describes "armed men supporting a Queene on their shoulders, whereby is signified Venice, and the winged Lyon is painted hard by her." And he goes on to recognize in the "company of naked slaues, with fetters about their legges, and armour and helmets vnder their feete; whereby are meant

the victories and conquests of Venice inthralling her enemies, and bring-
ing them into slavery and captiuity."[44]

Whatever his problems in viewing the picture and however discor-
dant, from a Venetian point of view, the political implications of his final
words, Coryat responded to the martial tone and detail of this composi-
tion. Both tone and detail, of course, return us to the model of the vic-
torious goddess Roma—"che si vede nelle medaglie."

Aut Venus à Venetis sibi fecit amabile nomen,
Aut Veneti Veneris nomen, & omen habent.

One final element in the makeup of the personification of Venice de-
serves our attention. It is the most blatantly mythological: the goddess of
love, Venus herself. This particular constituent may not seem evident in,
or even compatible with, the sumptuously but always decorously gowned
queen we have been examining thus far. It may even at first seem to con-
tradict the notion of Venetia Vergine, of Venice of the Annunciation.
Nonetheless, we recall, along with the Venetian mythographers, that Ven-
ice was born of the sea. And what was at first metaphoric and suggestive,
poetic even, became a certain topos later on as Venice became in effect a
literary theme. Again, we can call upon James Howell to summarize the
situation.

Venice, he declared, "is no other than a Convention of little islands
peeping up and above he waters, . . . her . . . salt tayle seepd and brind
perpetually in the Sea." Inspired by this ostensibly factual description, his
account then takes characteristic flight: "In so much that it may be well
thought that the Goddesse Venus and the Cittie of Venice had one kind
of procreation being both engendered by the Sea; It is also very likely
Aphrodite that wanton Lady had her Original out of that white Spume
which Neptune casts upon those little gentle Islands wheron Venice makes
her bed."[45]

Howell was drawing upon a Venetian poetic tradition, somewhat folk-
loric and difficult to document precisely, that he probably knew through
Doglioni's *Venetia trionfante et sempre libera* (1613). The opening pages of
this little book celebrate the mythological origins of the miraculous city
and, in an anonymous poem, the etymological implications of her name.
Playing upon the names of Venus and Venice, the poet wonders whether
the goddess had given her name to the city, or vice versa, and, in any
event, he concludes that whoever failed to love Venice was incapable
of loving Venus.[46] It is the courtly implications of this somewhat light-
hearted theme that offer a necessary prelude to our final discussion.

Looking back to the beginning of the quattrocento, that period of
particular imperial ambition in Venice, we find in the literature an imag-
ery that accords with the visual imagery of Venetian self-presentation.

Nor is it surprising that it occurs within a somewhat Petrarchan context. About 1410, in an incomplete manuscript entitled "Primo trionfo della gloriosa città di Venezia," one Cecchin da Venezia imagined his city as a most beautiful woman dressed in many colors, flanked by the winged lion.[47] Contemporaneously, another chronicler described the vision that appeared to him in a dream: a lady, kind in aspect and more radiant than the sun, "piena di gentilezza e ben ornata," who identified herself to the dreamer: "Venexia son chiamata qui per nome."[48]

Such courtly visions of gentle ladies, whatever their Apocalyptic implications, may not quite correspond to the martial virgins of justice that had generally come to represent Venice. Later in the quattrocento, however, we do encounter the officially sanctioned visualization of such a model, in an illuminated manuscript of 1486: the panegyric oration of Vittore Cappello to Doge Agostino Barbarigo.[49] Overseeing the presentation scene of the opening folio is a young woman, "piena di gentilezza e ben ornata." Her ducal cap and vexillum identify her as Venice; about her the richly miniaturized landscape is populated by rabbits. To my knowledge at least, these fruitful creatures are quite strange to such political contexts. On the other hand, they are well-known favorites of the goddess of love—as such, for example, they fill the landscape in the April fresco of the Palazzo Schifanoia in Ferrara, which is dominated by a most courtly triumph of love.[50] Here, then, in the miniature of 1486, we find the fusion of Venus—however unclassical her form—and the figure of Venice.

By the turn of the sixteenth century Venus had generally reacquired in art her full antique form, as a beautiful nude. So too did Venetia, in the course of the cinquecento, begin to shed her garments—at least on those occasions when she most closely approximated her Olympian prototype. The most telling document of this tradition is the image on the reverse of a medal of Sebastiano Renier.[51] Inscribed "MEMORIAE ORIGINI VENET[IAE]," it depicts a female nude riding above the waves and holding in her hand the standard of St. Mark. The design, which has been attributed to Maffeo Olivieri, represents the fullest synthesis of two traditions, the perfect identification of Venus and Venice: *Venetia anadyomene.*

The medal, with its highly individual *impresa*, tends to be a rather personal form of expression. Nonetheless, its meaning cannot be too hermetic; its message must be legible, capable of communication. In this sense, the medal carries a more public responsibility, and above all for a Venetian noble like Sebastiano Renier, whose official career of public service over many years is attested by the diaries of Marino Sanuto.[52] However unusual a nude personification of Venice may be, there can be little doubt that Renier's numismatic invention spoke clearly to the Venetian imagination.

Shortly after the middle of the century, however, a nude Venice figure makes her appearance in the Ducal Palace itself, amidst the generally Olympian iconography of the ceiling of the Sala del Consiglio dei Dieci

(fig. 6.6). There Giambattista Zelotti set a beautiful Venetia between the figures of Mars and Neptune. The presence of Cupid, who crowns Neptune with laurel, gaurantees a certain ambiguity of identity, a deliberate ambivalence. Only the lion alongside the female nude, which she caresses like a large pet dog, affirms her Venetian persona.[53] The same mode of iconographic intercalation that permitted, indeed, encouraged, easy interpretive passage in the Venetia/Iustitia/Maria complex here operates in a more purely mythological dimension. In the Sala del Consiglio dei Dieci the figure of Venice is quite at home among the gods.

Zelotti's canvas was part of an iconographic program that was invented by Daniele Barbaro.[54] That program and its pictorial realization represent, we might say, the Olympian highpoint in the tradition of *Venetia figurata*.[55] Following this epiphany of a Venice beautiful and nude, a pagan Venice, the official figure of the Serenissima returns to a more decorous persona, a lady "ben ornata," achieving her most splendid manifestation in Veronese's canvas. It would be much too facile to ascribe this shift back to the gowned lady to the influence of the Counter-Reformation, let alone to the actual proscriptions of the Council of Trent. Still, it is difficult to imagine a nude Venetia in the later cinquecento. From Veronese's triumphant personification (fig. 6.2) to Tiepolo's in the eighteenth century, Venetia remains the decorous queen of the Adriatic, a Juno rather than a Venus.

But the pagan appeal of myth proved stronger than the painted figure herself, and it conditioned the way later observers would view Venice:

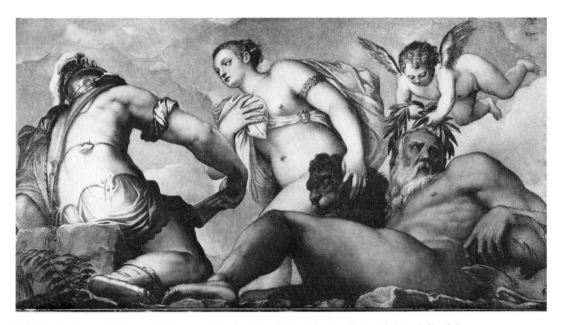

6.6. *Venice between Mars and Neptune*, Giambattista Zelotti, in the Sala del Consiglio dei Dieci, Ducal Palace, Venice.

"Venus and Venice are Great Queens in their degree, / Venus is Queen of Love, Venice of Policie." With that couplet James Howell concluded the opening poem of his *Survay of the Signorie of Venice*, full testimony to the effectiveness of the Venetian program of self-presentation.[56] Howell, as we have already seen, touches all the keys of her well-tuned political instrument as he celebrates Venice, "Great Neptunes Minion, still a Mayd." And in his own stilted fashion he tells us much about the impact of Venice's image of itself, that implausible—yet somehow convincing—construct of Virgin and Venus.

Out of those separate iconographic themes—of Justice, Roma, Virgin, and Venus, each continuing to resonate with its own associations—Venice patiently and deliberately created its own visual persona, a heroic queen subsuming all virtue, political wisdom, and historical destiny in her handsome self. The rhetoric of such imagery is obviously in the epic mode (however much the genre suggests romance), and although it was not unique in the political art of Renaissance Europe, it did establish the most convincing and effective model for subsequent generations, instructing the rest of Europe in the art of political figuration.

KENNETH BENDINER

7. Political and Social Themes
in Late Eighteenth Century
British Images of India

Colonialism was one of the most prominent forces in European politics in the nineteenth and twentieth centuries. Imperialism enriched European economies, enhanced national prestige, created fields for international competition and outlets for excess population, provided an escape from domestic problems, and excited nationalism at home. Numerous European paintings and publications quite naturally reflected imperialist attitudes and concerns, and these often served to justify, explain, and celebrate the European domination of non-Western peoples.

Such pictorial propaganda was not limited to scenes of military victory. Colonialism was justified as a civilizing force, a social and economic benefit to all peoples, and a testament to the superiority of Western progress and enlightenment. *Notre epopée coloniale* by Pierre Legendre, published in 1900, stands as a representative example of an illustrated imperialist publication for the general public.[1] In this large and attractive volume, one finds, for example, photographs of a New Caledonian chief's hut, and a few pages later, a photograph of a French colonial community in New Caledonia. The images and text are prosaic, seemingly purely descriptive and unprejudiced. But such a selection of views has definite meaning. The photograph of the French settlement includes an agricultural school, a model farm, a church, stucco dwellings, and administrative offices. The chief's hut is a pathetic building made of leaves and sticks—primitive, squat, buried in the vegetation, only one step away from living in the trees. The French compound appeals to European notions of cleanliness, order, religion, the cultivation of nature, and the power of technological progress. Even without written descriptions, the photographs in Legendre's book declare the benefits of colonialism.

Through social, religious, economic, and architectural contrasts, *Notre epopée coloniale* sings the praises of French imperialism, and every European imperialist nation throughout the nineteenth and twentieth centuries produced similar self-serving publications, which posed as ob-

jective, unbiased studies. The methods and reasoning of such pictorial propaganda, however were already in use by the end of the eighteenth century. An examination of British images of India, created at the moment when England finally subdued all of that subcontinent, reveals that the visual means of justifying Western imperialism were already well established before the nineteenth century.

In eighteenth-century England, the most important pictorial guide to India was a large-scale, six-volume work titled *Oriental Scenery*, which comprised 144 color aquatints, describing all parts of India.[2] The images had been sketched on the spot by Thomas Daniell (1749–1840) and his nephew, William Daniell (1769–1837). They toured India from 1785 to 1793 and published *Oriental Scenery* in England from 1795 to 1808. This was a monumental, lavish, and extremely expensive production, which sold for 200 guineas.[3]

Oriental Scenery is a thorough topographical compendium that seems innocuously picturesque or merely factual. But it is not just a work to indulge the sense nor a pretty coffee-table volume to elicit associations of exotic places visited or longed for. A topographical publication on the scale of *Oriental Scenery* is a means of grasping a region. Just as a survey of a private property reinforces the sense of ownership, so too does *Oriental Scenery* function as a document of possession. It clarifies and exhibits the landmarks, defenses, distances, and resources of the entire subcontinent. It is a means of comprehending India in bite-size pieces, capable of being swallowed visually and intellectually and, by extension, politically. It is significant that the East India Company, the most powerful commercial and political force in India, and an arm of the British government, purchased no less than thirty complete sets of *Oriental Scenery*.[4]

The years during which the Daniells traveled in India coincided with the general recognition of India as a British colony. The victory at Plassey in 1757 marked the expansion of the British in Bengal, and the French surrender at Pondichery in 1761 marked the eclipse of European competitors in India. The direction of the East India Company was taken over by the British government in 1773. Through treaties and coercion the British extended their control over numerous Indian rulers. In the 1780s and 1790s General Cornwallis advanced Britain's domination of India through military conquest. The arch enemy, Tippoo Sultan, was finally and totally conquered in 1799.[5] The Daniells followed the victorious armies of Cornwallis in South India. Their book is therefore an appeal to patriotism and imperialism.

In images such as *Jag Deo in the Barramahal* (part 4, plate 11) and *Verapadroog in the Barramahal* (fig. 7.1), the Daniells emphasized the height and impenetrability of the mountains depicted. A low vantage point suggests the monumentality of the hills in these plates, and the lower landscapes stop abruptly at the foot of the mountains; there is also no distant pathway provided for the viewer to scale the heights in his imagination. The peaks thrust toward the tops of the pictures, and in the scene of

Verapadroog they even project above the clouds. The figures in both these plates are tiny creatures, overwhelmed by their vast and jagged environments. If one looks closely, there are clearly fortresses on the tops of the mountains in both prints, and both the forts fly British flags. These sites in the Barramahal were the strongholds of Tippoo Sultan and his father, Hyder Ali. The British banners proclaim Britain's victory over these enemies, and the letter-press of *Oriental Scenery* noted that Cornwallis conquered these forts in 1792, even though they were considered impregnable.[6] The seeming invincibility of the fortresses were emphasized by the Daniells to enhance British fortitude, to suggest insurmountable obstacles overcome. We see large stretches of forbidding land, and the Union Jack flies above all. The Daniells were here saying: "India is mighty; she is extensive, and she is ours."

In describing Tippoo Sultan's conquered hill forts the Daniells wrote:

The scene is grand, but of that dreary aspect, which . . . produces in the mind a mixture of horror and melancholy. If the surface of our terrestrial residence presented to us prospects only of this kind, our state here would appear to have few temptations. The fortress . . . is moreover, surrounded with every impediment, natural and artificial, that can render access either impossible or difficult; and all this to enable one little tyrant to resist the hostility of another, or to favour his own projects of vengeance or plunder. The plain below, extending as far as the eye can reach, is one vast uninterrupted jungle; a rank, entangled, and impenetrable vegetation, swarming with its peculiar inhabitants, many of which are

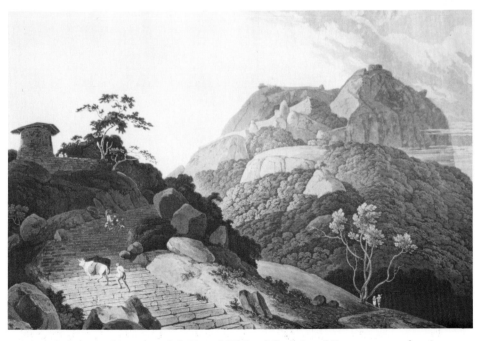

7.1. *Verapadroog in the Barramahal* (T. and W. Daniell, *Oriental Scenery*, pt. 4, pl. 13).

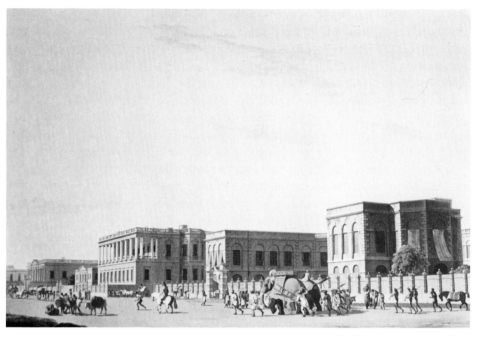

7.2. *The Council House at Calcutta* (T. and W. Daniell, *Oriental Scenery*, pt. 2, pl. 3).

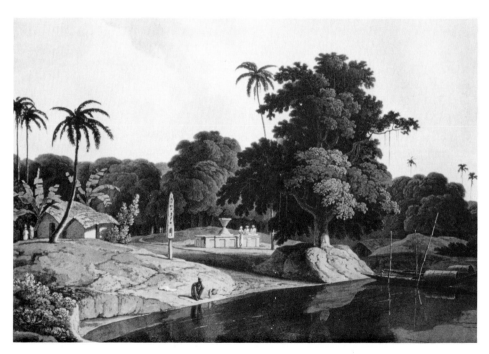

7.3. *Near Bandell on the River Hoogly* (T. and W. Daniell, *Oriental Scenery*, pt. 6, pl. 8).

no less terrible to man than to themselves; and where, urged by hunger, lust or cruelty, mutual destruction rages without intermission. In fact, while we contemplate the nature and situation of the place, with the circumstances combined with it, we cannot but be strongly impressed with an idea of the ferocious and sanguinary propensities of all animated nature.[7]

The above passage is essentially a portrait of India and the Indians as self-destructive and barbarous. The jungle habitat defines the place and the people. It is difficult to determine whether the Daniells were writing about wild beasts or Indian natives. Indeed, the two seem, in the Daniells' words, to be analogous. Implicit in this description also was Britain's superior position, above the rampant turmoil of petty tyrants and as conqueror of hostile terrain. The Daniells implied that British rule was necessary to prevent the Indians' internecine battles. In commenting on another plate, the Daniells castigated India's "petty chieftains, whose views of government are little better than those of savages."[8] The idea of the white man's burden was in gestation. The letter-press also indicates how rich in meaning an apparently straightforward topographical illustration could be.

There are some pointed contrasts in *Oriental Scenery*, and these too can be viewed as justifications of British domination. One of the curious and telling characteristics of the work is the virtual absence of any view of an Indian city. Isolated monuments from a city may be shown, but there are no extensive urban scenes. The centers of British power, however, are displayed as grand and populous cities. The view of *The Council House at Calcutta* (fig. 7.2) is but one example, and in contrast to almost every scene of Indian architecture and villages, there is in this image of the center of British power hardly any vegetation. Calcutta here appears as a neat, clean metropolis of straight lines, rational and completely manmade. The centers of Indian populace tend to be depicted as overgrown or set within nature. The urbanity of British life is an important differentiation. The appreciation of raw, sparsely inhabited scenery was still fairly rare in Europe at this period. Cities, not nature, were the points of attraction on the Grand Tour.[9] In *Oriental Scenery* the cultural superiority of the British is suggested by their metropolitan settlements. The Indians, on the other hand, are shown as still attached to the jungle. Furthermore, in the depictions of Indian habitations we see stasis and lethargy, in the centers of British rule, bustle and commerce appear. An image such as *Near Bandell on the River Hoogly* (fig. 7.3) may be pretty, but it is without any business activity, and the isolated figure squats in a thoroughly unEuropean posture. The Daniells' Indian village figures often appear lethargic, and eighteenth-century writers on India often pointed out the inherent laziness of the people. John Henry Grose in 1757 even felt that the Indians' "constitutional indolence" led them to accept slavery and despotism with indifference. British rule would obviously be for the Indians' own good. Grose attributed the passivity of India to vegetarianism.[10] The calm and lovely view of the River Hoogly with its lackadaisical figure thus contains an element of indictment, and the strange monu-

ments depicted in the scene reinforce the negative meanings. The letter-press identifies these structures as monuments of suttees, memorializing wives who committed suicide at their husbands' funerals. The Daniells patriotically moralized; they called the suttee "the perversion of human intellect," and remarked: "To the disgrace of human nature, this practice has prevailed during a long succession of ages in Hindoostan . . . but every feeling heart must rejoice that, with equal wisdom and humanity, it has been expressly prohibited in all territories over which the authority of the British Government extends." Such notes of the benevolence of British domination abound in *Oriental Scenery*. In *A View Taken on the Esplanade, Calcutta* (part 2, plate 1) the Daniells pointed out the Orphan House in the distance, beyond the manicured parkland and the busy scene of vessels in the harbor. The Orphan House may be viewed as a charitable counterweight to the exploitive commercial trade that appears in the foreground.

In contrast to thriving Calcutta and Madras, there are plates in *Oriental Scenery* such as *The Ruins of the Ancient City of Gour formerly on the Banks of the Ganges* (part 1, plate 4), a picture of an abandoned and ruined city, overgrown by vegetation. The Daniells noted that Gour existed 350 years before Christ, and that it had been the capital of Bengal three times, whereas British Calcutta now stands supreme in the region. Images of ruins may allude to the destructive passage of time or man's insignificance in the universe; they may be warnings of the ephemerality of worldly might or nostalgic and mysterious relics of lost grandeur; but they may also be evidence of impotence and degeneracy. The Daniells's view of Gour is certainly not without romantic melancholy, yet it is also an image of the barrenness of Indian society and its economy.[11] Gour and the other formerly grandiose monuments depicted in *Oriental Scenery* tell us also that the Indians are not like the natives of the South Seas encountered by Captain Cook. Unlike the Tahitians, they could not be embraced by eighteenth-century Englishmen as innocent noble savages, untouched by sophisticated society.[12] The Daniells thus presented Indian civilization in decline, and the superiority of the British is implied. Over and over again the Daniells depicted ruination, and such devastation was not the result of British conquest but of Indian degeneracy or internecine wars.

The plate representing *The Assembly Rooms and Race Grounds at Madras* (part 2, plate 11) shows severe Western buildings standing amidst a barren plain. An enframing palm tree adds a Claudian note, and flying from the edifice is a giant British flag. The letter-press states merely that "the races are supported by English gentlemen. This amusement takes place in the cool season, when the ladies of the settlement are invited to a splendid ball." But this picture speaks also of the wholesale importation of English culture into an alien country. It declares that British life will not be mongrelized by foreign custom. This print, furthermore, is an early example of the patriotic connection between sports and English nationalism. Sports in the nineteenth century became a symbol of British cul-

ture, a sign of British strength and decency. Wellington's reference to the victory at Waterloo and the playing fields of Eton is well known, and one might also note that the critic F. G. Stephens described the artist D. G. Rossetti as essentially un-English—because Rossetti had never engaged in sports.[13] The Daniells' view of the racecourse is a patriotic hymn. No pictures of Indian sports are included in *Oriental Scenery*.

Some of the Indian ruins in *Oriental Scenery* refer to specific political situations, rather than just general decline. In *The Sacred Tree of the Hindoos at Gyah* (part 1, plate 15) the Daniells depicted not only the Bo tree sacred to Buddhists and Hindu but also a humble religious structure. And noticeable in the scene are broken statues of deities. The letter-press points out that "frequently may be observed fragments of mutilated idols, the work of Mohammedan intolerance, which are again often collected by the patient Hindoos, and though defaced, are still regarded with veneration." This quiet picture of faithful Hindu is thus also a criticism of Muslim bigotry and oppression. Throughout *Oriental Scenery* ruined temples are accompanied by comments on the violent intolerance of the Islamic overlords. The benevolence and tolerance of British rule is, of course, the necessary antidote.

The Daniells' attitude toward the oppressed Hindu, however, was not all favorable. The artists were firm men of the Enlightenment and looked upon all religious activities with some disdain. They perpetually described

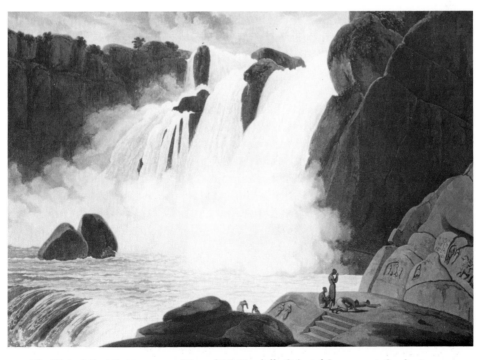

7.4. *The Waterfall at Puppanassum* (T. and W. Daniell, *Oriental Scenery*, pt. 6, pl. 2).

the Hindu as superstitious, credulous, and irrational, a contrast to the reason and sense of British civilization. In *The Waterfall at Puppanassum* (fig. 7.4) we see Hindu primitivism and blind worship of fearsome nature. Ferocious rocks and crashing torrents practically blot out the sky, and at the lower right are tiny Hindu devotees praying before images carved into the rocks. We see terrifying nature and man's superstitious response; we see a rational man's explanation of religious credulity. The Daniells wrote:

It is curious to remark in the history of mankind, what strange objects superstition has sometimes fixed upon to lavish its regards. . . . The respect which in India is paid to this awful phenomenon [the waterfall] may however be more naturally accounted for than many of the prejudices that have taken possession of the human mind. A large river is almost universally a blessing to man in a state of society; and water generally, but in hot climates more particularly, is an obvious source of endless comforts and advantages. It cannot therefore be surprising that the ancient philosophical priests, and fabricators of mythological systems, who well knew its importance in the economy of nature, should regard this beneficial element as entitled to peculiar respect, which they accordingly made the basis of many salutary customs, whereof there is perhaps none more so than the ceremony of ablution. . . . When water by such high sanction had acquired divine attributes, and the sacred fluid was believed capable of washing away the blemishes of sin, we cannot wonder that the unreasoning multitude, impressed with such opinions, should behold the foaming torrent, falling in thunder down the precipice, with equal dread and veneration; and imagine the holy haze that fills the surrounding atmosphere must give an extraordinary degree of sanctity to such situations. . . . Whatever regret we may feel on observing in these ceremonies the human reason so abused, and creatures of such admirable capacities made the dupes of doctrines so preposterous, we are in some measure consoled in the reflection that this duty, like many others by the magic of bramanical delusion, is made one of the means whereby the views of man are directed to a superintending cause.[14]

The attitude of the Daniells in the picture and the letter-press is one of cool superiority. The Hindu are dupes lost in the primordial jungles of superstition. The natural conclusion is that the Indians are unfit to direct their own destinies. Enlightened distaste is also evident in *Interior of the Temple at Mandeswarra* (part 3, plate 22) and *Dehr Warra* (fig. 7.5), pictures of Hindu shrines that convey a mood of dark oppression and imprisonment. An idolatrous devotee at Mandeswarra is locked into a barren hall. A dark empty portal appears on the back wall, but leads nowhere. There is no spiritual power in the scene, only hollowness, and the phallic idol is small and depressingly physical. At Dehr Warra unbroken perspective lines add a mannerist tension, a wish to flee, a frightening claustrophobia. This cavern temple has a mysterious beauty, but for the rationalist Daniells those haunting qualities were unpleasant. The ceiling presses down ominously, and the campfire is too pitiful and smokey to suggest the light of divinity or reason.

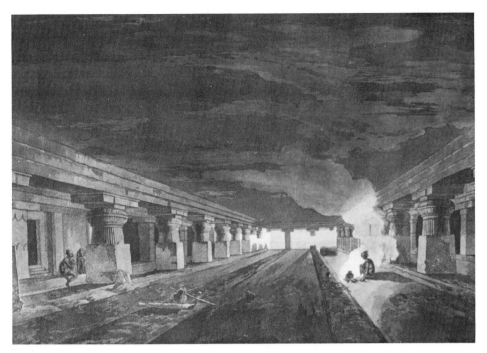

7.5. *Dehr Warra* (T. and W. Daniell, *Oriental Scenery*, pt. 5, pl. 24).

In the plates that depict the astronomical observatory at Delhi (fig. 7.6), the Daniells' sense of superior rationality and chest-thumping patriotism for once seems diluted. Here was evidence of great Indian capabilities in mathematics, technology, and the higher sciences that seemed equal to those of the West. Here was something that contradicted the decay, superstition, and weakness that appear in so many plates of *Oriental Scenery*. This observatory and many others had been devised by Jayasinha, Rajah of Ambhere, in the late seventeenth century. He was a great mathematician and astronomer, and he published his very exact observations. The Daniells approached this monumental scientific instrument without picturesque formulas. An astonishing boldness and directness guides the pictorial composition of these simple architectural masses. It would appear that a rational, scientific subject required a no-nonsense style. Clarity, not beauty, was in order. The images appear as celebratory testaments to Indian genius and modernity.

Unfortunately, this interpretation of the observatory plates must be qualified. In commenting on these prints, the Daniells directed the reader to an article by William Hunter in *Asiatick Researches*, a publication of the Asiatick Society in Calcutta.[15] In that article, all the scientific accomplishments of Rajah Hayasinha are attributed to the influence of Western books. Hunter added: "I have always thought that after having convinced the eastern nations of our superiority in policy and arms, nothing can

contribute more to the extension of our national glory than the diffusion among them of a taste for European science."[16] Thus the Daniells' views are not really a celebration of Indian reason, but monuments to the benefits of Western influence, hymns to the progress that comes from imperialist domination.

Not all the Daniells' views are attacks on Indian culture or expressions of British righteousness. There are favorable images, such as the picture of Cape Comorin (part 6, plate 1), where India appears as a peaceful land of agricultural wealth (and thus worth possessing). There are also unbiased appreciations of native architecture, such as the view of the Mosque at Juan Pore (part 4, plate 3). These lavish Indian monuments portrayed by the Daniells influenced such Indianized concoctions in England as the Royal Pavilion at Brighton.[17] These English architectural imitations served to allude to the luxurious world of Indian rajahs and to Britain's ownership of India.

The appreciative scenes of India, however, are undercut and overwhelmed by the bigoted and negative meanings of so many plates in *Oriental Scenery*. The kind of social, political, and religious biases presented by the Daniells were repeated and elaborated in imperialist pictures of

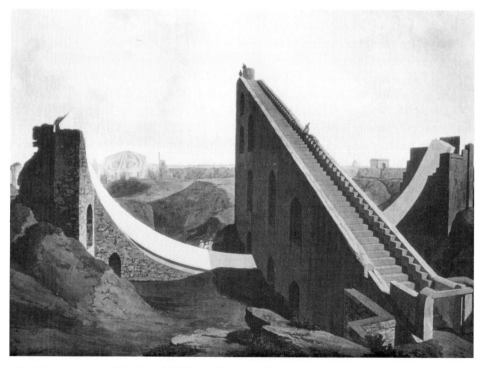

7.6. *Observatory at Delhi* (T. and W. Daniell, *Oriental Scenery*, pt. 3, pl. 19).

the nineteenth and twentieth centuries. This view of Third World peoples as benighted primitives and degenerates, incapable of self-government and sunk in superstition, lassitude, and savagery, made the victims of European imperialism appear as pathetic creatures who needed Western guidance. In the modern period domination must be justified as a benevolent act.

The images of *Oriental Scenery* and subsequent publications were important political forces. They fostered and reinforced the imperialists' sense of superiority and morality. Such pictures did not necessarily support specific political policies or action. But they helped form the frame of mind of those Europeans who conquered and ruled the peoples of foreign lands. The picturesque and undemonstrative propaganda of *Oriental Scenery*, endlessly repeated, colored the outlook of colonial civil servants, soldiers, visitors, and the populace back home, so that British imperialism in India could triumphantly succeed.

GEORGE L. HERSEY

8. Political Implications of
the Houses of Parliament

On the sixteenth of October, 1834, at the Old Houses of Parliament on the Thames, cartloads of wooden tallies once used in accounting procedures were being burnt in the heating stoves. The process took all day. A fierce draft was created, and visitors noticed that the stone flags of the building's floors were hot and that there was a lot of smoke. When the workmen finished putting the tallies in the stove, at about five o'clock, they went off to a pub. A brisk wind was blowing. The rest is history; it was the worst fire in London since 1666.

The old Houses of Parliament consisted of a ramshackle former royal palace, a fine medieval beamed hall called Westminster Hall, and a beautiful Gothic chapel, St. Stephen's. Remodelings of the complex had taken place over the years after the Crown granted it to Parliament in 1547. In 1792 John Soane designed neoclassical improvements.

Then, in 1799, James Wyatt provided a new chamber for the House of Lords and made it Gothic. Gothic was chosen, as contemporary accounts make clear, because it would harmonize with the immediate surroundings: Westminster Abbey and the rest of the Old Palace complex (fig. 8.1). But there were political implications to the choice of Gothic as well. Gothic, it was said, expressed a golden age of British governance. It evoked that complex of ancient traditions and laws that were responsible for the existence of Parliament itself. In the eighteenth century these traditions had been referred to as "Saxon liberties." In the nineteenth they were known as the British Constitution.[1] This constitution was, as everyone knows, informal, indeed unwritten. It was a bundle of habits and traditions, without symmetry or formal order, but it guaranteed certain individual rights, including the right to political representation through Parliament. Another basic effect of the constitution was to restrain the power of the monarch. One definition of the time said that the British sovereign was the king plus Parliament, both in turn deriving their powers from the constitution. And the constitution had meanwhile gradually

99

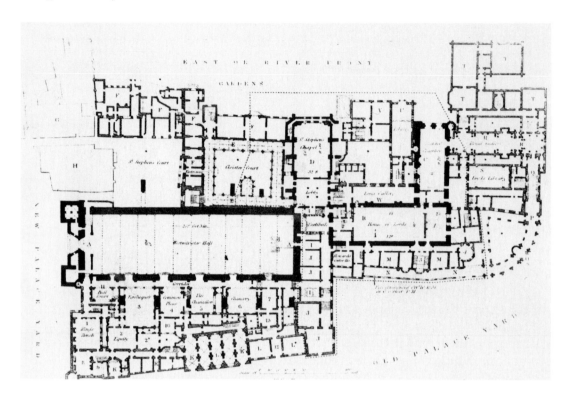

8.1. Old Palace complex, c. 1834, Houses of Parliament, London (from Port, *Houses of Parliament*, fig. 2).

developed out of the political checks and balances of English feudalism in the late Middle Ages. Both these considerations—the idea that the architecture of Parliament should harmonize with the architecture of London and that Parliament symbolized the constitution—were brought into play again when a complete new palace was planned after the fire.

But one further consideration was the fire itself. It was no tragedy; there was no loss of life. Instead, it was regarded as a magnificent spectacle. Turner's painting in the Philadelphia Museum of Art shows the glorious bursts of gold and pink that flung themselves into the sky all night long. The fireworks were watched by thousands of Londoners. The towers of Westminster Abbey are actually white in the glow. The whole north bank of the river is a colossal lantern. The only shadowed things are the brown-black huddled forms of wherries and enraptured spectators in the foreground.

Some people not only enjoyed the fire but actually rejoiced in its achievement. By 1834 a great deal more was known about Gothic architecture than had been the case when Wyatt made his contributions to the complex. The more progressive and extreme young intellectuals who led the Gothic Revival excoriated Wyatt, who had spent his career modernizing many of Britain's great medieval churches. He was known as Wyatt

the Destroyer. The leading young turk was Augustus Welby Northmore Pugin. About the burning of the Old Palace he wrote to a friend:

You have doubtless seen the accounts of the late great conflagration at Westminster which I was fortunate enough to witness from almost the beginning till the termination of all danger as the hall had been saved which is to me almost miraculous as it was surrounded by fire. There is nothing much to regret and much to rejoice in a vast quantity of Soane's mixtures and Wyatt's herasies [sic] [having] been effectually consigned to oblivion. Oh it was a glorious sight to see his composition mullions and cement pinnacles and battlements flying and cracking while his 2[s.] 6[d] turrets were smoking like so many manufacturing chimnies till the heat shivered them into a thousand pieces. The old walls stood triumphantly midst the scene of ruin while brick walls and framed sashes, slate roofs, etc., fell faster than a pack of cards.[2]

The most interesting thing to me in Pugin's letter is his picture of the true medieval work—the heavy stone walls of Westminster Hall, for example,—standing up to the holocaust while Wyatt's sham Gothic was instantly consumed. This idea of the durability and worth of what was truly old in English architecture, combined with a strong reaction against earlier phases of the Gothic Revival—these were the hallmarks of Pugin's life, and they were also hallmarks of the New Palace.

At this point in his letter Pugin turns to the future: "I am afraid the rebuilding will be a compleat job of as that execrable designer Smirke has already been giving his opinions which may be reasonably supposed to be a prelude to his selling his diabolical plans and detestable details. If so I can contain myself no longer but boldly to the attack will write a few remarks on his past work and if he does not writhe under the lash his feeling must be harder than his cement." Pugin refers to Sir Robert Smirke, architect of such buildings as the National Gallery, whose spindly porticoes and pepperpot dome attract the cognoscentis' disdain to this day.

But Pugin was wrong. Smirke did not get the Westminster Palace job, though he did submit preliminary drawings in 1835. Instead, a national competition was held, open to all comers. And, as everyone knows, Pugin acted as a silent partner for the winner of that competition, Charles Barry. As the New Palace of Westminster was slowly erected during the ensuing decades Pugin made drawings for its architectural details—everything from fan vaults to inkstands—that numbered into the thousands.[3]

Pugin was the son of an architectural draftsman, and his chief greatness was in the field of draftsmanship. He could make exquisite renderings of Gothic halls, castles, and churches. As an example, compare a rendering by Pugin made for one of the entrants in the 1835 Parliament competition—J. Gillespie Graham (before Pugin teamed up with Barry)—with Smirke's 1835 design just mentioned (see figs. 8.2 and 8.3). In both cases we see the river front. Gillespie Graham—not Pugin, who was only Graham's draftsman—called for a group of cathedralesque masses informally standing about and built out around a massive octagon in the center, which is grouped with Westminster Hall. The genre is that of a

monastery or college. It had none of the unity the government wanted to express.

But Pugin's rendition of Gillespie Graham's inappropriate design is delightful. Pugin's Perpendicular detail is correct, rich, and entirely lacks the baldness, the visual penury of much Regency Gothic. It is picturesquely modeled with a soft river light and almost looks old. I am unfairly contrasting Pugin's elaborate rendering with Smirke's drawing, which is a mere elevation sketch. But even so certain truths come through: Smirke provides a symmetrical classical skeleton with token medieval shapes grafted onto it. By any standards the composition is weak. It has Smirke's usual underscaled frontispiece, and the bay system is boring. The flanking pavilions are too big. And as to the details, to compare Pugin's with Smirke's is not so much unfair as unkind.

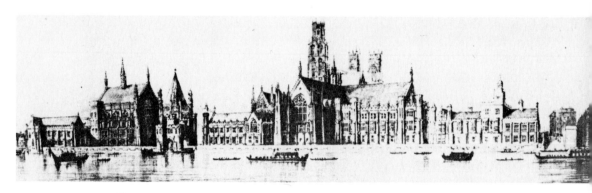

8.2. Gillespie Graham's competition drawing for the Houses of Parliament, drawn by Pugin (from Port, *Houses of Parliament*, fig. 31).

But if Britain now possessed a man, Pugin, who could design a Gothic that was practically as good as the real thing, there were still enormous problems with the New Palace project. A long article in the *Quarterly Review* for 1831, well before the fire, introduces us to some of them. The first premise of the article is that good architecture should express the specific character of the nation that produced it. At the same time the anonymous author finds no national expression whatever in contemporary British public architecture, which was so often designed by people trained in foreign countries and which was adapted from foreign buildings, usually French or Italian. Of all British architectures only the medieval domestic was national and peculiarly British. It was here that one found the right historic and social associations. English rural medieval vernacular, the author concludes, was in fact a direct statement of the political and social traditions that gave birth to the British Constitution. He then continues:

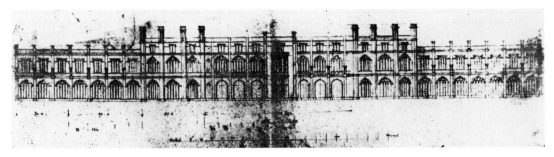

8.3. Sir Robert Smirke's design for the Houses of Parliament, 1835 (from Port, *Houses of Parliament*, fig. 18).

[We are filled with] melancholy regret, whenever we pass the remnant of some ancient manor-house, once the scene of comfort and joyous hospitality, now dreary and dilapidated,—the porch removed, and leaving unsightly traces of its former station,—the richly wainscoted banquet-room converted into a cheese-loft,—the stone-hall, with its fretted ceiling and colossal fireplace, employed as the cellar,—its many-mullioned bay windows blocked up with rough stone or un-couth plaster,—the chapel filled with straw and faggots,—the gate-house turned into the cart-stable,—the cows littered in the 'little green court',—and the dank walls and almost obliterated terraces of the garden overgrown with nettles, among which broken balls, and vases, and balusters lie strewed about, attesting the ancient ornature of the place, and vividly recalling to the imagination the figures of airy elegance or stately dignity, that once glided along the walks, and trod the broad flags, here now we see only the clumsy boor and gawky slip-shod dairy-woman.[4]

Here we have a good example of the sort of associationist description that was the rule in early Victorian architectural writing. But let us note the political content of the associations: the common people remain in the countryside but the gentry are gone. And the common people have taken over and ruined the gentry's house. The stable feudal system that once supported both classes has disappeared.

The *Quarterly Review*'s affecting word-picture conjures up the plates in one of those sumptuous volumes of the period dedicated to Merrie England, such as Joseph Nash's book, *A Series of Views Illustrative of Pugin's Examples of Gothic Architecture* with descriptive comments by W. H. Leeds and drawings by A. C. Pugin, the father of the man who rejoiced when the old Houses of Parliament burned. Here is illustrated a Norfolk manor house, Walterton, in its prime in 1500 (fig. 8.4). Lords, ladies, and their servants conduct a lively pageant of daily life. The same building, as it appeared in 1830, is a picturesque but shattered wreck (fig. 8.5). A peas-ant plows, and a cat spits at a trio of pigs lumbering through the ruins of the chapel. Here again we see the wreck of old, aristocratic England and the slovenly democracy of the new. To believers in the philosophy of his-toric associations—what later came to be called *architecture parlante*—

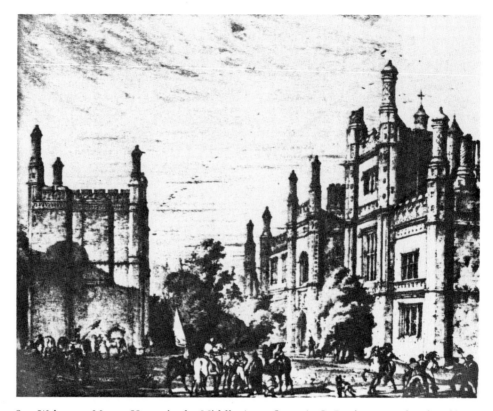

8.4. Walterton Manor House in the Middle Ages, from A. C. Pugin, *Examples of Gothic Architecture* (reproduced in *Architectura* 13.1 [1983] fig. 2).

those damaged halls and broken windows are damaged laws and broken customs. The swine in the chapel are symbols of society's decay. The point was made more forcibly still by Pugin in his 1836 book *Contrasts* (fig. 8.6), in which feudal Britain cared for its poor in a monastery, where generous portions of good food and ale are served out as opposed to miserable gruel; where Christian burial was holily observed as opposed to shipping the corpses off to the local medical school; where discipline was administered by a benign abbot who preached to the transgressors as opposed to the mother being snatched from her children and thrust into solitary confinement. And the contrast in masters is even more striking than the contrast in inmates! Pugin is of course satirizing eighteenth-century benignity. His modern poorhouse is a panopticon of the type pioneered by Jeremy Bentham. And, in direct accord with these ideas, the architecture of the medieval poorhouse is a rich and dainty feast of the Perpendicular style, ornate, sumptuous, beautiful: not too different from the new Houses of Parliament, as we shall see in a moment. The panopticon meanwhile is boring, bald, and bad, a Smirke-like building, worthy of its mechanical and uncaring age. Not only Pugin's writing but also his architecture is asso-

8.5. Walterton Manor House in 1830, from Pugin, *Examples of Gothic Architecture* (reproduced in *Architectura* 13.1 [1983], fig. 3).

ciational, and in this plate he has portrayed the associations of his own architecture as opposed to those of a vast eighteenth-century neoclassic structure. The latter presents the power of the modern state. The monastery is feudal. It presents the golden age of Saxon liberties, when social upheaval had not yet produced corruption in the British Constitution.

But I have said that the architectural style of the New Palace at Westminster was to harmonize with the surrounding city. And despite the powerful presence of Westminster Abbey, Gothic presented problems when it was reflected that the palace was to be erected in London. London, as the author of the *Quarterly Review* article ruefully admitted, was by 1831 a classical city, an Italian city, filled with miles of stucco entablatures and columns and, as he put it, "Horizontal lines and storied orders, pedimented windows, and balustered attics."[5] This classicism was particularly powerful in the latest largescale London housing project, John Nash's Regent's Park.[6] The author goes on to admit that it was too late to go against this horizontal, reticulated character by building important structures that exploited the verticalities of Gothic. We should be in favor of the right associations, says the *Quarterly Review*, but also against

the clashing of styles. The answer to the problem was to investigate the very late phases of Engish Gothic, which were reticulated and horizontal like classical architecture.

It is interesting in this connection that the closest stylistic prototype I have found for Barry's building is an essay precisely of this nature—a late Gothic domestic structure, a country house intended to elicit associations with Saxon liberties where "figures of airy elegance or gracious dignity" could once again glide along the spacious walks. It was designed by Charles Hanbury Tracy and erected near Toddington, Gloucestershire. Tracy, moreover, was a moving spirit behind the New Palace at Westminster and head of the parliamentary committee that chose Barry and oversaw construction (figs. 8.7 and 8.8). Notice Tracy's use of a huge square-finialed flat-topped tower as the central anchor of his composition, the articulation of the major corners with one-story turrets, and the compartmented facades of both structures, which form long strings of self-contained Tudor bays.

This then is the Gothic Revival answer to London classicism. Toddington, of course, is a typical country house of its time insofar as its program is concerned. The New Palace at Westminster had a very different program to say the least. It was in reality an early specimen of that omni-

8.6. Medieval poorhouse, A. W. N. Pugin (from Pugin, *Contrasts*).

8.7. Toddington, Glos., 1819, C. Hanbury Tracy (from Port, *Houses of Parlament*, fig. 20).

8.8. Charles Barry's design for the new Houses of Parliament, 1835, elevation of the north front (from Port, *Houses of Parliament*. fig. 30).

present nineteenth- and twentieth-century form that I call the mega-palace. In 1836 the chief spokesman of the associationist school of aesthetics, Archibald Alison, wrote in *Blackwood's Magazine* on this very point:

[The new palace must be built] on a scale suited to the riches and magnificence of the age, and in a style derived from our ancestors, adapted to the Gothic origin and time-worn buttresses of our constitution. . . . [Yet it must be] worthy of being placed beside the noble monuments of St. Petersburg and Paris, in the architectural race of the nineteenth century . . . and worthy of being the palace of the constitution which its authors boast of having effected so great an improvement on the old English government.

Once again we hear the proaristocratic, antipopular tone that runs all through the writings of the Gothic Revivalists, however much they celebrated the Constitution: "Even democratic jealousy will hardly envy the grandeur of the reformed House of Commons; democratic stinginess will not grudge what is laid out on the sovereign palace of the people. Now, then, is the time to adopt a truly princely view of the subject; to erect a work on such a scale of durability as may defy alike the war of elements, the decay of time, and the madness of the people."[7] This was a new attitude. The New Palace must be at once Gothic and comparable to the great palaces of the Continent.[8] And yet what were the associations of those imposing Continental buildings, most erected in the eighteenth-century architectural heyday of absolutism? The answer is easy. They are the same statist associations Pugin found in Bentham's panopticon. The megapalace was ineluctably linked to the nonconstitutional and indeed anticonstitutional rule of the czars, of the emperors, of the Bourbons in France, Italy, and Spain. Britain, the one great country in Europe at that time that had a constitution, was also the one country in Europe whose royal family had no such megapalace. The British royal family in the nineteenth century lived in medieval and neomedieval quarters, for example at Windsor or else in Buckingham House in London.[9] And Buckingham House did not truly become a palace until the twentieth century, when Sir Aston Webb erected the present facade adapted from Vanvitelli.

And even after Webb had done his best, Buckingham Palace remains almost comically picayune compared to the competition. Thus British monarchs all through the nineteenth century were much less grandly housed than many a Continental princeling. This relative architectural modesty well accords with the British monarchs' actual power as opposed to that of the Continental kings. By corollary we can say that a massive neoclassical megapalace in London would have had associations of absolutism that were completely false to the idea of the constitution. That is why Alison called for a Gothic Palace and made it a palace of the people, not of the Crown.

Alison's call for a huge luxurious building might have convinced Charles Hanbury Tracy's parliamentary committee that this was what was

needed. Or they might have come to that decision on their own. At any rate their program left no doubt that they wanted a megapalace whose size and style would proclaim that the British Constitution was still as strong as ever—especially given the Reform Laws being discussed and passed in these years.[10] (One of these laws, the Catholic Emancipation Act of 1829, in fact made it legally possible—and just in the nick of time—for Pugin, a practicing Catholic, to work with Barry on a government job such as this.) Not only were there to be meeting chambers for the House of Lords and the House of Commons but a host of ancillary committee rooms, offices, and the like. The MPs and lords wanted comfort. They wanted the most scientifically advanced heat, ventilation, and bathrooms. They wanted bars and smoking rooms. They wanted libraries and restaurants. And they wanted grandeur—the dignity they hadn't had in the Old Palace. So they wanted spacious lobbies, corridors, and stairs. They wanted security, which meant double and triple traffic circulation systems. And an immense amount of space was needed for robing rooms and chambers for the visits of the king and his entourage. They finally wanted ornament and decor: statues, emblems, frescoes of historic events. Barry said he wanted the building to be "nothing less than a history of England."[11] According to the Utilitarian *Westminster Review*, in fact, what was needed was "a powerful machine of nicest force . . . of wondrous power but composed of a multitude of parts adjusted to a thousand special functions, yet combining for the production of one grand general effect."[12] The author called for a detailed mapping of all the functions to be performed in the building—legislative, bureaucratic, ceremonial, and personal. And then that structure was to rise, designed according to mechanical principles that answered each and every one of these functions. It is perhaps in this spirit that Michael Port has called the New Palace of Westminster the first great modern building.[13]

What prototype could there be for such an extraordinary building? The tradition of megapalaces that Barry and the other competitors inherited was, as noted, an eighteenth-century one, involving neoclassic principles. And those principles, based on regular geometric forms, forced their way through even on odd-shaped sites. Compare Marie-Joseph Peyre's project for the Hôtel de Condé, a prince of the blood be it noted, with Barry's plan for the new Westminster Palace (figs. 8.9 and 8.10). Peyre had preexisting necessities for a raked, roughly trapezoidal set of masses just as Barry did. But look at the difference in treatment. Peyre sets four great symmetrical centers into his buildings: the forecourt, the rotunda, the stable court on the Rue de Condé, and the garden. Thus only the plan, or a bird's eye view, reveals the arrangement's asymmetry. Once inside, or viewed from the outside at street level, Peyre's project would read as a set of solemnly regular geometrical shapes.[14]

But the orderliness, the reason, and the repetitions of the Continent, where architecture is made of squares, circles, and their direct derivatives, were not for Barry. It is not that he allowed existing medieval struc-

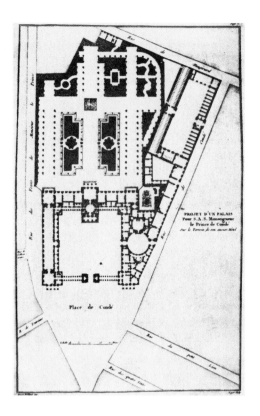

8.9. Project of the Hôtel de Condé,
Marie-Joseph Peyre (from A. Braham,
The Architecture of the Enlightenment,
fig. 108 left).

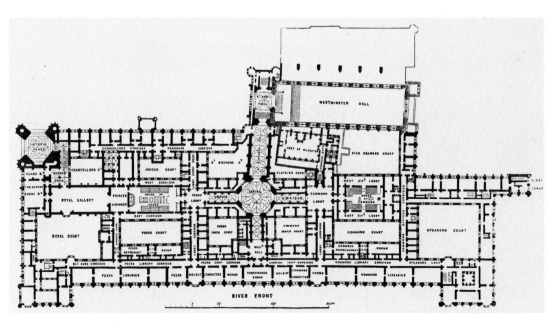

8.10. Houses of Parliament, plan in 1831 (from Port, *Houses of Parliament*, fig. 33).

tures such as Westminster Hall and the cloister court to disrupt his symmetry. It is that he went after asymmetry all the more—asymmetry, the planimetric handmaiden of the Gothic Revival. Thus every single court is a different size and shape and disposed according to no predictable pattern. At every point where the program would suggest that he can be regular and hierarchical, Barry swerved away from the idea. The major feature aside from Westminster Hall, namely the cylinder called the Central Hall, is nowhere near dominant enough by classical standards. And the two houses, of Lords and of Commons, instead of having a symmetry expressive of their different dignities and functions, are simply one large chamber and one smaller one. The clock tower stands in an isolation that, to an Italian or French-trained architect would be anything but splendid, way off in the upper left-hand corner. Pugin's famous remark, that the Houses of Parliament are Tudor on the exterior but "Grecian" in plan (i.e., neoclassical) is incorrect.

I repeat: what prototype, then, was there for this plan? What urban buildings are there that take a basically geometrical palace construct and then bend it peculiarly out of shape as Barry does? The only such buildings I know of are not far to seek, for they are everywhere. They are the classical housing estates mentioned both by the author of the *Quarterly Review* article and by Alison as determining the nature of the New Palace at Westminster, as forcing it to be horizontal and compartmented. Look, for example, at the Ladbroke Estate in North Kensington, dating from

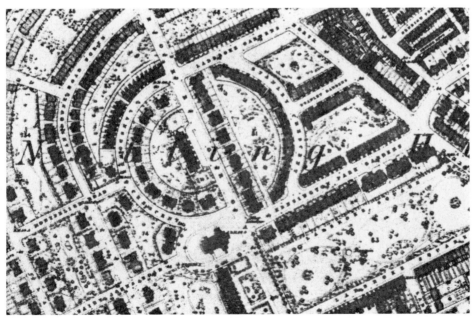

8.11. Ladbroke Estates, London, plan (from Muthesius, *The English Terrace House*, fig. 135 middle).

8.12. Ladbroke Estates rationalized

8.13. Barry's plan for the Houses of Parliament rationalized

the 1840s and 1850s (fig. 8.11). Seen from above, in plan, it has a majestic layout of sweeping curves and overriding symmetries that befit a French neoclassical palace.

But the geometry of the British housing terraces, though called classical by Alison, Pugin, and others, is invariably invaded by a strange, gaptoothed incompletion. Circles are begun and then abruptly bashed in. Axes are madly tilted. A given density is established and, just when it gets going, another density is substituted. But nonetheless all these layouts imply matrices that are perfectly correct; it is just that, once established, the matrix is abandoned (fig. 8.12).[15] I have taken the liberty of making a sketch of the matrix that the Ladbroke architect was breaking with: I now do the same for Barry's plan (fig. 8.13). And I ask, aren't both architects, Barry and whoever it was who masterminded Ladbroke Estate, essentially doing the same thing? Creating an informal, picturesque, interrupted, skewed, dramatic palace layout? It was by combining the broken classicism of the housing estates with Tudor and late Gothic detail that Barry and Pugin created their English megapalace, their reply to the great royal structures of the Continent, their palace of the British Constitution. They achieved this not by adapting the plans of any medieval buildings nor by sedulously avoiding the Continental prototypes; they achieved their masterpiece by adopting and then subverting those prototypes. And that is not a bad way, it seems to me, to elicit associations with the British Constitution and to contrast the picturesque traditionalism of that constitution with the forms of government in vogue on the Continent.

GEORGE BOURNOUTIAN

9. The Arts in Early Post-Revolutionary Russia: The Posters of Vladimir Mayakovsky

The Bolshevik Revolution not only toppled the monarchy and drastically altered the social and economic life in the multinational Russian Empire but also ushered in new artistic currents. As Dickens had said of another revolutionary setting, it was the best of times, it was the worst of times. Civil war, foreign intervention, atrocities, disease, and famine all combined to render the period from 1917 to 1921 as one of the darkest in Russian history. At the same time, the overthrow of autocracy initially produced a new artistic freedom, which, according to some scholars, made this the most provocative and innovative period of Russian intellectual and artistic history.

Men and women who were influenced by the new artistic currents in Europe and who had previously been barred from the art academies and other official art circles of csarist Russia, welcomed the revolution. These painters, sculptors, composers, choreographers, filmmakers, poets, and writers had considered the state of the existing arts stagnant and had claimed that artists should devise new techniques to express the realities of modern life. For a very brief period—for some, a mere four years, for others, as long as a decade—they were permitted to experiment in a wide variety of artistic styles.

Painters and sculptors, no longer restricted by the school of Russian realism,[1] were now free to experiment in cubism, expressionism, surrealism, futurism, and other avant-garde movements.[2] Even architects drafted designs for experimental and futuristic structures.[3] Composers abandoned traditional Russian music and experimented with new forms of operas, ballets, and orchestral music.[4] Choreographers and dancers expressed the revolution and the avant-garde in new movements.[5] Filmmakers, whose art form was recognized by Lenin as the ideal tool for revolutionary propaganda, were given free reign to use every resource the

state could muster.[6] Equally important were those writers, poets, and playwrights who welcomed the revolution as an opportunity to enter the mainstream of literary life in Moscow and Petrograd.[7] Their work was also viewed by the new state as an important tool of political propaganda and, more important, for the conversion of the illiterate masses to the Bolshevik cause.[8] Occasionally a group of young artists, poets, and painters, or filmmakers and composers, would collaborate to produce educational films, revolutionary posters or posters advertising revolutionary films,[9] and political plays.

No one exemplified the idea of the artist as disseminator of the political message of the revolution as did Vladimir Mayakovsky. Mayakovsky saw the revolution as a magnificent cosmic upheaval that resurrected Russia, an apocalyptic event and the dawn of a new era in the history of mankind. Together with a few other poets he had supported the Bolsheviks from the start and had embraced constructivism.[10]

Mayakovsky was born in Bagdadi (now Mayakovsky), Georgia in 1893 to an impoverished Russian nobleman. As a youth he was active in the Social Democratic movement and served a year in prison. After that he abandoned politics for the arts and was active in the Russian cubist and futurist movements.[11] He considered Russian art of the time as pastoral and reactionary and felt that new avenues were required to represent the new century. Like all futurists he ridiculed traditional styles and attacked them in his new and brash verses. Prior to the revolution he joined with others of that group in demanding that art should be free from utilitarian functions and strive for pure aestheticism. The Russian Revolution, however, jolted Mayakovsky's sense of artistic elitism. He not only openly embraced the Bolshevik cause but radically altered his literary style to serve its ends. He began writing in a simpler form aimed at the uneducated masses and no longer at the avant-garde. He founded the Left Front of the Arts (LEF), a radical artistic movement, which attracted a wide range of politically active painters, writers, and other artists. He gave public readings of his works in barracks and factories, versified the revolution for the press, wrote advertisements for state stores, for famine reliefs, and for various official commemorations. His play *Mystery-Bouffe* and his poem *150,000,000* are among the classics of revolutionary literature.

One of the lesser discussed contributions of Mayakovsky to the Bolshevik Revolution were his numerous posters and slogans. They were produced during and immediately after the civil war and were displayed throughout Bolshevik-controlled areas in factories, schools, thoroughfares, and every site of major public gatherings. The posters discussed here are among a group of some 1,000 that were displayed in the windows of the Russian Telegraph Agency (ROCTA)[12] from 1919 to 1921. The revolution and civil war had isolated Russia from the rest of Europe, and all news, domestic and foreign, passed through the agency's lines. Revolutionary newspapers were posted on its walls and it had become, in

effect, a gathering place for the semiliterate and illiterate citizens of Moscow to obtain, read, or be read the news of the national conflict and other events. These posters, produced by Mayakovsky in collaboration with a number of young unknown artists, thus served as the medium through which political messages were transmitted daily to a large number of people who did not have any other source of information from the state.

The posters displayed at ROCTA can be divided into three groups. The first included slogans calling on Russians to aid the new Soviet economy by participating in the labor force, eschewing idleness, and aiding the victims of famine in the war-torn countryside. Increased production quotas and the benefits of cooperation with the new state were depicted in colorful and optimistic messages. Second were political propaganda posters for the Bolshevik cause. These were aimed at the youth, who were encouraged to join the ranks of the Reds and thus become popular among their peers. Labor unions and Bolshevik social clubs were advertized as the solution to loneliness. Third and most important, were the antiroyalist, anti-European and American interventionist and other anti-counterrevolutionary posters. The civil war was winding down and the Bolsheviks needed to muster all their efforts to keep their regime stable and the population content. This last group of posters caricatures reactionary leaders, criticizes or satirizes British and American heads of state, and attacks all capitalists. They warn against spies and call on Russians to be on guard against betrayal. The artwork and captions are extremely simple and aimed at the uneducated. The contrasts portrayed in these posters are sharp and clearcut: the man in the streets pitted against rich aristocrats; brawny Russians versus weak and inbred-looking foreigners. They sounded a warning that if the old regime regained power all privileges of land ownership and production would be lost and workers and peasants would revert to their previous status. Peace, a bright economic future, full employment, free medical care, and schools were all optimistically promised.

The six posters reproduced here illustrate some of the political messages disseminated by means of this new and collaborative art form. Poster number one reads: "The weapon of the *Entente* is money by which the Whites were armed and stabbed the Mensheviks in the back. [Read] *Pravda*, open your eyes [death to the bourgeoisie] and that will be arms for the communists" (fig. 9.1). This poster exemplifies the simple style of both art and language used to transmit the message of Bolsheviks to even the least educated. The *Entente* is portrayed as Uncle Sam since the United States was (after 1917) the main power of the *Entente* and, as epitome of capitalism, the natural enemy of communism. The White is portrayed in the garb of a Ukrainian-Polish landed nobility rather than as a Russian. It is interesting to note that at this stage the Mensheviks are seen as victims of counterrevolutionary activities and are still within the ranks of the government hierarchy.

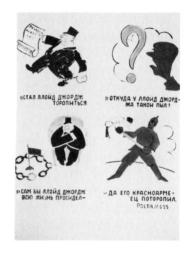

9.1. ROCTA poster no. 332, July 1920

9.2. ROCTA poster no. 443, Oct. 1920

9.3. ROCTA poster no. 625, Nov. 1920

Poster number two reads: "The baron sneaks in. The baron's gang sneaks in. Get lost baron! [Black Sea]. Get lost baron's gang [kicked out by the red boot of the Bolsheviks]" (fig. 9.2). Once again, political ideas are blended with historical events. The "baron" is a caricature of counter-revolutionary leaders of the Ukraine area and of the Rothschilds, who had prerevolutionary oil concessions and who were seen as backing the "rebels" in the Black Sea region. A hint of the atrocities committed by Whites against Reds is suggested by the blood dripping from the baron's dagger and by the gallows in the hands of his businesslike "gang."

Poster number three reads: "Lloyd George is worried. Why is he worried? Lloyd George would rather relax. But what makes him uneasy is the Red Army Soldier" (fig. 9.3). This poster reflects the efforts of the West to isolate the new Russian Soviet Federated Socialist Republic and "enchain" it.

Poster number 4 reads: "Hail to the Third Year of Soviet Rule which was Commemorated in October. The peasant should be happy in October. Why? What has the October Revolution given him? Before the October Revolution peasants sowed 76.3% of the land. But the landlords owned 23.7% of the land. On the peasants' portion millions could barely feed themselves. But on their portion the landlords became fat. After the October Revolution 98.8% of the land went to the peasants and to the landlords nothing. The state farms and the government gained 3.2% additional produce. The answer is clear. . . . For the peasant Red October is a holiday"[13] (fig. 9.4).

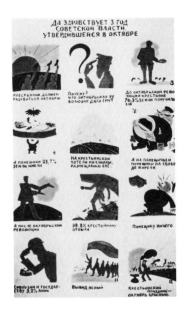

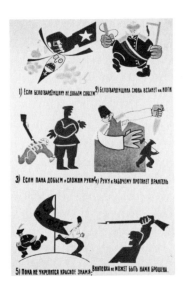

9.4. ROCTA poster no. 742, Dec. 1920

9.5. ROCTA poster no. 791, Dec. 1920

9.6. ROCTA poster no. 884, Jan. 1921

Poster number 5 reads: "If we do not crush the White menace completely, it will rise again. If we defeat the landed nobility and do nothing further, then Wrangel[14] will raise his hand against the worker. Until Red Rule is firmly established, we can not throw away our guns." By December of 1920, the civil war was, for all intents and purposes, over. This poster is intended to remind the Russians that constant vigilance was still vital to ensure the survival of the infant state (fig. 9.5).

Poster number 6 reads: "Red and Black. [On black board: "Ivanov the Slothful"] If you are on this board, die in loneliness. [On the red board: "Ivanov, Hero of Labor"] But if you are on the red board, smile like the clear day" (fig. 9.6). Since the civil war was over by this time, other socioeconomic concerns now came to the forefront and were addressed in the last of the ROCTA poster series.

The end of the civil war and the introduction of the government's New Economic Policy (NEP) in 1921 saw the slow stabilization of the country as new regulations began to be imposed. Artists who had been permitted to express their support of the revolution through a variety of unorthodox ideas and forms found themselves slowly restricted. On the other hand, traditionalists, who were on the whole apolitical and who still constituted the majority of the country's art establishment, were now encouraged to lend their talents to the new state. Conditions worsened after the death of Lenin in 1924. Until 1929, however, some degree of freedom continued. But thereafter, under Stalin, all free expression ceased and only artistic formulae sanctioned by the state were acceptable. Those

artists who abandoned their individual style were permitted to function;[15] those who did not were ostracized or blacklisted. Some of the disfavored turned to alcohol, were imprisoned, died forgotten, or committed suicide,[16] and a few were even executed.

Mayakovsky was no exception. He became isolated and came under increasing attacks from orthodox writers. His last works, the plays *The Bedbug* and *The Bath House*, concern the betrayal of the revolution by its self-appointed officials. Depressed by these and other personal problems, he committed suicide in 1930. Ironically, it was Stalin who rehabilitated his works in 1935, declaring that "Mayakovsky was and remains the best and most talented poet of our Soviet epoch" and that "indifference to his memory and works is a crime."[17] From that date Mayakovsky's style was imitated, numerous statues erected to his memory, and streets named after him. His works were republished and continue to be read to this day.

GAIL HARRISON ROMAN

10. Tatlin's Tower:
Revolutionary Art
and Life in Russia

Vladimir Tatlin's Project for a Monument to the Third International was designed in 1919–1920 under a commission granted by the People's Komissariat of Enlightenment (fig. 10.1). This design represented major trends and goals of the Russian avant-garde and early Soviet officialdom: a prominent landmark, a technological and industrial society, progressive urbanization, and international communism. Tatlin's "monument" is more fantasy than rationale, more utopian than practical. But it is just these contradictions that characterized the quixotic and frenetic activity in Russian art during the teens and twenties, that is, the decades more or less surrounding the revolution of 1917. The symbolic content of this project can be viewed on many levels and can especially be taken as a paradigm of Russian revolutionary thought.

With the assistance of several colleagues, with whom he formed the so-called Creative Collective, Tatlin developed and erected a model in a studio in Leningrad in 1919; the model was subsequently rebuilt for exhibition in 1920 at the Eighth Pan-Russian Soviet Congress in Moscow. The model, based on two drawings and composed of wood and netting, was 5 meters high, one-eightieth of the proposed full height of 400 meters in iron and glass.

Commonly referred to as the Tower, this projected building was to be composed of four thermal glass enclosures supported within a complicated framework of spirals, curves, and diagonals. The lowest section was designed in the shape of a cube and was to rotate on its axis one revolution per year. Its function was legislative: to house international communist congresses and meetings. The second section, in the form of a pyramid, was to turn on its axis one revolution per month and was to serve as an administrative center for the International Proletariat, including its Executive Committee and Secretariat. The third section, cylindrical in shape, was to turn at the rate of one revolution per day and was to serve as a propaganda center that would house an information bureau, a news-

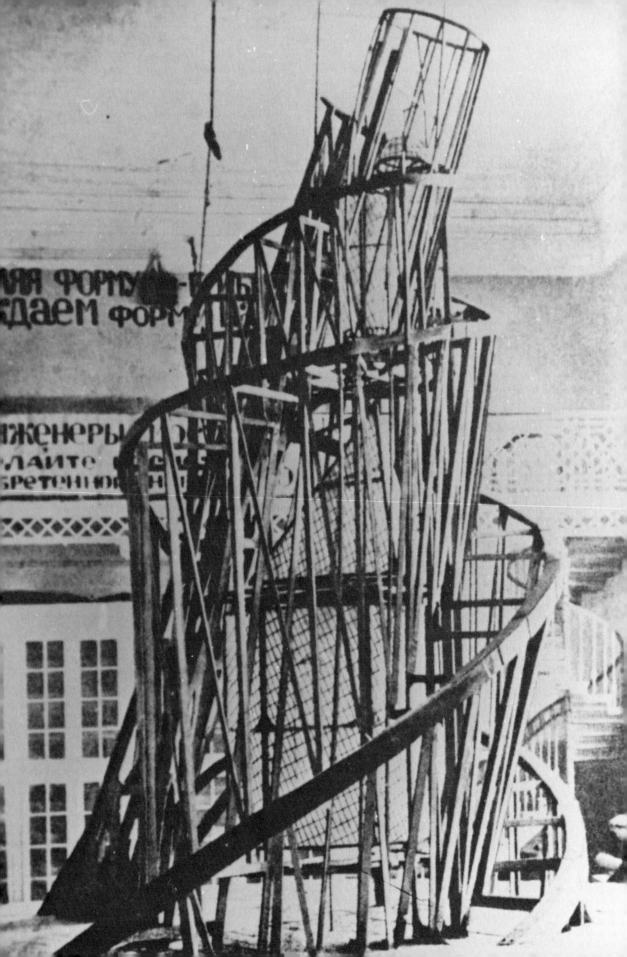

paper agency, and multilingual publication facilities for proclamations, brochures, and manifestoes. It also was to utilize its own radiotower, telegraph apparatus, and a projector for use with a screen that could be suspended out into the public domain at the bases of the hemispherical chamber above. This fourth section was to rotate at the rate of once an hour and would have provided auxiliary services for the propaganda center just below. The sections within the Tower were to be joined by electric lifts adjusted to the differential speeds of the various chambers. The rotations of the chambers within the Tower were to be accomplished by a transmission system between wheels of different sizes, corresponding proportionately in size and speed to each chamber.

As the Tower's base was to span the Neva River in Leningrad (still the capital city in 1920), the motor would have had to be located deep underground, beneath the riverbed, or far below its shores, on one or both sides. All these are technical details that Tatlin did not work out in advance of creating the model for this project—and the opportunity never was presented for him to transform his utopian vision into reality. Furthermore, discrepancies between Tatlin's drawings for the Tower and between the drawings and the model also suggest that his original plan was inadequate for construction. Accommodations apparently had to be made during the erection of the model, and these were no doubt offered by the other members of the Creative Collective. Sadly for Tatlin, the Russians lacked the technological capability for, and also the stylistic commitment to, the Tower. Disagreement about the nature and purpose of art, coupled with a lack of materials and technical expertise, however, in fact served Tatlin's advantage. Because his imagination was excited by the promises of the revolution for art and society, he gave free rein to his fantastic designs and ambitions. Typical of the utopian vision and thought that characterized the Russian avant-garde, Tatlin believed that the engineering problems would somehow be resolved by the logic of his design, and he went so far as to postulate versions of the Tower to stand in various river-cities throughout the Soviet Union, again without any specific technical plans.

In devising the Tower's large scale, Tatlin was proposing a prominent Soviet landmark. His Tower is reminiscent of the Eiffel Tower, which has frequently been cited as one of Tatlin's modern industrial sources. Similarities of size, shape, material, and the radiotower function come to mind. In fact, the scale of the Tower was calculated to provide an unstated competition with the Eiffel Tower; Tatlin planned his Tower to rise 400 meters above the River Neva in Leningrad, fully 100 meters higher than the Eiffel Tower. Tatlin's friend, the poet and posterist Vladimir Mayakovsky, voiced the early Soviet attitude toward the Eiffel Tower in 1923 in his poetic exhortation entitled "Paris." Calling for a revolt against

Opposite. 10.1. Project for a monument to the Third International: model (1920), Vladimir Tatlin; original destroyed.

the decadence of the French city, Mayakovsky invited the Eiffel Tower to the U.S.S.R.:

> Come, Tower!
> To us
> You—here
> Are much more needed!
> Steel-shining, smoke piercing,
> We'll meet you.

By summoning the Eiffel Tower to Moscow, Mayakovsky metaphorically expressed his compatriots' vision of a new technological society supplanting the worn-out relics of Old Russia. Mayakovsky's poem was not only a criticism of the decadence and alienation of Paris but also a yearning for a symbolic landmark. Had Tatlin's Tower actually been erected in 1920, Mayakovsky's "mission" to the Eiffel Tower might have been unnecessary.

An especially important symbolic meaning of the Tower was its use of industrial materials, such as iron and glass. These materials represented his country's desire to join the mainstream of the technologically-developed Western world and to close the gap between their country and the West by asserting their fledgling industrial and technical capability. Nikolai Punin, Tatlin's biographer and the chronicler of the Tower, referred to iron and glass as elements of the "new classicism," claiming:

10.2. *Corner-relief*, c. 1915, mixed media, Vladimir Tatlin; original lost.

Before our eyes, the most complex of problems of culture is being resolved: the utilitarian form is the purely creative form. Classicism has again become possible, not as a rebirth but as an invention. The ideologues of the international workers' movement long sought the classical content of Socialist culture. Now, it appears (i.e. in Tatlin's Tower). We assert that the present design is the first revolutionary work that we could send to Europe.[1]

The geometric forms of the Tower were chosen in part for their simplicity and seeming practicability as architectural elements; they also represented the tendency in art toward geometric abstraction that had been developing since the beginning of the century both in Russia and the West, notably in Tatlin's relief's of the mid-teens (fig. 10.2). Tatlin's version of this style was called constructivism. It placed a unique emphasis on an analytic approach to material and a utilitarian (or "productivist") application of art. Tatlin encouraged an art based on the "investigation of material volume and construction," which he credited with enabling him, "in an aesthetic form, to begin to combine materials like iron and glass."[2] His desire was to make art an indispensable element of everyday living. He sought, therefore, in his own words, to unite "purely artistic forms with utilitarian inventions in our work of creating a new world, and which call upon the producers to exercise control over the forms encountered in our new everyday life."[3] Above all, Tatlin expressed the prevailing revolutionary notion that aesthetic and practical form must be combined in an

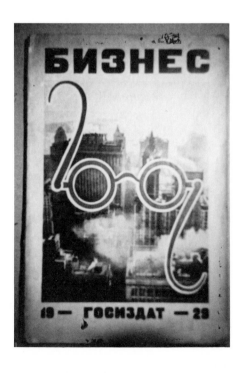

10.3. Cover of *Biznes* (1925), photomontage, Alexander Rodchenko.

art and architecture that would interest, inspire, and serve the proletariat. His particular contribution was to be a monument to the triumph of communism in Russia, with all the attendant hopes and excitement engendered by the revolution.

The dynamism and motion of the Tower were associated with the progressive urbanism that characterized Soviet planning during the revolutionary period. Tevel' Markovich Shapiro, the surviving member of the Creative Collective, relates that artists and architects were inspired, for instance, by the forms of construction cranes rising above Moscow.[4] These represented not only new building programs but also, by corollary, the building of a new society. The city was another symbol of the modern industrial world. Inspired by the urban-enthused futurist artists and writers of the teens, Tatlin and his contemporaries were thrilled by the excitement, movement, and noise of the urban environment. The roar of industrial mechanisms—factories, vehicles, airplanes—was for Tatlin and the other avant-gardists evidence of a "modern messiah" in Russia. Both the form and intention of the Tower embodied the technological and efficient mode of the twentieth century industrialism toward which the young Soviet Union aspired. It was not, however, the urban industrialism of western Europe, because the Russians considered that to be decadent. Mayakovsky's poem, "Paris," is just one proof of this attitude.

Initially the Russian avant-garde looked to America and especially to New York City as an example of a progressive urban technological environment, as illustrated by Alexander Rodchenko's photomontages (fig. 10.3).

Tatlin was not the only one to express such popular currents in his work. Of particular note was the Vesnin Brothers' use of visible moving elements in their 1923 Project for the Leningrad Pravda Building (fig. 10.4), which was more or less an "industrial product" containing mobile parts that were to operate on the building's exterior, including a red flag, a searchlight, a large clock, and a rotating billboard. These elements represented twentieth century technology while they also illustrated early Soviet "propagandistic decoration" of the urbanscape. There was also a *pater noster* elevator (that is, one that never comes to complete stop but moves slowly enough for entry and exit) that could be seen from street level. By not interfering or competing for visual attention with these moving parts, the transparent facade became their ideal counterpart: the exposed view through the extensive areas of glass allowed for "participation" of the interior in the overall impression of the building, while reflections in the glass from the outside added to the already "lively" facade. Therefore, this building incorporated the city itself in these reflections while the visible activity of the Pravda offices within represented the same hustle-and-bustle of the city around it. The workers within and the passersby without thus became part of the "life" of this building, integrated visually with the structural members of glass and iron. The labor of the Pravda employees and machines at the same time became an integral part of the structure. This design recalls Tatlin's revolutionary goal that a

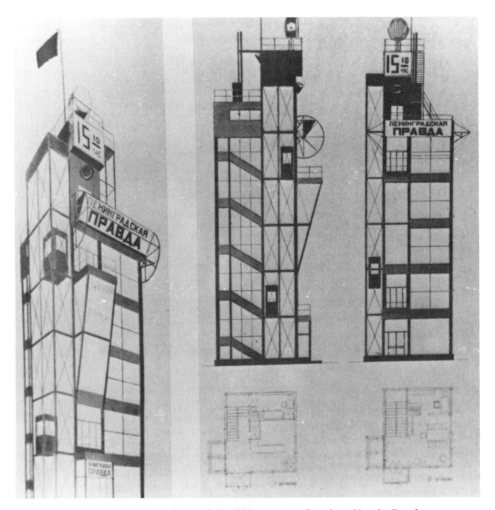

10.4. Project for the Leningrad Pravda building, 1923, drawing, Vesnin Brothers.

monument should represent the life of a city, and it also brings to mind the critic Victor Shklovsky's comment that the Tower used the Council of People's Komissars as artistic material and, as such, was composed of "iron, glass, and revolution."[5] Clearly, the Vesnin Brothers joined Tatlin in an appreciation of technology, especially dynamics. Their Pravda building design also represented an attempt to expand on Lenin's 1918 call for Monumental Propaganda. Although Lenin's plan originally called for heroic portrait sculpture, artists, architects, and designers extended it to the creation of works that would alter the Sovietscape with boldly designed forms that would provide both information and inspiration for the new country. These works expressed *agit-prop* (an abbreviation for "agitational propaganda") and functioned as posters or street murals. It was in the field of architecture that the *agit-prop* programs especially failed. Aside from a lack of stylistic agreement, economic and technological

limitations in the early Soviet Union inhibited the realization of many projects. Architects and designers, however, persevered, producing synthetic and imaginative—often fantastic—architectural schemes that were sometimes as adaptable to architecture as to sets for the theater or mass spectacles.

With this activist and sometimes utopian goal of transforming society, artists turned less to the fine arts than to *agit-prop* during the revolutionary period, seeking economic, social, and cultural expression in posters, books, periodicals, and street decoration, as well as in domestic and industrial design (fig. 10.5). The first "official use" of these aesthetic principles occurred in 1918, during the first anniversary celebration of the revolution, which announced on a grand scale the implementation of Lenin's Program of Monumental Propaganda. This program called on a Council of People's Komissars to replace the "hideous idols" of the monuments erected in honor of the csars with "new (decorations) reflecting the ideas and sentiments of the revolutionary working populace of Russia."[6] While Lenin was not specific about all the forms of this new propaganda, he selected cultural and political heroes of the past as subjects for large-scale statues. In general, however, his summons was interpreted as a call for new, nontraditional art forms that would commemorate the great revolution that was to transform Russia. Monumental Propaganda served several purposes: (1) it reminded the citizenry of its recent heroic struggles; (2) it boosted morale in the face of postwar privations; (3) it inspired confidence in new programs and products; and (4) it aimed also at transforming the physical environment—with the ultimate (and utopian) goal of transforming the sociopolitical environment as well.

The decoration of Leningrad was undertaken specifically in celebration of the first anniversary of the October Revolution, in the autumn of 1918. The whole city of Leningrad (then called Petrograd) was decorated with paintings, murals, posters, broadsides, and sculptures, with an apparent emphasis on the latest developments in style. Mayakovsky's exhortation to artists about their new role summarized the excitement of the artistic revolution:

> Enough of cheap talk!
> Wipe the old from your hearts!
> The streets are our brushes!
> The squares—our palettes![7]

The focus of the Petrograd decoration was the Alexander Column, originally constructed in 1822 in the large square of the Winter Palace, which had been a target of the revolutionary forces in 1917. Nathan Al'tman was commissioned to incorporate the column into the citywide event, and his avant-garde concept and design were by far the most impressive and innovative contributions to the whole celebration. He constructed a multistepped tribune around the base of the column, staggering squared-off sections around each of the four corners. Hollow cubes

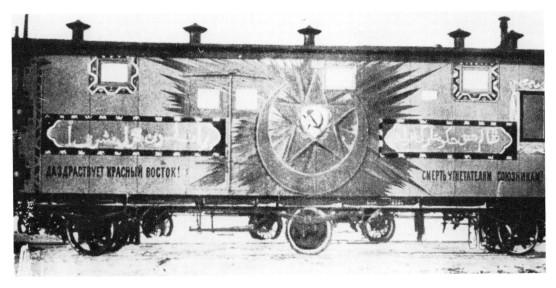

10.5. Agit-ship, anonymous artist, 1920.

with projections inside were mounted at each corner, and revolutionary
slogans on banners and placards were suspended out from the staggered
angles. A series of steps and platforms was placed on the sides between
the corners; the shaft of the column was adorned with colored cloth
panels cut into rhomboid, elliptical, and spherical shapes; and the entire
column was illuminated, according to Tatlin's design, throughout the long
nights. Even the illiterate sections of the population could understand the
propaganda message: the czarist symbol—the Alexander Column—had
been conquered and thereby transformed by new forms. These forms
were nonobjective, but their visual power enabled them to function as po-
litical symbols in this context. They also referred to recent movements in
Russian art: the cubic volumes referred to suprematism and construc-
tivism, while the colored cloth panels referred to the geometry of cubo-
futurism. These geometric forms had become associated with the "leftist"
artists and, by corollary, with the Bolshevik faction of communism. The
cloth panels, in red, yellow, orange, and vermillion, appear as flames on
the Alexander Column, at once symbolizing the destruction of the old
order and the fervor of the new.

One ironic footnote exists in the instructions given to the planning
committee of the 1919 revolutionary celebrations: "Under no circum-
stances let the design or execution fall into the hands of the 'perpetrators'
of 1918."[8] However, by 1920 the mood had shifted again and even more
startling projects appeared, bearing witness to the aesthetic confusion that
especially characterized Russia during the civil war period of 1918–1920.
One most noteworthy design of the period was Tatlin's Tower, which in-
spired a whole genre of visionary projects.

Like the decorated Alexander Column and the Tower, theatrical designs for mass festivals were also planned as part of the Monumental Propaganda program. One such work of 1919–1920 was the design for *Struggle and Victory* (fig. 10.6), to have been performed under the direction of Vsevelod Meyerkhol'd at an anniversary celebration of the revolution. A contemporary account provides us with the background for this unrealized performance:

Two hundred riders from the cavalry school, two thousand, three hundred foot soldiers, sixteen guns, five aeroplanes with searchlights, ten automobile searchlights, several armored trains, tanks, motorcycles, ambulance sections, detachments of the general recruiting school, of the associations for physical culture, the central directions of military training establishments were to take part, as well as various military bands and clubs. In the first five scenes the various sections of the revolutionaries were to have combined to encircle the capitalist fortress, and, with the help of artillery corps, to surround it with a curtain of smoke. Concealed by this dense screen, the tanks were to have advanced to attack and storm the bastions, while the flame throwers were giving out an enormous fireball of changing outline. The silhouette of the illuminated smoke would finally have represented a factory with the watchword of the fight inscribed on the walls: "What work has created shall belong to the workers." After a great parade of troops, the gymnastic associations on motorvans were to have shown the people of the future engaged in throwing the discus and gathering the hay into sheaves. Then a general dance, with the motto "Hammer and Sickle," was to introduce motions representing industrial and agricultural work, the hammer bearers from time to time crossing in a friendly way their instruments with the sickles of the other group. Rhythmic movements performed by the pupils of the public training schools were to have symbolized the phrase: "Joy and Strength— the victory of the creators:" now nearing, now retreating from the tribunal, they were finally, in conjunction with the troops, to have been effectively grouped in the "city of the future." The final items of the performance were to have been provided by a display of flying aeroplanes, with searchlights, fireworks, and a great choral singing, accompanied by orchestras.[9]

The constructivist theater set designed by Liubov' Popova and Alexander Vesnin for this mass festival production of *Struggle and Victory* included contrasting forms for the opposing forces: the "capitalist fortress" was to be the compact and irregular mass at the lower left: the victorious "creators" (workers) would occupy the "city of the future," located at the lower right, with antennae, cranes, and other industrial-technological apparatus. Like Tatlin's Tower, this design also included facilities for the Komintern: the Komintern here was to operate from two air-vessels whose mooring wires would carry multilingual slogans declaring "Long life the Third International!" The original commission had called for *Struggle and Victory* to be staged as part of the celebrations that accompanied the Third World Congress of the Communist International (convened in Moscow from June 22 to July 12, 1921), but the massive dimensions and the requirement for a "cast of thousands" including armed military personnel made the production impossible at the time.

Perhaps the formal element of the Tower's design that has received the most critical attention is the spiral. The spiral elements of Tatlin's Tower have various prototypes in architectural history,[10] but Tatlin's use is quite specific and unique. As Punin explained, the spiral provided an escape from the earth along the tightest and speediest lines known; it is full of motion, aspiration, flight. Extending this metaphor, Punin cited the spiral's significance for Tatlin and his contemporaries: it was "the line of movement of liberated mankind. . . . The ideal expression of liberation; digging its heels into the ground, it flees from the earth."[11]

Thus, the spiral provided the implied means for overcoming gravity; in its serpentine motion, it coiled up—almost mechanistically—from the earth toward the heavens. All this dynamism is contrasted to the horizontal line of motion that Punin claimed to represent the classical static world, in which class-conscious societies struggled for possession of territory. Whereas the horizontal represents stasis, the spiral represents dynamism.

An association with international communism can, I believe, properly be cited as an element of the Tower's political symbolism, for but the symbolism of the Tower of Babel and its archaeological counterpart, the ziggurat, should also be cited. The Citadel of Sargon II, built during the eighth century B.C. and known today through reconstruction, was particularly relevant here. Tatlin's contemporary, Lissitzky, actually referred to Tatlin's Tower as an "ancient formal construction, manifested, for ex-

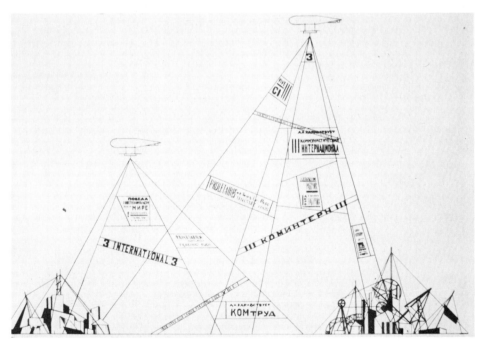

10.6. Design for *Struggle and Victory*, 1920–21, Liubov' Popova and Alexander Vesnin.

ample, in Sargon's pyramid at Khorsabad, (which) has here been re-created in a new material and given a new content."[12] The convoluted, stepped design of ancient Near Eastern ziggurats may have suggested to Tatlin a building design based on gradually rising levels, but whereas the ziggurat's form was squared at the edges, Tatlin's Tower rose on a double set of spirals along a diagonal axis, with the choice of spiral and diagonal elements determined by the following factors: futurist-inspired ideas of movement; the universal symbolism of these forms—aspiration, energy, dynamism; and various mechanistic and mathematical prototypes.

But above all, Tatlin's Tower should be seen as a metaphorical response to the biblical Tower of Babel, which according to Genesis II was erected "with its top in the heavens" by all humankind united as one race with a common language and purpose. Lest this be "only the beginning of what they will do," the legend continued, and lest "nothing they propose to do will now be impossible for them," the Lord halted the erection of the Tower of Babel by confusing the builders' common speech into various tongues and then scattering them across the face of the earth. Thus, the Tower of Babel has come to symbolize the cultural and historical divisions among peoples and nations. Tatlin's Tower was designed to house the Third International; to hail the triumph of communism in Russia; and—according to one interpretation of communist ideology—to proclaim the Russian Revolution as the first step toward international communism. In fact, Tatlin's Tower was specifically designed for international uses, such as multinational congresses and the worldwide dissemination of propaganda. Just as the Tower of Babel symbolized the original division of the peoples of the world, the Monument to the Third International was to symbolize the reconciliation of all nations—under the banner of communism. The rallying cry of the Soviet communists during the 1920s was, after all, "Proletariat of all nations, unite!"

The formal opposition of the massive, static ziggurat—like Sargon's citadel—and the open, kinetic Tower reinforced the contrast of retrograde political ideas and progressive ones. Again it was the opposition of static horizontal forms and dynamic diagonal or spiralling ones. Whereas the biblical Lord sought to deny unlimited power to humankind, the Russian revolutionary seems to have adopted as a Promethean credo Leo Shestov's philosophical statement: "Only one assertion has or can have objective reality; that nothing on earth is impossible."[13] The Babel symbolism had been expressed by Mayakovsky as early as 1915 in his anti-czarist poem, "A Cloud in Trousers," in which he wrote:

> In our pride
> We raise up again
> The cities' towers of Babel,
> But God,
> Confusing tongues
> Grinds
> Cities to pastures.

Thus, Mayakovsky recognized the retrograde, antiurban effect of the old order. He concentrated on the urban milieu because it signified to him— as it did for so many members of the Russian avant-garde—the potential for a progressive, technological society.

The Tower's international symbolism and proposed functions seem to have foreshadowed the political controversy over "Socialism in one country" that arose in the Soviet Union following Lenin's death in 1924. Briefly stated, this conflict was waged by three factions: the Left, the Center, and the Right. The Left, led by Leon Trotsky, considered world-revolution necessary for the survival of socialism in the U.S.S.R. The Center, under Joseph Stalin, supported consolidation of power within the country and called for a massive socioeconomic transformation of the Soviet Union. The Right, supporting Nikolai Bukharin, agreed in principle with the Left, but its militancy was tempered by the harsh political and economic exigencies that caused them to accept Stalin's compromise measures, including relations with the bourgeoisie abroad and support of the New Economic Policy of limited capitalism at home. Although the various arguments did not crystallize until the mid-twenties, these had been crucial issues for Russian revolutionaries since early in the century.

Reactions to Tatlin's Tower were mixed, but in the Soviet Union condemnation won out over praise. Its awkward mechanism and clumsy appearance were harshly criticized, especially in comparison to the Eiffel Tower. Trotsky, for example, held this view, although he did approve of Tatlin's innovative use of geometric forms and industrial materials. What is surprising, however, is that Trotsky did not welcome the Tower as an expression of his own international ambitions. While Lenin found the model "interesting," he was concerned with the pragmatic considerations of a massive monumental and agitational program of propaganda. Stalin's reactions to the Tower do not seem to have been recorded, but his taste for massive, monolithic, quasi-baroque architecture is so well-known that one can extrapolate for him a negative opinion of the Tower. During the 1920s, the Tower could not be constructed because of material shortages, technological limitations, and socio-artistic controversy. By the time the Soviet Union had mobilized its construction industry and advanced to greater technological capabilities, however, Social Realism had been declared and, although the political axe did not fall specifically on architecture until 1937, the die had already been cast. Despite the immediate practical reasons for the ultimate failure of Tatlin's Tower, its form was too abstract, its plan too complex, and its symbolism too variable for it to have succeeded in a society in the throes of revolution and transformation.

BARBARA L. TISCHLER

11. Modernists and
Proletarian Music:
The Composers' Collective
of the Early 1930s

It comes as no surprise that there exists in the United States a
long tradition of workers' music. The very nature of manual labor con-
tributes to the creation of music that adds to the work process itself
through its rhythmic articulation. Such pieces often also add to the cul-
ture of the working class in their descriptions of life and labor, specifically
of the relationship of labor to capital. The picket line, with its "make up a
new verse to fit the situation" approach to composition, has provided
countless examples of the folk process as inspired by industrial capi-
talism. The music of a strike was almost always music that workers al-
ready knew, and the purpose of the Industrial Workers of the World's *Red
Song Books*, for example, was to provide revolutionary texts to songs
which were accessible. Pieces like "The Star Spangled Banner," "The
Battle Hymn of the Republic," "O Tannenbaum," and "Just Before the
Battle, Mother" were transformed to meet the needs of labor protest.
Rarely did a composer of art music add to the literature of proletarian
music in this country. Workers made their own strikes, and they sang
what they perceived to be their own songs.

But in the early 1930s, several American composers who had studied
in Europe and previously confined their efforts to writing music for the
concert hall turned briefly to the music of class struggle. Many of these
composers were highly skilled modernists, while others appear to have
had more political fervor than contrapuntal expertise. The work of the
Composers' Collective provides an interesting example of the interaction
of the musical message of the avant-garde with the political needs of the
working class.

Many of the composers who would become members of the Collec-
tive had studied the most current trends in "new" music in Europe in the
decade following World War I. Even the best known among them had

never made a popular success of his ventures into modern music in the 1920s, but the stock market crash and the ensuing depression placed composers in dire economic straits in the same way that it affected most Americans. The desire to have one's music heard and put to some practical use, along with the dramatic shift in economic and social realities, encouraged a new perspective on the role of the American composer in society and on the potential for music to contribute to social change.

For many artists, a heightened interest in the social and political environment of the early depression years brought forth an awareness of the future possibilities defined by the American Left. Many American composers had found themselves at a distance from audiences that had little interest in or understanding of the modern musical idiom, even when that idiom claimed to incorporate popular music, as in the case of Aaron Copland's cerebral approach to jazz in the late 1920s. A few modern composers felt that they could best reach a large audience by participating in the activities of the Left. They wrote articles for *New Masses*, composed songs for political events, and entered song competitions sponsored by the Communist party or one of its affiliated groups, even as they continued to write in the modern styles they had learned in Europe.

American left-wing political music in the early 1930s reflected the philosophy of the Third Period, which advocated international class struggle over national cultural expression. The absence of good workers' music to further that struggle prior to the formation of the Composers' Collective was lamented by Mike Gold, who wrote in 1931 that "there are no new workers' songs and music being written in this country."[1] Two years later, he asked, "Why don't American workers sing? The Wobblies knew how, but we still have to develop a Communist Joe Hill."[2]

In 1931, New York's John Reed Club set out to remedy the lack of workers' songs by forming a music committee whose goal was "the creation of songs expressing and projecting the class struggle."[3] In June of the same year, the Workers' Music League, the music section of the Workers' Cultural Federation, which called itself "the central organization of all musical forces connected with the American revolutionary working class movement," was founded for the purpose of providing "ideological and musical guidance" to groups involved in the class struggle.[4] The league's leadership in its composition, publishing, and performance divisions came from the Pierre Degeyter Club (the musical counterpart of New York's literary John Reed Club) and adopted as its slogan "Music for the Masses." The league's *Red Song Book*, published in 1932, contains music that workers would be likely to know, including such pieces as Degeyter's "The Internationale," "Red Marching Song," whose tune was derived from the last movement of Beethoven's Ninth Symphony, and the traditional "Hold the Fort" and "The Preacher and the Slave," both of which had previously appeared in the *Red Song Books* of the Industrial Workers of the World. Lan Adomian, Hanns Eisler, and several anonymous composers also contributed pieces to this small volume. Most of the

music is quite easy to sing, and there is little modernist influence in these works, which are mostly derived from the German and Russian marching songs and the American folk song traditions.

The Composers' Collective emerged out of the Workers' Music League in February of 1932 as a workshop for the creation and performance of revolutionary music and as a forum for discussion of how modern music could be used to further the workers' cause. The Collective described itself as a group in which "conservative and radical musical thought and taste meet in free and vigorous clash upon the question of the definition of a musical style 'national in style, proletarian in content.'"[5] The diversity of compositional points of view is amply illustrated in the Collective's membership, which included at various times Henry Cowell, George Antheil, Lan Adomian, Charles Seeger, Jacob Schaefer, Wallingford Riegger, Elie Siegmeister, Marc Blitzstein, Max Margulis, Herbert Haufrecht, and Aaron Copland. While most Collective members did not belong to the Communist party, that organization did offer loft space, opportunities for performance, and political inspiration. A synthesis of proletarian content and modern musical style can be heard in Elie Siegmeister's "Strange Funeral in Braddock," after a poem by Michael Gold. The song is dissonant and very difficult to sing. This was music for workers to listen to and learn from but not to sing themselves. The text expressed outrage at the death of Jan Clepek, a Bohemian steelworker, in the Pennsylvania mills. "Strange Funeral in Braddock" provided a message for workers, but later works by Siegmeister and other Collective participants would serve the class struggle more directly as vehicles for protest.

Strange Funeral in Braddock

words by Michael Gold *music by Elie Siegmeister*

Listen,
Listen to the drums of a strange American funeral.
Listen to the story of a strange American funeral.

In the town of Braddock, Pennsylvania,
Where steel-mills live like foul dragons, burning, devouring man and
 earth and sky,
It is spring. Now the spring has wandered in, a frightened child in the
 land of the ogres.
And Jan Clepek, the great grinning Bohemian, on his way to work at six
 in the morning.
Sees buttons of bright grass on the hills across the river, plum-trees
 hung with wild white blossoms.
And as he sweats half naked at his puddling trough, a fiend by the lake
 of brimstone.
The plum-trees soften his heart, and
The green grass-memories return and soften his heart,

And he forgets to be hard as steel and remembers only his wife's breasts,
his baby's little laughter,
He remembers cows and sheep, and the grinning peasants, and the
villages and fields of sunny Bohemia.

Listen to the mournful drums of a strange funeral.
Listen to the story of a strange American funeral.

Wake up, wake up! Jan Clepek, the furnaces are roaring like tigers,
The flames are flinging themselves at the high roof,
Wake up! it is ten o'clock and the next batch of flowing steel is to be
poured into your puddling trough,
Wake up! Wake up! for a flawed lever is cracking in one of the fiendish
cauldrons,
And now the lever has cracked, and the steel is raging and running like
a madman,
Wake up! Oh, the dream is ended, and the steel has swallowed you
forever, Jan Clepek!

Listen to the mournful drums of a strange funeral.

Now three tons of hard steel hold at their heart the bones, flesh, nerves,
the muscles, brains and heart of Jan Clepek,
They hold the memories of green grass and sheep, the plum-trees, the
baby-laughter, and the sunny Bohemian villages.
And the directors of the steel-mill present the great coffin of steel and
man-memories to the widow of Jan Clepek, with many mournful
speeches.
On a great truck it is borne now to a great trench in the graveyard.
And Jan Clepek's widow and two friends ride in a carriage behind the
block of steel and mourn the soft man who was killed by hard steel.

Listen to the drums of a strange funeral.
Listen to the story of a strange American funeral.

And Jan Clepek's widow is thinking,
"I'll wash clothes, I'll scrub floors, but my children will never work in a
steel-mill."
And three mourners were sitting in a grave-yard and thinking strange
thoughts.
"I'll make myself hard as steel, harder,
I'll come someday and make bullets out of Jan's body, and shoot them
into a tyrant's heart!"

Listen to the drums, to the mournful drums
Listen to the drums, to the drums.
LISTEN!

In 1934, the Workers' Music League published the first *Workers' Song
Book*, which contained pieces by Collective members and other contrib-

utors. The intent throughout this volume was to inspire revolutionary en-
thusiasm and in some cases to offer rounds and other pieces that workers
could sing for themselves. But these pieces were by no means all sim-
plistic in musical terms. Some contained changing time signatures and
unusual melodic turns, all with texts of contemporary political import.
"The Scottsboro Boys Shall Not Die" by L. E. Swift (Elie Siegmeister) is a
rousing piece in the marching song tradition that exhorts workers to
unite in support of those wrongly accused and to assert the workers'
cause:

> Workers, farmers, Negro and white,
> The lynching bosses we must fight.
> Close your fists and raise them high,
> Labor defense is our battle cry.
>
> *Chorus:* The Scottsboro boys shall not die,
> The Scottsboro boys shall not die.
> Workers led by I. L. D.[6] will set them free
> Set them free.
>
> By mass action we will defend,
> Our own class brothers to the end.
> Death to lynchers we declare,
> Frame-ups and lies to bits we'll tear.
>
> *Chorus:*

"God to the Hungry Child" by Janet Barnes is more contemplative in
character. Written for solo singer and piano, it is not difficult for a
trained singer, although its alternations of $\frac{4}{4}$, $\frac{6}{4}$, and $\frac{3}{4}$ metres might prove
a bit daunting for a novice. The words, however, are not at all difficult or
ambiguous:

> Hungry child,
> I did not make this world for you.
> You didn't buy any stock in my railroad,
> You did not invest in my corporation.
> Where are your shares in Standard Oil?
> I made the world for the rich.
> And they will be rich,
> And they have always been rich.
> Not for you
> Hungry child.

In his *New Masses* review of the *Workers Song Book*, Aaron Copland
argued that "composers will want to raise the musical level of the masses,
but they must also be ready to learn from them what species of song is
most apposite to the revolutionary task."[7] Copland asserted that the mass
song was the most appropriate vehicle for communicating the political
message of the "day to day struggle of the proletariat." He was convinced

that "as more and more composers identify themselves with the workers' cause, the challenge of the mass song will more surely be met." He concluded that those composers who had already turned their creative talents to the writing of mass songs were owed a vote of thanks "by those of us who wish to see music play its part in the workers' struggle for a new world order." Copland contributed to this effort with a song that won the 1934 *New Masses* song competition and was published in the second *Workers Song Book*. "Into the Streets, May First!" changes key a few times, but with good pianistic guidance it is definitely singable by workers' choruses. The text by Alfred Hayes expresses confidence that music and political consciousness can change the world:

> Into the streets, May first,
> Into the roaring square.
> Shake the midtown towers,
> Crash the downtown air.
> Come with a storm of banners,
> Come with an earthquake tread.
> Bells, ring out of your belfries,
> Red flag, leap out your red.
> Out of the shops and factories,
> Up with the sickle and hammer.
> Comrades, these are our tools,
> A song and a banner.

The first *Workers Song Book* contains revolutionary texts and some relatively sophisticated music. There is little evidence that the contributors were much influenced by folk music. In fact, Carl Sands (Charles Seeger) considered folk music to be detrimental to the cause of struggling workers. He wrote in the *Daily Worker* that most folk songs were "complacent, melancholy, defeatist—originally intended to make slaves endure their lot—pretty, but not the stuff for a militant proletariat to feed upon."[8] The only folk pieces that Sands considered appropriate for workers were those expressing "a spirit of resentment toward oppression."

Despite the absence of folk influences in the first *Workers Song Book*, there are some relatively easy and humorous rounds that were appropriate for amateur choruses. The round itself is an old and popular form that dates back at least to the sixteenth century in England. Elie Siegmeister's "Poor Mister Morgan" exploits this form and pokes fun at a name that was synonymous with American big money:

> Poor Mister Morgan, cannot pay his income tax.
> Pity poor Morgan, he cannot pay.
> He's dead broke, he hasn't got a cent!

In the United States, the shift from the idea that complex high art should be created to serve the class struggle to a philosophy of Socialist Realism[9] was encouraged after 1934 by the Communist party's attempt to

broaden its appeal, with particular emphasis on Earl Browder's slogan, "Communism is Twentieth Century Americanism." On the relationship of musical form to political meaning and the newly-perceived need to derive both form and content from the experience of American workers, Mike Gold wrote in the *Daily Worker* that "a new content often demands a new form, but when the new form gets so far ahead of all of us that we can't understand its content, it is time to write letters to the press."[10] Socialist Realism allowed for the use of American folk tunes, or at least melodies that sounded like folk tunes, as purveyors of political messages. Although not all of the Composers' Collective members were quick to incorporate the folk idiom, Lan Adomian defended cowboy songs, spirituals, and other varieties of folk music as "a colorful addition to our repertoire. Such an approach [composing with real folk materials or in a similar style] would carry us a long way toward rooting our work in the tradition of American music. It would give the lie to those who would insist that our music is nothing but an importation from the outside."[11] The call here is not only for political music, but for an *American* political music. The change in the political line inspired a rethinking of the value of national music to the American political struggle.

By 1935, the influence of Socialist Realism was apparent in music and the writings of some modernist composers. For example, Henry Cowell, the musical experimenter and proponent of the more dissonant and difficult works of Charles Ives, also supported the cause of political music. He wrote for *New Masses* and published several manuscripts by Soviet composers in his own journal, *New Music*.[12] Cowell, who was not known for composing singable melodies or simple rhythmic patterns, nevertheless responded to the call for political music that workers could easily understand and even create themselves. His *New Masses* article, "Useful Music," described the evolution of an original protest song from a familiar melody as workers marched on a picket line. Cowell wrote that it was the creation of the new song as well as the act of singing together that created unity among the marchers.[13] Where social function and ideological content had earlier been of little or no importance to Cowell and other modernist American composers, these two facets of the larger creative process assumed new meaning to many who identified with the Left and who were influenced by new Socialist Realist currents.

The second *Workers Song Book* (1935) represents the shift to a Socialist Realist approach by many collective members. It contains pieces by twelve composers, and six of the eight Americans represented were affiliated with the Composers' Collective. The songs here are virtually devoid of rhythmic and melodic complexity. Copland's "Into the Streets, May First!" appears here, as do songs by Earl Robinson, the composer of "Ballad for Americans," Swift, Sands, and the German refugee composer Hanns Eisler. It also includes two Afro-American protest songs, "I Went to 'Tlanta" and "Sistern and Brethren," both contributed by Lawrence Gellert.

Workers' rounds also appear in this volume. By 1935, Carl Sands had evidently decided that singable music need not be melancholy, resigned, or weak, and he turned his caustic wit to the task of mocking John D. Rockefeller in a round called "Not If, But When."

> Oh joy upon this earth to live to see the day,
> When Rockefeller senior shall up to me and say,
> "Comrade, can you spare a dime?"

Sands lost none of his revolutionary anger in a round about industrialist Charles Schwab:

> Schwab, Schwab, Charlie Schwab,
> Life and happiness you rob
> From the workers in your mills,
> From the miners in your hills.
> Says you, "Bake my cake you slaves,
> And I'll eat it."
> We can bake and eat it too,
> Charlie Schwab, beat it!

Ideas of Socialist Realism and the declaration of the Popular Front in 1935 made it possible for those composers affiliated with the Collective who had seen their commitment to the Left in terms of the victory of an international proletariat now to identify with struggles against fascism abroad and for democracy at home. Mike Gold declared in 1935 that "the chief battleground in the defense of culture against fascist barbarism is this question of national tradition. . . . In our pamphleteering, we should learn to use naturally and easily, examples and metaphors out of the American past."[14]

On February 10, 1936, the Workers' Music League dissolved itself in favor of the formation of a more broadly based organization, the American Music League, whose purposes were to promote the Popular Front in American music and to encourage the study and collection of native folk music. The Composers' Collective continued to function under the auspices of the new league, but by 1936 only Siegmeister, Blitzstein, and Robinson remained of the original membership. Party identification and the furtherance of the international class struggle had been supplanted by a less clearly defined but musically more fertile and longer lasting vision of America. Native-born and immigrant American composers with any nationalist inclinations at all now saw their country not only in terms of ranks of triumphant workers but also in the context of the United States' natural, political, and man-made wonders. The cowboy, pioneer, railroad man, political hero of the Abe Lincoln variety, and balladeer found their way into concert music through the folk and popular tunes which depicted them. Collective members had helped to pave the way for a broader nationalistic musical expression in the decade following the Collective's heyday, although it was clearly not always their intention to do

so. By showing us the struggles and aspirations of the workers of the world, they helped themselves, their colleagues, and their audiences to imagine a voice for the American worker.

CAROL HERSELLE KRINSKY

12. Rockefeller Center:
The Success of the
Architecture and the
Failure of the Art Program

For a series of papers devoted to the artistic rhetoric of power, one could hardly find a more appropriate subject than Rockefeller Center and its art program. The entire building project presents the complementary perspectives of John D. Rockefeller, Jr., a representative of our country's business establishment, and of Columbia University, representing the American educational establishment. By examining the work done there, we see what kind of artistic rhetoric was effective in proclaiming the virtues of enlightened capitalism and why it was effective sometimes, but not always.

The project was initiated in 1928, during a period of business optimism. It was built, however, during the depression following the stock market crash of 1929. Calamitous business reversals might have led to cheap and ugly buildings, but the men in charge responded with remarkably enlightened self-interest. They made the project an urbanistic and commercial success, and thereby made its message convincing. Nevertheless, when they tried to add an overt ideological component to the building project by including applied artistic images with specific meaning, they were much less persuasive about their ideals. The virtues of thoughtful capitalism were clearly shown when the property owner, a developer, and some architects did what they were good at doing—building for profit in the best way they could. Conversely, the limitations of the people and of their project were revealed when they attempted something for which they had no aptitude—trying to make the Rockefeller Center project take on additional ideological meanings.

It is clear from what has been said already that I think the buildings erected in 1929–1939 exemplify very good architecture and urbanism. A brief account of its building history helps to show how Rockefeller Center became as good as it is despite its imperfections and how the sponsors

reacted appropriately to economic misfortune, devising forms that proclaimed the strength and good will of capitalism in a time of crisis.

The original fourteen Rockefeller Center buildings were planned to occupy nearly all of the three blocks from Fifth to Sixth Avenues, 48th to 51st Streets.[1] The landowner, Columbia University, had earlier offered such long leases on the property that the site was still full of nineteenth century tenements with small shops and modest restaurants at street level. A noisy elevated railway line ran on Sixth Avenue, darkening the street and lowering real estate values near it. The three-block site lay too far from Grand Central and Penn Stations to attract suburban commuters who directed prestigious businesses and determined their office addresses. In 1928, when Frederick Goetze, Columbia's real estate director, realized that the leases on the tenements would terminate by 1931, he tried to find an entrepreneur who would redevelop the university's midtown property, but with the low social status and inconvenience of the site, no one would have wanted to build there without a strong inducement to do so. Knowing that the Metropolitan Opera's owners were hoping to move away from Broadway and 39th Street where their antiquated building had recently been dwarfed by office buildings for the garment industry, Goetze suggested that the Opera move to Columbia's property. A respected and socially acceptable consultant architect, Benjamin Wistar Morris, was asked for a plan. Morris proposed that a new opera house face an open plaza with tall office buildings on the plaza's other three sides. The office towers were to be developed by one person to such a high standard that they could command high rents, especially on the plaza side, and thus cover the revenue that would be lost by leaving open a large plaza and perhaps donating the opera site. John D. Rockefeller, Jr., was advised by his staff to become the office building developer, and he signed a lease for the land.

The signing was virtually coincident with the crash. The calamity on Wall Street brought about the economic ruin of some of the Opera's owners, and no new opera house could be financed. Without the Opera, there was no attractive tenant for the site, and no inducement for anyone to move to the three blighted blocks. But Rockefeller could not avoid building something there, because he was paying Columbia a high rent while getting only about a tenth of that amount from the occupants of the tenements. He had to think about investing for a return in the long run. That meant building something so good that prestigious tenants would want to move in, eventually attracting others.

By the end of 1928, Rockefeller had engaged three architectural firms to develop ideas.[2] Raymond Hood, the principal design partner in one of the firms, knew that radio-movie-experimental television companies associated with RCA were growing rapidly, especially since radio advertising had started around 1927. He proposed that the modern arts companies for radio and film replace the old art of opera in the building project.[3] Negotiations with the "radio group" were swift and successful.

Plans were quickly drawn up to accommodate the corporations' desire to make their presence conspicuous and well-regarded, and to serve the financial requirements of Rockefeller and Columbia while doing honor to their reputations.

Even in the earliest of the new plans, the RCA building was given the central position. It is the logical successor to the opera house that was to have occupied the site. Its design is dramatic, soaring upward in tiers, slicing the sky and challenging the towers of St. Patrick's Cathedral. Its workmanship and details are excellent, to suggest the high standard that American business and American craftsmen could attain when they turned their attention away from the opera and its old world associations in favor of the things that mattered to depression-era Americans— obtaining work, making money, and being entertained.

Rockefeller bought lots on Sixth Avenue adjacent to Columbia's property once it was clear that the elevated railway would come down, to be replaced by a subway line. On his land, he erected an office building for the RKO motion picture interests, and two theaters, of which the surviving one is Radio City Music Hall. Eventually buildings for other modern communications media entered the project, such as the tower erected for Time, Inc., and the lower structure for the Associated Press with a cinema tucked into its south side. Few tenants with these modern business interests were available, so Rockefeller's staff filled the remaining offices with groups dealing with the family's interests, and with international firms and government agencies. Energetic marketing strategies were devised; even Mussolini stood for a photograph in front of a model of the project, shown as surpassing the size—and perhaps eclipsing the glory—of the Pantheon and the Column of Marcus Aurelius.

The result, despite some piecemeal revisions of the early plans, is exceptionally well-coordinated and handsome (fig. 12.1). There is a focal point, the RCA Building, and that is appropriate because RCA and its affiliates saved the project from ruin by becoming the principal tenants. The skyscraper is clearly visible because space was left in front of it—the plaza, which is the vestige of the former opera plaza. A path from fashionable Fifth Avenue, the open space, and the RCA Building mark a principal axis. Reinforcing it is the gradual crescendo of forms rising from low buildings along Fifth Avenue past the pause of the plaza to the climax in the 66–story skyscraper. A major cross axis is established by a private street inserted into the city's grid to increase street frontage for office buildings and to ease the flow of traffic through the project. There are subordinate axes in and through the buildings. Sloping and flat terrain helps to guide visitors and vary the pace of movement. Areas for sitting and people-watching can be found as well. There is the comforting similarity of low, limestone-clad buildings at the Fifth Avenue end, offering simple forms in the crowded cityscape, and yet there is variety. There are contrasts in building height, shape, and detail. There are changes in material and texture from limestone to metal, granite, glass, and bronze.

The surfaces are smooth and rough, matte and shiny. Rockefeller Center offers color accents given by plants, water, statuary, shop windows, and flags.

All this gives us a sense of place, something important to successful urban experience. We are enclosed there by skyscrapers laid out around a plaza, but we are free to leave by the many paths that are clearly evident. We can rest there, but there are things to do. If we want to move, we are guided by walkways, well-marked doors, and the obvious axes. The space can be static or active, or both. The Center is pretty in a way familiar to a

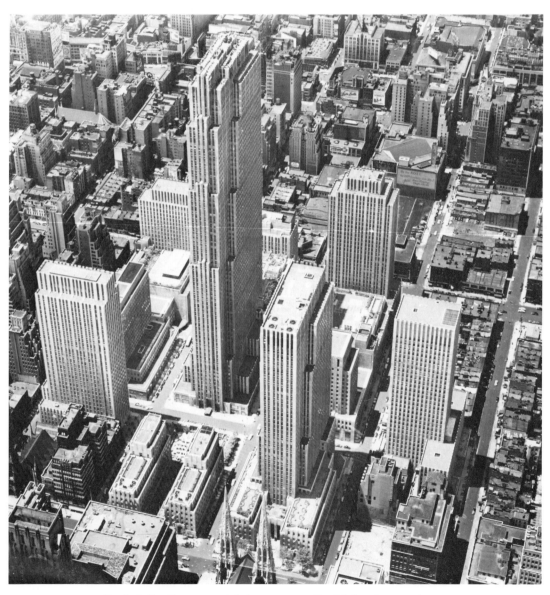

12.1. Rockefeller Center, aerial view, c. 1950 (Rockfeller Center photo no 1160).

wide range of people, including business executives. They like the sense of order combined with flexibility. So do tourists, and so do architectural historians.

The project also turned out well for the city. The Center staff lobbied for the Sixth Avenue subway because it would reduce the noise and darkness on Sixth Avenue and would consequently raise land values there. But citizens benefited, too, because the subway was faster than the "El" and was coordinated with other subway lines; moreover, the subway relieved congestion on the street, and by fostering higher land value it brought increased real estate taxes to the city. Rockefeller Center coordinated the subway entrance level with underground corridors connecting all its buildings; this relieves street level congestion and provides comfortable passage through the area no matter how inclement the weather outdoors. Convenient restaurants and businesses such as copy shops, greeting card stores, and women's clothiers do well along the underground streets. A separate post office with its own zip code eases the crush of Rockefeller Center mail on nearby postal facilities. In addition, the Center provided its own underground truck ramp for deliveries, so that huge vehicles do not jam the streets there as they do elsewhere in midtown. Moreover, the maintenance and cleanliness of the property puts most other landlords to shame, and while this shows businessmen that Rockefeller Center is a fine place to be located, it is also good for the city. A huge security staff makes this one of the safest places in all of New York, comforting the potential renter and the fearful out-of-town visitor.

Because all of this serves the owner and tenants while serving the public, it represents enlightened capitalism—doing well by doing good. The project had to be respected in order to succeed financially, and in the end the planners made the project loveable. Rockefeller and his associates had to calculate carefully what businessmen needed, but they decided not to be stingy about fulfilling those needs. And so the Center is clean and handsome, even elegant in many details, but it is open to the public, provides summertime entertainment for everyone in the area, and gives New Yorkers their annual Christmas tree.

The planners did all this by ignoring the avant-garde, the derrière-garde, and artistic theory. They knew what they liked, and they knew what could sell. The buildings are vertically emphatic with a few almost hidden Gothic ornaments because Rockefeller liked Gothic. They have emphatically marked doorways and symmetrical, familiar geometric shapes because the architects had been trained in the classical tradition, which also dominated the public's experience of major civic buildings. It is true that there are some dead areas in the long stretches of 49th and 50th Streets along the flanks of the RCA Building, and the largest buildings are bulky. But the ensemble is the most agreeable one produced by American business up to the Second World War, and it inspired various attractive urban commercial projects designed since then, from Embarcadero Center in San Francisco (a Rockefeller family investment) to the

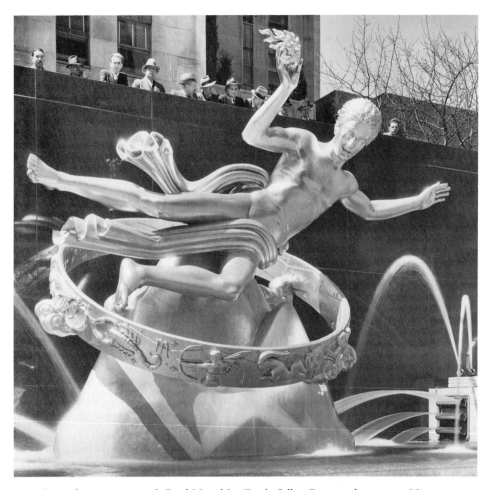

12.2. *Prometheus*, c. 1933–36, Paul Manship (Rockefeller Center photo no. 988).

New York's South Street Seaport area and its relatives in Boston and Baltimore.

If few people quarrel with the overall design and with the best of the Center's buildings, even fewer people look at the art program. Those who do are often dissatisfied with it, and for good reason: it did not create an appropriate image of enlightened capitalism.

John D. Rockefeller, Jr. had little interest in painting and sculpture. His development manager, John R. Todd, preferred a painting of a Kentucky landscape to most things that one could find in a museum,[4] and especially to things that could be found in the museum that Mrs. Rockefeller sponsored—the Museum of Modern Art. But Abby Aldrich Rockefeller was not at first connected to the art program in her husband's business center.

Rockefeller and Todd told the architects to find artists to decorate the doorways and principal lobbies and to decorate the theater interiors.

The architects' taste ran to representative art done in one of two classicizing modes, either a stolid and simplified type exemplified by the work of Lee Lawrie and Robert Garrison, or a lighter, prettier, and rather sexless type exemplified by Paul Manship's gilded statue of Prometheus (fig. 12.2), by the murals of Frank Brangwyn in the RCA Building lobby, or by Ezra Winter's huge allegorical painting in Radio City Music Hall (fig. 12.3). Most of the Center's artists were experienced decorators of commercial buildings; Winter had recently executed murals in the Cunard Building opposite Rockefeller's Standard Oil Company Building on lower Broadway, and Brangwyn had worked for Lloyd's of London. These were not radicals or the avant-garde. Their conventional if lucrative commissions were suited to their conventional ideas. As a result, they could not conceive meaningful images showing the importance and virtues of capitalism, Americanism, or philosophical truth.

If we look at Prometheus, we see some of the faults of their work (fig. 12.2). He is slim and graceful, but Prometheus must be stronger and more daring than that. His floating position makes him look unstable rather than in energetic motion. This is not a persuasive way of showing a divinity who was responsible for bringing fire to earth, changing the course of human history. He subordinates himself well, because of his weakness, to the RCA Building behind him. Ironically, that is appropriate if not to Prometheus then to the Rockefeller Center project, because the building and its tenants were what really mattered.

The idea of human achievement made possible by Prometheus was directly if unwittingly contradicted by Ezra Winter in his Music Hall mural. Hartley Burr Alexander, the philosophy professor who conceived the art program's themes,[5] had proposed to have the mural give a moral lesson about man's vain striving to cross impassable frontiers. But if man had not thought of what to do with Prometheus' gift, many frontiers would have remained impassable. If Rockefeller and his associates had not found a way to make a profit from an undesirable site during the depression, they would have lost millions of dollars and not crossed their own nearly impassable frontier. Apparently seduced by Alexander's lofty prose style, Rockefeller and his otherwise astute staff allowed a theme to be introduced that philosophized about defeatism, represented by—of all things for a New York theater lobby—an old Oregon Indian legend. Alexander had summarized a tale about an old man who ascends to a mountain peak that is separated by a chasm from the fountain of youth. From this vantage point, he reviews a "rainbow procession of the ambitions and vanities of his life." This certainly should not have been suggested to elderly men like Rockefeller and Todd, neither of whom found making money and developing property an undue ambition or a vanity of life. Fortunately for Winter and Alexander, Rockefeller and Todd gave little thought to the ramifications of Indian legends. Rockefeller was surprised at how much he liked the entire Music Hall, and said simply that words failed him when he contemplated the mural.

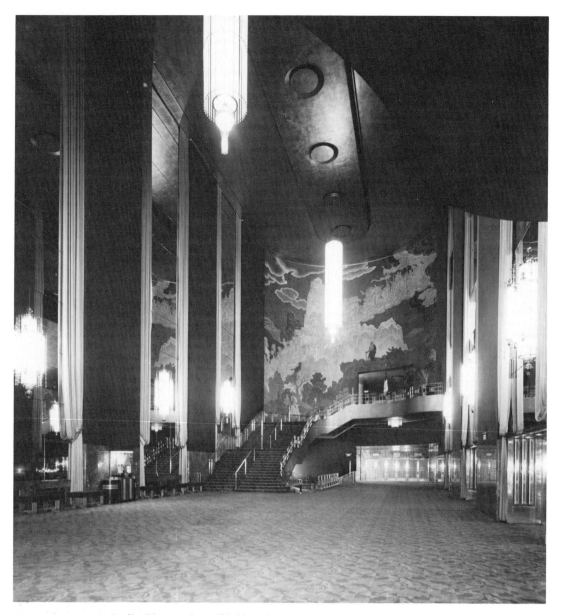

12.3. Radio City Music Hall lobby, showing mural by Ezra Winter in background, 1931–32.

In the more heroic or bulky style, Lee Lawrie and René Chambellan executed the statue of Atlas, across Fifth Avenue from St. Patrick's Cathedral (fig. 12.4). Its virtues include heroic scale and a recognizable image of strength. But the body is massive, the musculature is excessive, and there is not enough space around the statue to contain it and building visitors comfortably. The face bears a disconcerting resemblance to that

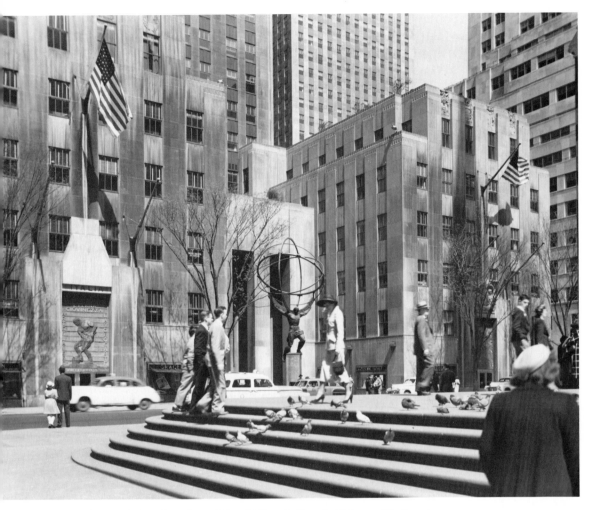

12.4. *Atlas*, 1936, Lee Lawrie and René Chambellan, in Palazzo d'Italia, view c. 1950 (Rockefeller Center photo no. 1295).

of Benito Mussolini, probably a consequence of the fact that Il Duce's business supporters leased space in the adjacent low building which is still called the Palazzo d'Italia. Rockefeller and Todd were Protestant Christians,—Todd's father was a minister—but they seem to have found nothing odd about presenting a pagan view of support for the world opposite St. Patrick's in which a Christian view was made clear. Their silence on this may indicate how superficially Rockefeller and Todd regarded the Atlas statue and how little they cared about its meaning. By the time that Atlas was designed in the mid-1930s, Professor Alexander's whole conceptual program had disintegrated, and each new work of art had a new subject, depending upon circumstances of the moment. The messages of Atlas and internationalism are so unclear to Americans today that recently

when I arranged to meet a broadcaster from a national network under the Atlas statue, he waited for me near Prometheus, having no idea that one Greek god looked different from another.

In the mid-1930s, the Italian tenants wanted some sculpture on the low buildings flanking Atlas that would express their current political ideology, and they were given a pair of reliefs by Attilio Piccirilli. One showed young men chasing a chariot and the other showed a man working under the inscription, "Sempre Avanti Eterna Giovinezza" accompanied by the fascist motto "Lavoro e Arte, Arte e Lavoro." Eager to attract tenants, the Center's management allowed this propaganda on its entrances, even though a celebration of fascism had little to do with Rockefeller's ideal of laissez-faire capitalism in a democracy. Perhaps the decision-makers assumed that hardly anyone would understand the words, and that most people would simply like images of virile youths. In this case, no one's rhetoric was well represented.

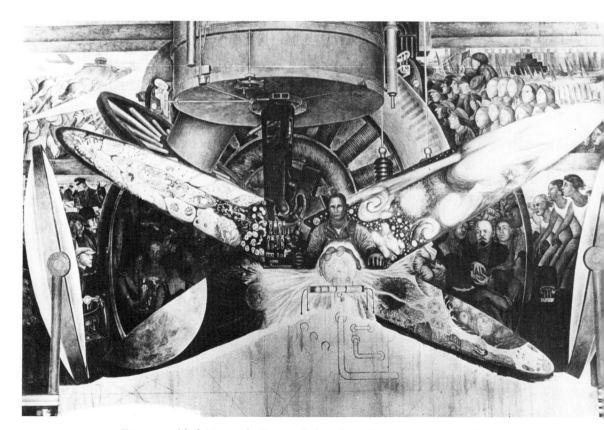

12.5. Fresco, entitled *Man at the Crossroads*, by Diego Rivera, c. 1933–35, RCA Building lobby; now destroyed (Wide World Photos).

The most egregious failure was the mural commissioned from the left-wing Mexican artist, Diego Rivera, intended for the wall opposite the chief entrance to the RCA Building. A man who had been a Communist was the last person whom one would expect the Rockefellers to patronize. But Mrs. Rockefeller, a sincere lover of art, admired Rivera's work, and Mr. Rockefeller acquiesced to her suggestion because Rivera's work guaranteed some publicity. Perhaps he also wanted to appear to be broadminded about the arts. Todd was uneasy about the choice but could not veto the commission. Perhaps Rockefeller and Todd were comforted by the thought that Rivera's theme was so obscure that no one would have been able to interpret the image in any case: "Man's new possibilities from his new understanding of material things." The mural was also somehow to include "man's new and more complete understanding of the real meaning of the Sermon on the Mount." In 1932 when Rivera submitted a sketch of what he was going to paint, he said that he would include a worker giving his hands to a peasant and a soldier, a group of workers "arriving at a true understanding of their rights regarding the means of production" (Rockefeller may not have recognized the Marxist phrasing), and scientific instruments to show man's apprehension of distant and microscopic entities. But nowhere did he suggest that he was going to paint what he did paint in the end—Lenin, or red flags, or venereal disease germs floating near rich people playing cards (fig. 12.5). Rivera worked on his mural under a tarpaulin to hide it, but when the Rockefellers found out what he had insinuated into the mural, they asked him to change it, fired him when he refused but paid him in full, tried to move the fresco

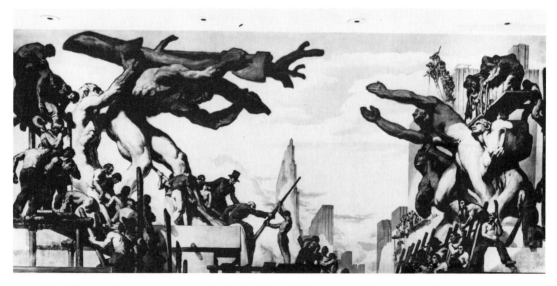

12.6. Mural by José María Sert, 1937, RCA Building lobby (Rockefeller Center photo no. 699).

to the Museum of Modern Art, found removing it too hard, and in desperation finally chopped it off the wall.[6] In 1937 it was replaced by the present mural by José María Sert (fig. 12.6), showing Abraham Lincoln implausibly assisting nude and clothed people and giants in building primitive structures, while Rockefeller's new towers rise like mirages in the background.

The people concerned with the art program at Rockefeller Center were either men of letters like Professor Alexander, who thought that art could illustrate words literally or people who cared so little about art that anything short of Lenin's face in a business building conveyed no meaning to them at all. The former group thought more of literature than art; the latter group, apparently including Rockefeller, seem to have thought of art as mere wall decoration.

It is not that Rockefeller lacked taste. He had the discernment to despise the reliefs by Leo Friedlander that surmount the side entrances to the RCA Building. These clumsy images are allegories of radio and television transmission, and as Rockefeller wrote to Todd, they are "gross and unbeautiful."[7] But it did not occur to him to question Alexander's conceptual program that would have taxed even a good sculptor's interpretive abilities.

At Rockefeller Center, then, the effective rhetoric of power was the wordless kind—the kind created by the buildings, spaces, and their grouping. This was what really interested the sponsors, the tenants, and the public. When they sincerely wanted good buildings because they needed good buildings, they got good buildings. Hardly concerning themselves about painting and sculpture, they got the unconvincing and barely competent images that ignorant and careless people often accept. Fortunately for the image of enlightened and responsible capitalism, most people look at the buildings and not at the art.

JACQUELINE AUSTIN

13. A Battle of Wills:
How Leni Riefenstahl
and Frank Capra
Fought a War with Film
and Remade History

In the period between the Russian Revolution and World War II, documentary films were not notably pro-state, monumental objects. Vertov and Ivens, Clair and Lacombe, Flaherty, the Cooper/Schoesdack team, Cavalcanti, Ruttman and Grierson were all, in their own countries, making seminal and original films revealing the workings of people, nature, even cities. Vertov, still inflamed with a revolutionary spirit, was producing his most profoundly experimental work.[1] Yet it was not until World War II that propaganda, documentary, and the newsreel would fuse to politicize and to condition, as well as to educate and to entertain, millions.[2] The films of two ambitious filmmakers, backed by the wartime resources of their respective governments, were largely responsible for this leap to a monumental nationalism. With her Nuremberg Trilogy, most particularly with *Triumph of the Will*, Leni Riefenstahl brought form—political as well as aesthetic—to Hitler's romantic, passionate rationale for the Thousand-Year Reich. Her artistic vision, showing Hitler as a dynamic, modern Roman emperor, catalyzed a massive popular response to nazism as well as a perception that the Nazi State, as exemplified by the Nuremberg party rallies, was the archetypal empire made manifest.[3] On the other side of the conflict, almost a decade later, with his "Why We Fight" series, Frank Capra readied his audience (at first only the 8 million soldiers of the United States army, but later a large portion of the Allied citizenry) to serve in a way that surpassed even basic training in providing motivation. He created a "humanist" documentary form, as eclectic and as romantic in its way as Riefenstahl's, both to speak for the common man and to bring down, once and for all, the notion of film for film's sake.[4]

In most ways, the viewpoints of Riefenstahl and Capra—as artists, nationalists, and citizen-subjects of their respective empires—couldn't have been less similar. Riefenstahl wanted to sweep away her audience with Nuremberg's grandeur and force and to create an empathetic awe for Hitler as avatar and deity. Capra would talk to his audience, not sweep it away; he found Riefenstahl's elitism, her glorification of superhuman endurance, as repellant as were her politics: "*Triumph* was the classic, powerhouse propaganda film of our times. It was at once the glorification of war, the deification of Hitler, and the canonization of his apostles. . . . That film paralyzed the will of Austria, Czechoslovakia, Scandinavia, and France. That film paved the way for Blitzkrieg. . . . How could I mount a counterattack . . . keep alive *our* will to resist the master race?"[5]

The heart of American democracy, indeed of life, as Capra saw it, was the small-town individual, not the person who led the pack. The answer that Capra found was to convince that individual: to let the enemy himself (with a little help from Capra's judicious editing) show the danger inherent in passivity. Thus instead of creating a historic imperative on the spot for his empire, as was Riefenstahl's choice (with a crew of 170) at Nuremberg, Capra used archival footage assembled from an international variety of sources to convince small-town Americans that they were fighting the same evil as were small-town people everywhere. Nazism meant the loss of individual freedoms. Where Riefenstahl ignored the enemy, Capra would assail it. Riefenstahl's attitude was that of a romantic individualist, claiming the best of Nature for her—and nazism's—own;[6] Capra's was that of one citizen among many, claiming only for the masses, not for himself.

What did the films of that naive genius, Riefenstahl, and that former screenwriter of comedies, Capra, have in common? They shared profound lip-service to, and profound disregard for, the facts of history. Riefenstahl's *Olympia* uses classically Greek images of discus throwers and nude goddesses; her torchbearers pass the burning flame of civilization directly from Hellas to the Third Reich—yet these historic-literary figures are drained of all except their visual content and a certain residual glamour. Capra's *Battle of Russia*, while emphasizing "history," fails even to mention that there ever was a Russian revolution. Both filmmakers made the choice of letting their sources speak for themselves: a profoundly good artistic choice, but a profoundly propagandistic political one. With their "educational" films, both Capra and Riefenstahl are as ecstatically optimistic an example of a "triumph of the will" as were the nations that gleefully employed them.

Capra and Riefenstahl were ardent nonintellectuals who, while appearing to make factual arguments, used the excitement of montage editing to override unpleasant issues.[7] Dramatic music and tight compositions, bits of fact and bits of fantasy, all went into one editing bin and came out revolutionizing the rhetoric of persuasion. Riefenstahl's art and Capra's entertainment values were aggrandized by (and parenthesized by) the persuasive aims of their leaders, Führer Hitler and Chief of Staff

General Marshall. (Both filmmakers were commissioned directly by their leaders, bypassing state bureaucracy—Goebbels's film department, in one case, and the U.S. Army Signal Corps, in the other.) These leaders knew how to get the most out of "their" artists, who each felt personally responsible to a charismatic, enthusiastic leader for his or her work. The results, in both countries, surpassed all expectations.

For the first time since theater's inception, the speed and direction of a multi-idiomatic medium could be controlled absolutely, draining an argument of the necessity for accurate as well as persuasive content. Film's greatest virtue over temporally static art forms, its unidirectional flow, would also be its vice. People would accept filmed depictions as truthful documents, without consciously taking into consideration aesthetic—and here, dangerous—decisions, such as cropping of the frame, choice of source material, or juxtaposition of shots.[8] (In Capra's case, the scripts were approved by fifty officials, up and down the military and civil hierarchy; this doubling of propagandistic content with equally propagandistic editing was to prove simplistic in some films, devastating in others.) The two filmmakers, while retaining all of the artistic attitude and seeming political independence of "individual" artists, had been chosen most carefully by their respective states for their willingness and likelihood to please, as well as for their knowledge of craft. Thus the battle of wills between Riefenstahl and Capra, between Axis and Allies, would be unprecedented in terms of resources used and in numbers of people persuaded as well as in terms of artistic-rhetorical method.

Triumph of the Will

Before 1935, Hitler's hold on power was far from complete. Events such as von Hindenburg's death, the slaughter of Röhm, and the wholesale measures against Jews had convinced many citizens only that their new president was a dangerous extremist who had as yet done little to alleviate the country's internal political and social chaos. *Triumph*'s 110 minutes changed all that. Riefenstahl's artistry, pushed to the nth power by Hitler's and Speer's rebuilding of Nuremberg and orchestration of a media event, had given the regime glamour and soul; what's more, Hitler had been compellingly portrayed as a passionate humanitarian and patriot.[9] "*Triumph* transforms the reality of 1934 party disunity into a massive spectacle of regimentation, unity, and fidelity under the Führer."[10]

Riefenstahl's method is notable not only for its editing, but also in terms of how the images were gathered and how these images dealt with chronology. Her eye for composition is directly traceable to the art documentaries of Walter Ruttman and of Lang (both favorites, artistically speaking, of Hitler, though eventually Lang would be forced to flee Germany); particular sources are Ruttman's *Berlin: Symphony of a Great City* and Lang's *Metropolis*. The cloud sequences at *Triumph*'s beginning derive from Riefenstahl's own "mountain films," paeans to the grandeur and simplicity of nature, such as her *Blue Light*.

What Riefenstahl does in *Triumph* is to turn the Nazi party into a force of Nature. Though she insisted she was not a propagandist (indeed, she inserts no verbal propaganda into the script), her treatment of Hitler, like a mountain seen at first in the distance and then looming large in close details; her montage of the city of Nuremberg waking to a new dawn under party rule; her careful placement of cameras, pits, and dollies for dynamic angles—all these could hardly be construed as anything but passionately sympathetic to the cause.[11] In her camerawork, she "decided on fundamental effects that resulted in disoriented and animated frames. . . . She would show the upper parts of buildings and the sky, but not the earth, to give the effect of floating buildings; she would shoot human bodies from angles that made them appear to be apparitions. . . . If the subject was moving, she ordered the cameraman to move his camera. She wanted no static newsreel shots. She wanted animation, action, life."[12]

This expressionistic, almost mythic naturalism was a radical departure from other films that had been planned about the party. These were to have been history documents; even Ruttman's proposed film of Nuremberg dealt with such episodes as the 1923 stock market crash and Hitler's gradual rise to power. Riefenstahl's aim was to *create* history, not to recapitulate it: to show the Nazis as the leaders of an eternal pageant of God-given power that stretched back to Teutonic mythology and to the Romans—to sources so ancient they were the very stuff of primordial Earth. (The only part of Ruttman's suggestions actually incorporated in *Triumph* was the aerial opening, which fit this scheme.)

Both Riefenstahl and Albert Speer have written autobiographies in which they tell how images of Nuremberg were gathered; never before had an event been so planned for the media. Pits were dug and structures built for the masses of cameramen. Marchers and speakers who did not fit the Nazis' vigorous, youthful image were omitted or transformed by lighting. For example, a huge group of flabby party bureaucrats, too important to omit, were hidden by night. They were asked to carry flags that were then spotlit.

Riefenstahl's claim that . . . "nothing was staged for her cameras" . . . ignores the fact that Hitler himself did a great deal of planning. . . . Early in 1934 (the rally was in September) Hitler assigned Albert Speer to remodel Zeppelin Field . . . and to replace the . . . bleachers with a huge flight of steps topped and enclosed by a long colonnade. . . . Speer arranged for thousands of flags . . . to be displayed in groups of ten and spotlighted by 130 anti-aircraft searchlights. The beams . . . penetrated the darkness to a height of 26,000 feet, giving those assembled the feeling that they were in a vast room, a cathedral of light.[13]

The images were then edited into thirteen sequences. These ignored the chronological order of the rally and proceeded, instead, in a psychologically determined order meant to keep the events flowing in ecstatic peaks of activity, followed by energy-gathering valleys.[14] The two highest "peaks" are the first sequence (Hitler's arrival) and the last (the rally's clos-

ing, complete with Roman S. P. Q. R. banners and a stirring speech by the Führer).[15]

In editing, Riefenstahl expands on the rhythmic hierarchy of forms so beloved by Ruttman and Lang in their art documentaries. She even quotes Ruttman directly—her image of a Nuremberg clockface striking seven is almost exactly the same as that which Ruttman used in *Berlin* as a transitional device, except that by skillfully intercutting scenes of marching crowds, she has twisted Ruttman's message into a call to arms. Another technique of Riefenstahl's, derived from expressionistic films such as *The Cabinet of Dr. Caligari*, is to synecdochize, to take the part for the whole. Using extreme close-ups wherever possible, she directly impresses phenomena on the beholder's brain. For example, in close-ups of a peasants' parade, an image of Hitler's hand lifted in a *heil* salute cuts to a "flag-bearer jerking his head to attention."[16] Usually details such as these would be part of a wider shot, noticed only by a fragment of the audience. By regularly expanding such details to fill the screen, composing them expressionistically (usually on the diagonal) and editing them in a rhythmic sequence, Riefenstahl fully exploits their psychological and emotional significance, while sidestepping the perceptual choice and analysis that might be part of the baggage of a wider shot.

Music, excerpts from party speeches, and "random" noises (laughter, slogans) heighten the reality, increase the immediacy, and broaden the propaganda value of *Triumph*. "Herbert Windt's music plays a key role in forming the audience response to the titles. Beginning with sorrowful, mournful notes that underline the message of the titles, '20 years after the outbreak of World War, 16 years after German woe and sorrow began,' the character of the music changes to an uplifting, triumphant nature with the appearance of the title, '19 months after the beginning of Germany's rebirth.'"[17] Only then, in this triumphant context, is the viewer given a Nazi song: the Horst Wessel song.

Windt's masterful score, recalling Wagner, underlines both the mythic pretensions and the modest sentiments chosen by Riefenstahl to illustrate only the party's "sincerest," highest motives. One example of such is her editing of the speech of the Third Reich's press chief, who intones, "Truth is the foundation on which the power of the press stands and falls, and our only demand of the press, and the foreign press as well, is that they tell the truth about Germany." And at the film's end, in Hitler's longest speech, the viewer is told that "while the older generation could still have doubts, the younger generation is ours body and soul. . . . The tradition-minded warriors and party members will educate the German people . . . for our idea and the movement are a living expression of our people and a symbol for all time."[18] None of this, none of the film, was written by Riefenstahl; it was edited to give the most "candid" impressions. No wonder Frank Capra was to find Riefenstahl's portrait of the German Reich to be so psychologically devastating, and so terrifying.[19]

"Why We Fight"

Capra's sources—with one significant exception, his German footage—
were totally different from Riefenstahl's. First of all, Capra was not a stu-
dent of art documentaries. "To me, documentaries were ash-can films
made by kooks with long hair."[20] He was an entertainment specialist who
focused on narrative, dramatic, and comedic timing (he had started as
a gag-writer for Mack Sennett); he believed in accretion of argument
rather than of small visual-mosaic details. Second, Capra believed in his-
torical rather than mythological precedent; and for financial reasons, he
could not shoot his own film. That meant he had to rely on archival
footage, overlaid by a script (which Riefenstahl would have scorned). As
well as letting the enemy damn itself—showing the Nazis' own view of
their aggression—Capra obtained the relevant newsreel footage from
international sources and edited together bits and pieces to re-create
history.

This difference between Riefenstahl's and Capra's methods was to
have a profound effect on the evolution of Allied wartime documentary
and to define its rhetoric as one of practical "factual" argument, of con-
scious defense and counterattack, rather than one of emotion, of offense
and surprise. Capra's editing, even his perception of war, was thoroughly
derivative of the news—broadcast, print, and newsreel, as epitomized by
Murrow's "London is Burning" broadcasts, Shirer's "man on the street"
stories from Berlin, and the "Time Marches On" films.[21] It was as chrono-
logically accurate as he could make it, except for certain "generic" shots,
common even then to the news, such as bomb blasts, happy folk dances,
and raving Nazis. In "Why We Fight," as in the news, he tended to stick
to the periodic (daily, monthly, seasonal) bulletin; his errors, like those
of the news, would be those of oversimplification and omission, not of
willful or "intuitive" restructuring.

In the early 1940s, the media widely perceived that the Germans
were using news as a weapon against the British and the Russians, that
this offensive was also meant to soften up the United States, and that the
Allies lagged at least ten years behind the Axis powers in their propa-
ganda's scope and method.[22] "The Germans believed that democracy had
no genuine convictions for which people would be willing to stake their
lives. . . . (They) believe that men are more interested in the *élan vital*
than the *élan moral*. . . . (The British) hope that an appeal to the Platonic
principle of justice will triumph."[23] The rationale of *Triumph* (1934) was to
rouse and awe; contrast this with England's films of the early 1940s, such as
London Can Take It, meant to create sympathy. Alexander Hammid's and
Herbert Kline's *Lights Out in Europe* (1940) was "an indictment of fas-
cism"[24] rather than a direct presentation of democracy's virtues; Kline's
Crisis, about Nazis in Czechoslovakia, was meant "as a warning to Amer-
ica of things to come."[25] The story was the same again and again, to show
the courage of the RAF, to present a lyrical study of Britain's day-to-day

routine of wartime living.[26] It was not until late 1941 that Britain produced its first aggressive film, Harry Watt's *Target for Tonight*, about a single raid over Germany.[27] Oppose these to German films such as *Triumph* or *Baptism of Fire*, about the shelling of Poland, both prime examples of strong, offensive propaganda. In America, things were not much better; not only was the army jealous of German tactics, but it was squeamish about them, feeling them to be unsuitable for democracy (as indeed they were).

Before Capra, the army produced "useful" films about, for example, personal cleanliness, sex hygiene, and military courtesy. By 1942, when these were no longer seen as adequate, the army activated the Signal Corps Photographic Center, which began to produce a series called "Fighting Men." *Kill or Be Killed* was about a Nazi soldier's treachery; after he persuades an American to fetch him water, he shoots him. Capra, commissioned by the Signal Corps to think up ideas for these films, was almost immediately transferred to the Morale Branch, where he, under General Marshall's orders, set up a one-man film propaganda department.

His ideas, unlike the army's, came from the private sector—from travelogue and newsreel. "The factual film is not, like the newsreel, limited to mere reportorial coverage of a particular event at a particular time. It is, like all documentaries, built round an idea, a point which the producer tries to make."[28] From travelogue, Capra would cull techniques for presenting the "normal" face of a country: Britain's smiling, plucky working folk; Russia's colorful folk dances; Big Ben; the Kremlin. From newsreel, Capra would cull techniques for re-presenting history.

Recently, the March of Time had attempted to counter German feature-length efforts with a pioneering propaganda film of its own. *The Ramparts We Watch*, a compilation effort about a small town in America facing World War I, was so incomplete, indirect, and muddled that the producers attempted to sharpen it by including strafing scenes from Germany's *Baptism of Fire*. This technique, almost an accident in *Ramparts*, would be expanded and made to work on a grand scale in Capra's "Why We Fight" films.

Ramparts was done in classic March of Time style; that is, it combined bits of news footage with dialogue and dramatic recreations of important episodes in order to tell and editorialize a story economically.[29] In "Why We Fight," Capra tightened up this scheme. His dramatic recreations, because of limited funds, were primarily of two types: animation and simple narrative on the soundtrack. For both of these, he begged or borrowed the services of the best; Hollywood screenwriters and professional reporters (even Shirer) told the story. Capra asked the Walt Disney Studios to provide, gratis, animated maps of the major theaters of war between 1931 and 1941 and to show German aggression by spreading black ink over all the conquered territories. Places where the Germans were successfully pushed back were honored with flashing stars and then with a recoloring of gray. The black German graphics did not allow for any indi-

vidual place names to show through, but the gray Allied graphics did. The entertaining maps and soundtracks were a strong foundation on which to place equally entertaining human-interest and travelogue footage, stock shots, and revealingly detailed newsreel episodes. Even in the first of the series, *Prelude to War* (1943), Capra used all of these materials in a number of ways originally unintended by the makers. (He was eventually to obtain all German, Japanese, and Italian newsreels of the 1920s to 1940s, most of the extant propaganda documentaries, and a good selection of Russian, Chinese, and British war films.)

Reactions were positive: "The (footage) is formula, but it is still worth seeing Mussolini mugging to sell a line of oratory two minutes after the line is spoken, or Hitler simpering. . . . Its most surprising departure from earlier films of this type is its determined branding of all the fascist leaders, saying 'Remember these faces!' as it shows careful closeups of everyone from Hess to Dietrich. . . . The finest part—a symphonic arrangement of dictators' armies marching, keeps enlarging, Bolero-like, on the grotesque sleep-walking quality . . . yet never loses sight of their concentrated power."[30]

In *Prelude*, Capra dissolved together or double-exposed Axis images in order to compress their timing and to intensify their message of an ultimate threat to freedom. He would perform similar feats of tightening for all his relevant Allied footage, culling out the high points and underlining them with a simple, hard-hitting soundtrack. He also took full advantage of the irony that the passing of time tends to bring to newsreel footage; a 1939 poll of Americans' war feelings seems, to say the least, tragic and smug in the 1943 *Prelude*. Scenes of small-town America, when preceded by or followed by marching fascist armies, seemed as doomed as they were pleasantly and sweetly cheerful.

"Why We Fight" ultimately comprised seven films: *Prelude to War* (1943); *The Nazis Strike* (1943), about Hitler's rise to power and invasion of Poland; *Divide and Conquer* (1943), about events up to the surrender of France; *Battle of Britain* (1943) and *Battle of Russia* (1945), the two most successful projects; *Battle of China* (1944), a weakly unconvincing presentation of nasty Japanese warlords against great, humanitarian, strongly united Chinese; and *War Comes to America*, which Capra loved the best— he thought it was "one of the most graphic visual histories of the United States ever made."[31]

The Battle of Britain and *The Battle of Russia*[32]

Capra's method was to come to full fruition in his depictions of America's most significant allies. This is not an accident, but a function of the availability of usable "heroic" footage from Allied sources as well as of Capra's extreme sympathy for their cause. *The Battle of Britain* shows the story of inspirational courage under impossible odds. (It has previously been shown that Britain's early wartime documentaries concentrated on gath-

ering footage that would raise sympathy and show such heroic emotions.) *Battle* opens with images of Hitler as Napoleon, a characterization intended to raise British hackles. "Where Napoleon failed, I shall succeed; I shall land on the shores of England." Chamberlain's disastrous leadership is never mentioned; instead, Capra outlines Hitler's offensive three-part invasion plan, using Disney maps: in step one, Hitler wished to destroy the RAF and the lines of communication and supply; in step two, to destroy morale with dive bombers and paratroop attacks; and in step three, to invade Britain as a preliminary to an invasion of the United States. British footage of Dunkirk is edited to show the hopeless odds, at least 10–1: one tank, for example, defendng each 1,000 square-mile area.

What could Britain oppose to German might? Its daring (if outnumbered) air force—and the might of the common man. Churchill's speeches, his spirit, set the mood for the defense. Each air raid is shown as part of a personal attack against common people: each battle is one of giant menacing squadrons of airplanes against plucky individual citizens, who refuse to be cowed by the odds. The planes swoop down; old people and children decorate Christmas trees in their underground air-raid shelters; determined-looking women in fetching overalls package bandages and bombs; the brave little airplanes strike back again and again, even reaching (by means of Disney maps and a couple of shots of burning buildings) into the heart of Germany. This is a classic story of an underdog, and it was written by an eyewitness, Eric Knight, who was born in England, had seen all the British documentaries (and even worked on some), and who had penned the 1942 army *Pocket Guide to Britain*. (Parts of the *Britain* screenplay use the exact wording of this guide.)

The Battle of Russia uses exactly the same strategy on an even larger scale. After a brief introduction, showing that the war between fascist Germans and freedom-loving Russians has been going on for centuries, and a little sidestepping into travelogue, Capra shows a map of Europe burning black with Nazi aggression. Hitler's plan is outlined. Armies march. Heroic Russian underdogs—old women, smiling soldiers, even children—beat back the Nazi machine (fig. 13.1).

In *Russia*, the Germans always advance from left to right (west to east) across the screen; portions of their offensive that do not fit this editing scheme have simply been left out. They are shown *en masse*, while the nationalist defenders are shown, about 80 percent of the time, as individuals—one or two heroes large on the screen. German retreats go from right to left (east to west) across the screen. German advances are shown slowly on their Disney maps, with black ink; retreats occur very swiftly on the maps, maximizing the threat (fig. 13.2).

Capra pulled many of the events in this film from fictional films or from Russian government sources. The "historical" montage at *Russia*'s opening is, as a matter of fact, culled from Russia's equivalent of Hollywood films, including a shorthand account of German knights invading Russia, from Eisenstein's *Alexander Nevsky*, and other quotations from his

13.1. *Battle of Russia*, sequential cuts showing hardships endured by the Russian population.

Ivan the Terrible. Capra even intensifies the Eisenstein footage, as he did in editing German and Italian films, by compressing the narrative and taking only the most expressionistic, dramatic shots.

As the narrator burbles on and on about Russia's great size, natural resources, fertile land, and the fact that "Russia is also people, . . . 193 million people . . . of every race, color, and creed . . . all citizens of one country" (a fact which wasn't, at the time, entirely true), there is a montage of pretty folk dancers, farmers, and Cossacks in ethnic dress culled from Russian government films. No music accompanies images of Russian politicians, but similar images of German politicians are underlined by ominous, low orchestrations. At every possible moment Russia is likened to the United States (e.g., "Their industry, which, like ours, was designed for the ways of peace"). Opposed to sections montaging individual Russian civilians' faces, including those of women burning their own farmsteads so that Germans may not profit from them, are mass wide-angle shots of Germans marching, graphs, maps covered with black arrows, and the like, intensifying the effect of a unidirectional Nazi war machine. Even religion, never Soviet Russia's strong point, is used: people pray un-

13.2. *Battle of Russia*, sequential cuts: *above*, Disney map showing the progress of the battle; *below*, Hitler advocates the invasion of Russia.

obstructed in a couple of churches, and the Bishop of Moscow states emphatically that the fascists will be defeated by Christ.

As the Russians fight back, the cutting becomes much swifter, and the soldiers begin to march from right to left across the screen. Russian soldiers, never showing running on the defensive, now virtually race across the screen; the music gets much louder, and there are quick shots of smaller groups of Germans in retreat. The Russian movements are never shown by means of maps; instead, there are images of women kissing soldiers, Russians pulling down German-language signposts, and civilians returning to their cities on foot or with sleds. In flashback shots of burning houses and a quick montage of drifting sheets of music (Tchaikovsky's house in flames), the audience is reminded of the German's brutality and lack of love for culture. A sequence of German war atrocities follows: unburied Russian civilian corpses lying next to graves of Germans, buried on Russian soil; people weeping over the corpses of children; and then Capra's most melodramatic quotation, taken from a Russian propaganda film, several shots of dozens of hanged Russian girls who had resisted the attentions of German soldiers.

One of the most stirring sequences, the defense of Leningrad, is told in classic March of Time style: Leningrad is besieged, the populace is starving, and then, in shots from newsreels, "a miracle," as the soundtrack puts it, "happened." Heroic Russians secretly lay a railroad track across a frozen lake and bring in supplies. Again and again the Capra point is made: to images of springtime in Leningrad—trolleys starting up again, people washing windows, music, dances, fiddles, clapping sailors—the viewers are informed that "the citizens of Leningrad proved that generals may win campaigns . . . but *people* win wars." The defense of Stalingrad follows in much the same style. At the end, there is a switch: a sequence of Germans in defeat (proving that the Superman is not undefeatable, if citizens have the right type of morale). The soundtrack grows stern: Germans will be attacked, attacked, attacked by these united people of these united nations. There is a montage superimposing flags of many nations and sternly marching soldiers as the soundtrack swells in a cheery marching song. The American flag flaps proudly. Marshall makes a statement. *The Battle of Russia* draws to a close.

Conclusion

According to Frank Capra and to many professional analysts of society,[33] "the 'Why We Fight' series really does define American official war aims."[34] In Capra's words, "By extrapolation, the film series was also accepted as the official policy of our allies."[35] By personal order of Stalin, *Battle of Russia* was shown in every Russian theater. These United States Army training films were mandatory viewing for British, Canadian, Australian, and New Zealand armed forces; three of them were distributed commercially in America. They also were widely distributed in France, Spain, Portugal, China, and Africa and were even shown under fire in enemy territory to civilians.

Though "Why We Fight" was to be attacked by some—Senator Holman and many others thought it was shamefully partisan to Roosevelt,[35]—it was cheered by most. The underdog approach used by Capra, romanticizing truth, freedom, and the American way (and pioneering a very selective use of international footage in American propaganda) ultimately may have won over many more people than did the Superman approach used by Riefenstahl. In film, as in life, the underdog is often more attractive than the person who is already bloated with superhuman power.

"Why We Fight" and *Triumph of the Will* were flip sides of the same coin. Popularism and elitism, entertainment and art, democracy and fascism may seem like mutually exclusive concerns. Yet in film all concerns are equivalent and are subsumed to the unidirectional flow of edited montage. In making pro-state, monumental documentary series, the first of their kind and the largest to date in scope, Riefenstahl and Capra considerably broadened and revolutionized the medium.

Each nation in World War II had the major problem of spelling out war aims so as to instil sufficient civilian zeal for sacrifice. Churchill may have been correct in

his insistence that nobody ever won a war with his mouth, but World War II was a moment when everyone looked to film in hopes that propaganda might have the desired effect. The "Why We Fight" films defined American war objectives to military and civilian audiences throughout the world in a way Roosevelt's Four Freedoms never could. It is the medium of film which provides the most comprehensive statement of war aims produced in America between 1941 and 1945.[37]

BERNARD APTEKAR

14. Making the Invisible Visible: The Roots of an Original Magic Language

> Many workmen
> Built a huge ball of masonry
> Upon a mountaintop.
> Then they went to the valley below,
> And turned to behold their work.
> "It is grand," they said;
> They loved the thing.
> Of a sudden, it moved.
> It came upon them swiftly;
> It crushed them all to blood,
> But some had the opportunity to squeal.
> —Stephen Crane, "Many Workmen"

Consider our society, the whole vast structure of it: an artifact of enormous proportions; an interlocking maze of interests, organizations, and social relationships. By definition and necessity our society is an interdependent construct not only of material structures and technologies but also of customs, traditions, laws, rules, mores, ideas, ideals, values, dreams, passions, fears, desires, and visions. A huge, complex, unseen reality that always has a material manifestation. The vagrant, invisible masonry, actual and authentic, is the source, the prelude, to such diametrically opposite visions as the graceful Apollo Belvedere on the one hand, and the grotesque Aztec Coatlicue on the other, complete with skulls, serpents, and flayed skin. The thought and the object; the invisible visible.

This is not a duality—light and darkness, growth and decay, life and death—but a continuum, an uninterrupted whole, a succession of connected events; a möbius we live in with phantom thoughts, feelings, ideas, continuously passing from one state, through all the intermediate steps, to another.

Occasionally we see the process in an arrested state—the material half finished, the ideas half defined, as was Michelangelo's St. Matthew, part-

way along the continuum, left incomplete because the substance would not fulfill the vision.

But what happens when the vision fails? Not just for the person, but on a larger scale. What is it that holds the masonry together and keeps it in place? What does it mean when a society as rich and as powerful as ours finds it necessary to cut back on shelter for the homeless, assistance to the disabled, aid to the elderly, nutrition for children, food stamps for the hungry, student loans, education, medical research, the National Endowment for the Humanities and the Arts; yet is anxious and obsessed with spending hundreds of billions for bombs, missiles, and any and all systems of mass murder and destruction?

The sensibilities and values expressed by those in power reveal a crumbling of the social mortar:

Military pensions are not extravagant (the future bill now stands at $564 billion according to the *New York Times*) because the military is special.

"If my own son . . . came to me and said, 'you promised to pay for my tuition at Harvard; how about giving me $50,000 instead to start a little business?' I might think that was a good idea." ("Ripped Off" Bennett, the U.S. Secretary of Education.)

The rush to promote the "right-to-lifers" and official state murder (capital punishment) in the same breath.

The notorious National Guard of Somoza (killers), now known as the "contras" and described as our "brothers" and "freedom fighters."

The Westmoreland-CBS trial on how to lie to yourself.

James Watt, Secretary of the Interior.

Ann Buford, head of the Environmental Protection Agency.

Obviously, "['Tis] brillig, and the slithy toves
[Do] gyre and gimble in the wabe;
All mimsy [are] the borogoves,
And the mome raths outgrabe."

It is not just charade that's going on, but much more sinisterly, Orwell's newspeak. The Pentagon has a whole cottage industry going on to sanitize its vocabulary: the population at large must be outwitted and tricked.

Trapped between professed values, professed moralities, and an insatiable drive for total power and global dominance, our leaders understand neither what they are tearing apart nor what they are creating. Hypocritical manipulation is endemic, polarization is cultivated, and the grotesque ballooning defense establishment is out of control. We are seeing not just a fragmentation of values but a simultaneous militarization of society both materially and psychologically. This has become an addiction—and we are increasingly being led by arms junkies, with all that it implies: an inability to weigh or focus on anything but the next fix

(at the moment the MX missiles). In an individual, addiction is a tragedy; in a society, it is a catastrophe that may well bring that huge ball of masonry down to crush us all to blood.

All of us, and artists in particular because they have an immediate and direct route to new realities, must know and understand where we are in order to know where to go. The world may well be absurd, but we don't have to be trapped in Wonderland. I always liked this exchange between Alice and the Cheshire Cat:

> "Cheshire-Puss" she began, rather timidly, as she did not know whether it would like the name . . . "Would you tell me please, which way I should go from here?"
> "That depends a good deal on where you want to get to. . . ."
> "I don't much care where. . . ."
> "Then it doesn't matter which way you go."

What you don't know can surely get you into trouble. Nevertheless, asking questions is part of the solution. For whom is the work intended? What do you want to get across? What do you mean, intend, propose, question? What ends will be served? Being clear-headed and articulate can only help. The artist must think, sort, and evaluate.

The fact is that content is the key—content in all its nuances and subtleties. All great artists have something to say—something to reveal, information, insights to pass along:

> There on that scaffolding reclines
> Michael Angelo.
> With no more sound than the mice make
> His hand moves to and fro.
> *Like a long-legged fly upon the stream*
> *His mind moves upon silence.*[1]

The artist (a magician) transposes the mind moving upon a stream of silence into palpable concrete reality. To do this he or she must invent a language and vocabulary, a plastic structure, a form to translate and communicate all the relevant thoughts and feelings. It is a lot to do and it takes time. If it is done honestly and fearlessly it always comes out unique and distinctive because it is filtered through the mind of a single separate consciousness. The work of good artists, even within the same milieu, does not look alike.

The plastic and formal elements—the craft, the invention, the fancy, the play—are the seductive elements. They are easier to focus and dwell upon, describe and talk about. But intrinsically important as they are, they are just spin-offs, the concrete means by which the artist makes the invisible visible.

It is here that most art schools and departments get into trouble. Understandably, they tend to focus on the wrong end of the spectrum, the craft and the object. These are easier to criticize, quantify, and grade,

but they are not the core. The core is not the form, even though that is the part that you see and feel—the part that makes the work comprehensible and the part that touches you. The real core is the idea, the meaning, the perception made clear and visible by a form invented for just that purpose. This is true even though the images themselves may reveal unconscious assumptions and attitudes. The more you know about what you are after and not after, the more successful you are likely to be.

One of the elements that seems to be almost "disconsidered" (as in disinformation), at least in America, is the fact that art always has a political dimension. It may be stated or unstated, subliminal, disregarded, ignored, or overt, but one way or another it is there. To be sure, art has many functions and serves many ends, but there is always a political element of some sort.

Brecht, being didactic, said, "Ah, what an age it is when to speak of trees is almost a crime, for it is a kind of silence about injustice!"[2] But it is not necessary to be that direct to appreciate the ramifications of politics. To vote is a political act; not to vote is also a political act. It may be passive and "nonconscious," but this non-act unquestionably has political meaning and consequence. Similarly, the artist must know and understand his or her circumstances and choose accordingly; otherwise, he or she is adrift and it shows.

You can see the drift in the essential anarchy in the art world today. You can see it in the stylistic escape into the recent past. In films or fashion we call it nostalgia. But it is reactionary, a kind of romanticism without any historical consciousness. The whole notion that art is, or should be, non- or apolitical is part of what can be best described as our "official art" and aesthetics.

There is an "official art," though it is not defined by style; any style will do. It is content that counts, but only one particular aspect of it. Our official art is nonjudgmental about social conditions, structures, and values. It is understood that art is somehow remote from daily life. This attitude represents a remarkable achievement. It gives direction and guidance in near total unconsciousness to innumerable styles and forms without appearing to do so. It is not a conspiracy because the aesthetic and intellectual background is set. We operate within it without noticing.

The drive is on to produce an art that is "universally human." This sounds splendid and indeed is in many ways, but what does it mean? Its manifestations and implications are extraordinary. Let us take video as our medium for the moment, for it offers some very clearcut illustrations.

How many different kinds of cops can you remember seeing on television? Just think about it for a moment; there are fat cops, bald cops, cops on horses, cops in wheelchairs, invisible cops, blind cops, men, women, sexy, tender cops, and tough cops; they are black, oriental, pinko-grey, white, Irish, Italian, Armenian; they come elderly gray, slovenly middle, delectably young; in ones, twos, threes, and fours; as upper uppers and lower lowers; they come smiling and brooding, laconic and diffi-

dent; they come from outer space; they come from outside the law; and they have pets as well! Why? What is it all about? What does it mean?

The "universally human" is what it's all about. This notion, the official doctrine of our official art, blurs distinctions. The intent is not to illuminate social relationships but to mask them. Never mind that the police have special rights and may do things you and I may not; video suggests that the police are Everyman. Yet the police know that their role is special: They have the right to violence. It is the order of things. That is why, for example, when their behavior was questioned over the killing of the elderly Mrs. Bumpers during an eviction, the entire unit of the New York City special police sent in their resignations. After all, they followed the rules and the guidelines, and they do have special rights. We should not forget it.

Sometimes, though, it is hard to remember that the dominant aesthetic, the official art, is opposed to acknowledging the reality of social roles and relationships. Official art guides us away from speculation in this area. When it deals with social roles at all, it tells us that we are all the same, just plain folk; station and status to the contrary, we all have our problems; we are all human; when you get right down to it there are no real differences; we are cut from the same mold. But, as we know, this is not true. We are not the same. There are hosts of differences.

So, the end result of our official art and its emphasis on the "universally human" is to make society opaque. When you obscure differences, blur distinctions, and hide social contradictions, there is a loss of reality and a consequent alienation and fragmentation.

Another aspect of our art is a kind of combined formalism and romanticism. As Hauser points out "the whole exuberance, anarchy and violence of modern art, its drunken, stammering lyricism, its unrestrained, unsparing exhibitionism, is derived from [romanticism]. And this subjective, egocentric attitude has become . . . a matter of course to us . . . absolutely inevitable."[3]

> In my craft or sullen art . . .
> I labour by singing light
> Not for ambition or bread . . .
> But for the lovers, their arms
> Round the griefs of the ages,
> Who pay no praise or wages
> Nor heed my craft or art.[4]

Look inward; there you can be as intense as you like. Passionate, violent, delicate, subtle—all perceptions, all explorations, all inventions are seen as the expression of an individual psyche only. Thus they remain on safe ground. Socially, politically, this approach is searingly neutral! There is no question of evaluating the quality of life or the social structure. No questions are asked: must it be this way, is it right, can it be changed, how could this happen? All perceptions are seen as equally good or bad,

equally legitimate, equally valuable. But this can't be. Not everything is equally good. You must evaluate. Unfortunately, judgments are either not made, or are made on so narrow a focus that they do not matter. The result is a further shrouding of reality, a mystification. The "universal" human condition is considered an enigma. It is unsolvable; one can only experience it. There are no solutions; it is unfashionable to think there are, and this is the official art.

The ancient Aztec knew a great deal about art and aesthetics. They understood the situation well. Look at this definition:

The artist: disciple, abundant, multiple, restless:

The true artist: capable, practicing, skillful; maintains dialogue with his heart, meets things with his mind.

The true artist: draws out all from his heart, works with delight, makes things with calm, with sagacity, works like a true Toltec, composes his objects, works dexterously, invents; arranges materials, adorns them, makes them adjust.

The carrion artist: works at random, sneers at the people, makes things opaque, brushes across the surface of the face of things, works with care, defrauds people, is a thief.[5]

I think that in spite of the fact that there are artists and works of real achievement on the contemporary scene, the overall picture is one of the carrion artist. The unhistorical character of American thought, the failure to appreciate that the artist stands halfway between the past and the future, and a commodity-oriented sensibility all complicate the problem.

We know that the artist makes the invisible visible, but that the official art makes no judgments on the order of things. How, from here, can we get to an original magic language? How from here could we change a university, or an art department, into a Renaissance city? After all, a modern university should have the resources to draw upon to make it possible. The numbers aren't that difficult. The brains and capacity are there. What do you need to do to get it going? To give direction? In this arena at least a handful of people can really make something happen.

With art we deal with the shortest distance between mind and material reality, thought and object. No committees to convince, no elections to be won, no legislation to pass, no need to rely on anyone else. If you think it, you can make it. It's direct and immediate. It is an easy fashion of existence.

Some years ago I had the opportunity to try out some of the ideas I have on the problem. I developed the first independent study classes in painting at Pratt Institute (until then the program had been a highly structured Bauhaus regimen with no electives). The results were excellent; the work exciting. At a time when most classes almost came to a halt, because of various student demonstrations, the independent study classes

were self-sustaining and going full blast. I ran the program for two and one-half years. Here is what we did.

First, we would review a body of work and focus on what the student wanted and where he or she was stylistically, intellectually, and emotionally. Any place was a good place to be, it didn't matter. The only thing that mattered was to establish and to acknowledge what the student really cared about, what the pictorial derivations were, what influences were visible, and what and who the visual sources were. Usually the stylistic range was heavily dominated by what was currently fashionable. Whatever has been hyped or otherwise promoted in recent years is what you see most of—naturally, since you must start somewhere.

Then, we would put this to the side for a while and try to find out what the student spent most of his or her time thinking about, feeling about, dwelling upon. This is critical. You must push it if necessary. You must establish what the student really thinks is important. What really matters. Naturally you may not be able to do this all at once. Young artists (people in general) can be very inarticulate about what they are really concerned with. In fact, they probably don't even really know what they think if they have never taken the time to put it systemically into words. The very act of transposing ideas and feelings into words forces them to define what they mean. It is also essential that the evaluations not be too general. The more specific the better. The more exact you are about what counts, about what you value and want and think and about examples, the better off you are. Now you know what you should be painting.

At this point we would send the artist back to what he or she had been making. It does not matter how well done, how well crafted, how subtle or fine the composition and design is. Wherever you see the ideas and visual language of the Constructivists, Cubists, Dadaists, or Expressionists, even though beautifully achieved and formally elegant, you are seeing a built-in limitation and barrier. The very achievement of success is here a failure of insight and freshness.

It is naturally easier to understand that working in the style of the Renaissance or of the Impressionists is dated. But for the emerging artist, working as an Abstract Expressionist (or in any of the newer fashions) is equally dated. In any of these cases, the ideas and the visual language used to carry the original meaning have already been digested and absorbed and reflect a past view and somebody else's experience. Therefore, such styles cannot touch a new chord or truly reflect new conditions and personal experience; they will not awaken and sustain a quickening of feeling and insight. This is the most difficult area.

Everywhere and from all sources you, the artist, are urged to produce work that is fresh and good. The hottest fashions with their attending hype are hard to resist. What needs to be done is to weigh the things you really care about. Focus on getting the true meaning across as powerfully as possible. Rigorously resist making the composition "work" by putting in design elements previously absorbed. It is far better at this point to

leave out the part or area altogether if it isn't directly part of the concept. This approach helps clarify what really counts. First know what you are after and embroider later on. At this stage you must incessantly clarify. Be brave enough to produce paintings that don't "work." Eliminate anything that just "looks good" if it isn't part and parcel of what you are after.

When you get through all the temptations and seductions, when you get to the core of the idea and feeling (which must include where you sit historically, socially, politically, emotionally), then you will have reached the roots needed to invent a new and original language.

We always think of ourselves as technologists. We manipulate all kinds of machines and mechanical contrivances. We assemble and re-assemble molecules in original ways. We can splice genes and invent new creatures as well as substances. But, above all, humans are technicians, par excellence, of the sacred. That is to say, we are always inventing, elaborating, and constructing myths, religions, political structures, philosophies, mores. We are always interpreting and reinterpreting, attempting to make the world and our lives comprehensible, meaningful, logical.

The artist's situation today is unprecedented and confusing. There are thousands of years of art history and innumerable cultures to draw from, all having produced masterworks. Before modern times the artist was immersed in a specific culture and place. It was, in a sense, more linear and simple. Now there is everything to draw from simultaneously. It is exciting but more demanding.

The technology that the artist must use is philosophical, political, historical, and intellectual. You must weigh the "most important factors of human culture, the principles of the natural and supernatural world order, the laws of morality and logic, the ideals of truth and right, the destiny of man and the purpose of social institutions."[6]

This does not mean that you can't reject it all in the end. You can, but first you must consider it. The artist must think through and decide what the work is about, what it means, whom it serves, what it's for, what it should communicate. Otherwise you are lost, "work at random, brush across the surface of the face of things, make things opaque."[7]

Art is still, as it was in its beginnings, a magic aid toward mastering the real world. In a fragmented and alienated world, social and psychological reality must be presented in an arresting way, in a new light as it were. It must grip its audience but hopefully not in a passive way. It must make you do more than just look. Behind it you "need reason, alertness, sobriety of mind, and the will and capacity for self-control."[8] I'm interested in an imagery that demands action, that shows the rules are temporary, in constant flux, and imperfect. I'm interested in an imagery that makes you think, pass judgment, say that what is strange, unbelievable, or unfair must stop. Like the "long-legged fly upon the stream the mind moves upon silence," and it can move worlds too. That is the power of a magic language. But, you must first try to do it, certain that it will make something happen.

My sculptural paintings developed as I applied these ideas (see figures 14.1–14.6). When I decided that I did not want to make some easily transportable precious object for a private home and that I needed to reach a wider audience, the requirements and possibilities of scale changed dramatically. I felt that for the greatest impact, the figures and objects should be slightly larger than normal and that the units should be able to work in different configurations depending on the space available. This led to the shape of *The Defeat of the City of Plutonium.* In figures 14.1 and 14.2 you see the work in the Fine Arts Center at Stony Brook. As set up in figure 14.1 the piece is approximately fifty-five feet across and eighteen feet high. In figure 14.2, you see a portion of the work from the other side with a full view of the section titled *The Martydom of the Races and Sexes* In figure 14.3, you see *The Defeat* in a different configuration as it is now set up in the lobby of the Lab Office Computer Science Building at Stony Brook. Here it is approximately forty-five feet across by twenty-three feet high.

As you can see, shifting the units around allows you to play with the composition, adjust it to the space available, without in any way altering the content. I also quite literally, in developing the work, left out everything that I felt did not really count. Applying this decision meant the

14.1. *Defeat of the City of Plutonium,* Bernard Aptekar, Fine Arts Center, SUNY Stony Brook.

14.2. *Defeat of the City of Plutonium: The Martyrdom of the Races and Sexes*, Bernard Aptekar, Fine Arts Center, SUNY Stony Brook.

14.3. *Defeat of the City of Plutonium*, Bernard Aptekar, Lab Office Computer Science Building, SUNY Stony Brook.

14.4. *Aliens at the Intergalactic Cafe*, Bernard Aptekar. *Left to right: Cog from the Conglomerate Bog, Any Secretary of State, Glad-Handed Glow Worm.*

elimination of a rectangular format. This made possible a much freer, more inventive overall structure. It also allowed the development of a simultaneous abstract pattern of shape congruent with the subject matter.

Aliens at the Intergalactic Cafe (fig. 14.4) is an ongoing series. Here you see from left to right, *Cog, from the Conglomerate Bog, Any Secretary of State*, and the *Glad-Handed Glow Worm*. There are about a dozen pieces so far and the number will grow. They range in size from seven feet high (*Cog*) to about two feet high. They can stand on the floor, hook onto a wall, or hang from the ceiling. I think of them as characters and types from something like a contemporary version of the *Caprices* by Goya. I feel that at first glance they look rather playful. That is just the bait. Here I've tried to play with the shapes and color in a more formal way and have the content and its irony slip in afterwards. I wanted it cheerful, upbeat, plastic-colorful-clean, American fantastic on the surface, with the bite to follow.

They Turn Everything into Garbage (7 feet high by 15 feet across by 7 feet wide) and *One Head* (6½ feet high by 5½ feet across by 6 feet wide) are single separate pieces (figs. 14.5 and 14.6). In *They Turn Everything into Garbage* I dealt with the attitude that makes all things expendable, to be used and then discarded. Machines and people. Just something to ex-

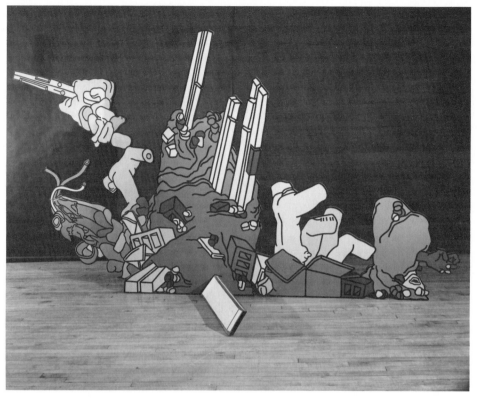

14.5. *They Turn Everything into Garbage*, Bernard Aptekar.

ploit, use up, and then forget. It is a dump consisting of sand, mortar, stone, cinder blocks, beams, pipes, and fragments of bodies. *One Head* is a more personal sort of vision. Two figures, interwined, share one head, one state of mind. There are rumpled sheets and a television set, there because they are part of our everyday life, and therefore important. That goes for all the objects and things used in these paintings. The wires or rods are tentacles of the outside world intruding into the situation. Toward the lower left is a king of organic mechanical structure with switches and dials. The image in the upper left was suggested by a line from Lorca's "Gacela of the Flight"—"There is no one who in giving a kiss does not feel the smile of / of Faceless people"—and by Catullus; Poem Five.

> Vivamus, mea Lesbia, atque amemus,
> rumoresque senum seueriorum
> omnes unius aestimemus assis.
>
> (Come, Lesbia, let us live and love,
> nor give a damn what sour old men say.)[9]

Opposite. 14.6. *One Head*, Bernard Aptekar.

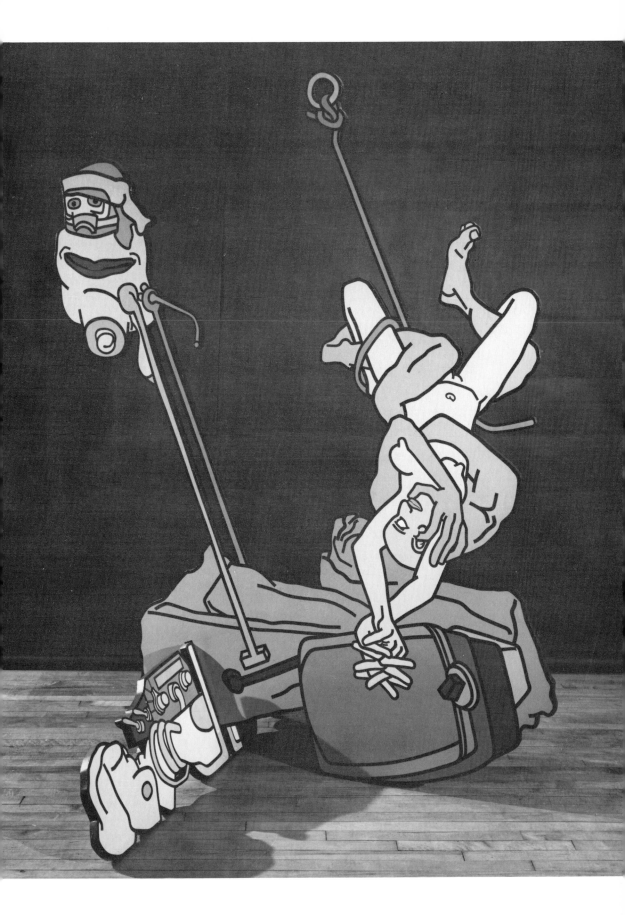

I like this piece, but fear it may be interpreted violently, which I do not intend.

I am now working on a very large opus, somewhat bigger than *The Defeat of the City of Plutonium*. It is the second part of what I expect will be a kind of trilogy. Entitled *Mephisto and the King*, it is a diptych with three hanging sections on each side. One side comes from Mephistopheles' comment to Faust that all that is born of man deserves to be destroyed in scorn. It's a kind of *Clockwork Orange*. The other side repeats some of the elements from the Mephisto half, but here they are either tamed or more whole. It comes from Martin Luther King: "I have a dream . . . now is the time." The Mephisto sections should be finished by the end of the summer of 1984, and the King section the following year. That is, if I'm not being overly optimistic—which is my general inclination and why I make this stuff in the first place!

Notes
Contributors
Index

Notes

1. Introduction: Political Art and the Rhetoric of Power in the Historical Continuum

1. Fernand Braudel. "History and the Social Sciences," in *Economy and Society in Early Modern Europe, Essays from Annales*, ed. P. Burke (New York, 1972), 11 ff.

2. Liddel and Scott's *Intermediate Greek-English Lexicon*, 7th ed. (Oxford, 1968), s.v. "πολῑτῐκός," definition III.

3. Henri Frankfort, *Kingship and the Gods, A Study of Ancient Near Eastern Religion as the Integration of Nature and Society* (Chicago, 1948), 246–47, the coronation prayer of the Assyrian king: "Before Ashur, thy god, may thy priesthood and the priesthood of thy sons find favor/With thy straight scepter make thy land wide." Also compare the inscription of Asarhaddon in R. Borger, *Die Inschriften Asarhaddons Königs von Assyrien* (Graz, 1956), no. 53, p. 81, col. 2, ll. 50–51: "(Asarhaddon) whose priestly kingship was pleasing to Ashur."

4. Frankfort, *Kingship and the Gods*, 221–22.

5. J. Burnham, *The Structure of Art* (New York, 1973); J. Ehrmann, *Structuralism* (New York, 1970).

6. Borger, *Inschriften Asarhaddons*, p. 65, col. 2, ll. 6–9, text of Asarhaddon from Nineveh.

7. Henri Frankfort, *The Art and Architecture of the Ancient Orient* (Harmondsworth: Penguin, 1977), 157 and fig. 182.

8. Compare the coronation prayer of the Assyrian king, Frankfort, *Kingship and the Gods*, 247:

The diadem of thy head—may Ashur and Ninlil, the lords of thy diadem, put it upon
thee for a hundred years. . . .
Before Ashur, thy god, may thy priesthood and the priesthood of thy sons find
favor. . . .
May Ashur grant thee quick satisfaction, justice, and peace.

with the similar relation of the Attalid dynasty of Pergamon to Dionysos, or the Seleucid rulers of Syria to the god Apollo, discussed at length by H. von Prott, "Dionysos Kathegemon," *Athenische Mitteilungen* 27 (1902), 161 ff. and F. Ohlemutz, *Die Kulte und Heiligtümer der Götter in Pergamon* (Giessen, 1940), 90 ff.

9. Concerning the messianic implications of this Augustan theme, see H. Jeanmaire, *Le Messianisme de Virgile* (Paris, 1930), and more recently R. G. M. Nisbet, "Virgil's Fourth Eclogue: Easterners and Westerners," *Bulletin of the Institute of Classical Studies of London University*, no. 25 (1978), 59–78.

10. The imagery of the local hero Theseus in the friezes of the mid-fifth century B.C. temple of Hephaistos in Athens furnishes an example of this kind; see H. Thompson, "The Sculptural Adornment of the Hephaisteion," *American Journal of Archaeology* 66

(1962), 338–47, esp. 346–47. Also see W. R. Connor, "Theseus in Classical Athens," in A. Ward, ed., *The Quest for Theseus* (New York, 1970), 143–174, concerning the larger use of this mythological figure as a symbol of the Athenian democracy. A Roman parallel would be the well-known late Archaic bronze statue of the She-Wolf on the Capitoline, closely associated with the myth of Rome's founder Romulus. The antiroyalist or republican significance of this work has been stressed by O. Brendel, *Etruscan Art* (Harmondsworth, 1978), 250–51.

11. Although the antique figure of Dea Roma anticipates the Renaissance personification of the state, she only acquired a real importance in imperial rather than republican Rome, in close association with the central figure of the emperor; see U. Knoche, *Vom Selbstverständnis der Römer = Gymnasium*, Beihefte, Heft 2, 1962, "Die augusteische Ausprägung der *Dea Roma*," 145–73.

12. See L. Nochlin, "The Imaginary Orient," *Art in America* 71 (1983), 118–31, 187–91; E. Said, *Orientalism* (New York, 1978), and in general the exhibition catalogue. *The Orientalists: Delacroix to Matisse. The Allure of North Africa and the Near East*, ed. M. A. Stevens (Washington, D.C., 1984).

13. F. Whitford, *Bauhaus* (London, 1984), 192 ff.

14. For anti-fascist protest art during the Third Reich, see the exhibition catalogue from the Badische Kunstverein, Karlsruhe, *Widerstand statt Anpassung. Deutsche Kunst im Widerstand gegen den Faschismus 1933–45* (Berlin, 1980).

15. The ceiling paintings in the lobby of the Chrysler Building (New York) provide a good example of this proletarian glorification, showing the worker as the backbone of the nation or economy, as he appeared in contemporary Soviet painting.

16. Compare the Social Realism of Nazi Germany in Johannes Beutner's *Reifezeit*, in J. Wulf, *Die Bildendenkünste im Dritte Reich*, (Sigebert Mohn Verlag, 1963), fig. 29, above left; or that of official Soviet painting, G. Sumpf, *Russische und Sowjetische Malerei* (Berlin, 1973), illustrations on pp. 14ff.

17. See Wulf, *Bildendenkünste*, esp. fig. 14, Ruff's design for the Kongresshalle, so highly reminiscent of Roman imperial fora, or fig. 22–3, classicizing sculptural treatments of Nazi political themes. Also see S. Kostof, "The Emperor and the Duce," a discussion of the Piazzale Augusto Imperatore and related fascist projects in Mussolini's Rome, in *Art and Architecture in the Service of Politics*, ed. H. A. Millon and L. Nochlin (Cambridge, 1978), 270ff.

2. The Uses of Art to Convey Political Meanings in the Ancient Near East

1. J. Meuszynski, *Die Rekonstruktion der Reliefdarstellungen und ihrer Anordnung im Nordwestpalast von Kalhu (Nimrud)*, Baghdader Forschungen, vol. 2 (Mainz, 1981), plan 2.

2. See A. L. Oppenheim's translation of the "Banquet of Ashurnasirpal" in *The Ancient Near East*, vol. 2, ed. J. B. Pritchard (Princeton: Princeton Univ. Press, 1975), 104.

3. The excerpt from Ashurnasirpal's account of his campaign in what is today the country of Lebanon is taken from a translation by A. L. Oppenheim in *Ancient Near Eastern Texts Relating to the Old Testament*, ed. J. B. Pritchard (Princeton: Princeton Univ. Press, 1950), 276.

4. See my article, "The Iconography of Death in Mesopotamia in the Early Second Millenium B.C.," *XXVI Rencontre Assyriologique Internationale* (Copenhagen, 1980), 259–69.

5. Ernst Michel, "Die Assur-Texte Salmanassars III (858–824)," *Die Welt des Orients* (1955), 141.

6. Julian Reade, "Hasanlu, Gilzanu, and Related Considerations," *Archaeologische Mitteilungen aus Iran* 12 (1979), 175–81.

7. R. N. Frye, *The Heritage of Persia* (Cleveland and New York, 1963), 99.

8. Ibid., 85.

9. Ibid.

10. Ursula Seidl, "Ein Relief Dareios' I in Babylon," *Archaeologische Mitteilungen aus Iran* 9 (1976), 125–30.

11. J. V. Canby, "A Note on Some Susa Bricks," *Archaeologische Mitteilungen aus Iran* 12 (1979), 315–20.

3. *"I Come to You as Your Lord": Late Roman Imperial Art*

1. See S. G. MacCormack, *Art and Ceremony in Late Antiquity* (Berkeley, 1982), reviewed by J. Trilling, *Times Literary Supplement* (Aug. 13, 1982), 884–85; G. Koeppel, "Profectio und Adventus," *Bonner Jahrbücher* 169 (1969), 130–74.

2. See Shakespeare, *Henry V*, act 4, sc. 1.

3. St. John Chrysostom, "An Address on Vainglory and the Right Way for Parents to Bring Up Their Children," trans. M. L. Laistner, *Christianity and Pagan Culture in the Late Roman Empire* (Ithaca, 1967), 87 (late fourth century); see Alan Cameron, *Circus Factions* (Oxford, 1976), 230–70 on the claque.

4. *S.H.A.*, "Tacitus," vol. 1–2, Loeb Libr. ed., vol. 3, trans. D. Magie (1954), 303–5; see also Averil Cameron, ed. and trans., *Flavius Cresconius Corippus, In Laudem Iustini Augusti Minoris* (London, 1976), 96–113 (mid-sixth century); J. Burian, "Die kaiserliche Akklamation in der Spätantike," *Eirene* 17 (1980), 17–43.

5. See S. G. MacCormack, "Latin Prose Panegyrics," in *Empire and Aftermath, Silver Latin*, vol. 2, ed. T. A. Dorey (London and Boston, 1975), 143–205; L. K. Born, "The Perfect Prince According to the Latin Panegyrists," *American Journal of Philology* 55 (1934), 20–35.

6. H. Laubscher, *Der Reliefschmuck des Galeriusbogens in Thessaloniki* (Berlin, 1975); M. Pond Rothman, "The Thematic Organization of the Panel Reliefs on the Arch of Galerius," *American Journal of Archaeology* 81 (1977), 427–54; H. Meyer, "Die Frieszyklus am sogennanten Triumphbogens des Galerius in Thessaloniki," *Jahrbuch des Deutschen Archäologischen Instituts* 95 (1980), 374–444.

7. See R. MacMullen, "Some Pictures in Ammianus Marcellinus," *Art Bulletin* 46 (1964), 435–55; H. P. L'Orange, *Art Forms and Civic Life in the Late Roman Empire* (Princeton, 1965); R. Brilliant, "Scenic Representations," in K. Weitzmann, ed., *Age of Spirituality* (New York, 1979), 60–69.

8. Julian, *The Heroic Deeds of Constantius*, Loeb Libr. ed, vol. 1, trans. W. C. Wright, 205 (about 355 A.D.).

9. Weitzmann, *Age of Spirituality*, 107ff., no. 99.

10. A. Lippold, "Herrscherideal und Traditionsverbundenheit im Panegyricus des Pacatus," *Historia* 17 (1968), 228–50 (given before Theodosius in Rome in 389 A.D.).

11. Ammianus Marcellinus XVI.10.9,10,12 (on the entrance of Constantius II into Rome in 357), XV.1.3, Loeb Libr. ed., vol. 1, trans. J. C. Rolfe (1950), 247, 111; see E. Auerbach, *Mimesis* (Princeton, 1953), 52ff.

12. See I. Lavin, "The House of the Lord," *Art Bulletin* 44 (1962), 1–27; F. K. Yegül, "A Study in Architectural Iconography: *Kaisersaal* and the Imperial Cult," *Art Bulletin* 64 (1982), 7–31; and in general, H. P. L'Orange, *Studies in the Iconography of Cosmic Kingship in the Ancient World* (Oslo, 1953).

13. J. and T. Marasovic, *Der Palast des Diokletian* (Zagreb, 1969); Yegül, "A Study in Architectural Iconography," 22, 23; H. P. L'Orange, *Art Forms and Civic Life in the Late Roman Empire*, (Princeton, 1965) 70–76.

14. Weitzmann, *Age of Spirituality*, 74–76. no. 64.

15. For the use of light metaphors and solar imagery in reference to Constantine, see Eusebius, *Speech on Constantine's Thirtieth Anniversary* 3.4-5, 5.1-4, in H. Drake, *In Praise of Constantine* (Berkeley, 1976), 87–89; also R. Turcan, "Images solaires dans le Panegyrique VI," *Latomus* 70 (1964), 697–706; M. H. Shepherd, Jr., "Liturgical Expressions of the Constantinian Triumph," *Dumbarton Oaks Papers* 21 (1967), 59–78.

16. Weitzmann, *Age of Spirituality*, 67–69, no. 58; R. Brilliant, *Visual Narratives* (Ithaca, 1984), 120–23.

17. See R. Klein, "Der *vomos teleotatos* Konstantins für die Christen im Jahre 312," *Römische Quartalschrift* 67 (1972), 1–28.

18. Weitzmann, *Age of Spirituality*, 18, 19, no. 11; H. Kahler, *"Konstantin 313,"* *Jahrbuch des Deutschen Archäologischen Instituts* 67 (1952), 1-30; T. Buddensieg, "Die Konstantinsbasilika in eines Zeichnung Francescos di Giorgio und der Marmorkoloss Konstantins des Grossen," *Münchener Jahrbuch der bildenden Kunst* 3d ser., 13 (1962), 37–48.

19. Lactantius, *De mortibus persecutorum* XLVI.vii; Drake, *In Praise of Constantine*, 23, 24.

20. R. Dowden, "In the Terror of Teheran," *New York Review of Books* (Feb. 2, 1984), 8.

4. The Revival of the Augustan Age in the Court Art of Emperor Frederick II

1. The standard biography remains Ernst H. Kantorowicz, *Kaiser Friedrich der Zweite*, 2 vols. (Berlin, 1927–31; Erganzungsband 2. unveränderte Aufl., Stuttgart, 1980) and in English, *Frederick the Second*, trans. E. O. Lorimer (New York, 1957). More recent studies include Thomas C. Van Cleve, *The Emperor Frederick II of Hohenstaufen. Immutator mundi* (Oxford, 1972) and H. M. Schaller, *Kaiser Freidrich II. Verwandler der Welt* (Gottingen, 1964). Recent exhibition catalogues and collected essays include Württembergisches Landesmuseum, Stuttgart, *Die Zeit der Staufer. Geschichte Kunst, Kultur, Katalog der Ausstellung*, 4 vols. (Stuttgart, 1977) and Atti della III Settimana di Studi di Storia dell'Arte Medievale dell'Universita di Roma, 15–20 May, 1978, *Federico II e l'arte del Duecento italiano*, ed. A. M. Romanini, 2 vols. (Rome, 1980).

2. Kantorowicz, *Frederick*, 3ff, 335, 395, 506ff.

3. For a description and illustration of the World Chronicle of Otto von Freising (Milan, Biblioteca Ambrosiana, Ms. F. 129. Sup.) see *Zeit der Staufer*, vol. 1:241–42, cat. no. 336; vol. 2:pl. 164.

4. The text and illustrations are reproduced in G. B. Siragusa, ed., *Liber ad honorem Augusti di Pietro da Eboli secondo il Codice 120 della Biblioteca Civica di Berna*, Fonti per la Storia d'Italia (Rome, 1905–6).

5. Siragusa, *Liber*, pl. 44; *Zeit der Staufer*, vol. 1: cat. no. 810; vol. 2: pl. 605.

6. Kantorowicz, *Frederick*, 512.

7. Ibid., 107ff.

8. Ibid., 223ff.

9. Ibid., 167ff., 197ff., 215.

10. James M. Powell, trans., *The Liber Augustalis; or Constitutions of Melfi, Promulgated by the Emperor Frederick II for the Kingdom of Sicily in 1231* (Syracuse, N.Y., 1971). In his introductory essay he discusses the law code as a political and social document and as a statement of the character of Frederick's rulership. For the Latin text, see Jean L. A. Huillard-Bréholles, *Historia Diplomatica Frederici II*, 6 vols (Paris, 1852–61), 4:1–178.

11. A recent monographic treatment of this coin type can be found in Heinrich Kowalski, *Die Augustalen Kaiser Friedrichs II von Hohenstaufen* (Geneva, 1976).

12. Ibid., 90ff., figs. 14, 15.

13. Ibid., fig. 11.

14. The major studies include: Carl A. Willemsen, *Kaiser Friedrichs II. Triumphtor zu Capua* (Wiesbaden, 1953); P. Toesca, "L'architettura della porta Capua," *Mélanges Bertaux: recueil de travaux dédié à la memorie d'Emile Bertaux* (Paris, 1924), 292–99; C. Shearer, *The Renaissance of Architecture in Southern Italy* (Cambridge, 1935); M. Cordaro, "La porta di Capua," *Ann. dell'Istituto di Storia dell'Arte, 1974–76* (Rome, 1977), 41–63; G. Scaglia, "La 'Porta delle Torri' di Federico II a Capua in un disegno di Francesco di Giorgio," *Napoli nobilissima* 20 (Sept.-Dec. 1981), 203–22 and 21 (May-Aug. 1982), 123–34.

15. Both Willemsen, *Triumphtor*, 7–10, and Shearer, *Renaissance*, 11–16, quote and discuss the primary sources for the construction of the gateway. The contemporary account is preserved in the 1233 entry of the chronicle of one of the Emperor's secretaries, the *Chronica Priora* of Ryccardi de Sancto Germano, ed. A. Gaudenzi (Naples, 1878),

145–46. Mention of roofing for the towers occurs in correspondence from Pietro di Capua to Nicola di Cicala written Nov. 17, 1239, see Huillard-Bréholles, *Historia Diplomatica*, 1:513. For the other references to the accounting of expenses and the *protomagister* Liphantis, see Huillard-Bréholles, *Historia Diplomatica*, 2:673, 880.

16. See Scaglia, "Disegno", 203ff.; Willemsen, *Triumphtor*, 26–32, figs. 98, 99; Toesca, "Capua," 295ff.; Shearer, *Renaissance*, 22–23, regarding the later history of the gateway in the sixteenth century and the drawings made just before its partial demolition. The entrance facade as it appeared c. 1500 is suggested by a drawing by Francesco di Giorgio Martini (Florence, Uffizi Gabinetto dei disegni, n. 333A recto). An earlier view is provided, c. 1500, by a drawing now in Vienna (Oesterreichische Nationalbibliothek Cod. 3528, f. 51 verso). These drawings are reproduced in figures 4.5 and 4.6.

17. See the description written in 1265 by Charles of Anjou's court poet, Andrei Ungari, *Descriptio victoriae Karolo Provinciae comite reportate* in *Mon. Germ. Hist. Script.*, 26:571. The Latin text is reproduced by Willemsen, *Triumphtor*, 77n.3, and Shearer, *Renaissance*, 16n.3.

18. Powell, *Liber Augustalis*, 123.

19. Shearer, *Renaissance*, 22ff., translates and comments on Scipio Sannelli's *Annali della città di Capua*, manuscript in the Biblioteca Communale, Capua.

20. Shearer, *Renaissance*, 19n.6, and Willemsen, *Triumphtor*, 79n.27, reproduce and translate the relevant passages in Campani, *De rebus gestis Andreae Brachii Perusini*, Muratori, *Rer. Ital. Script.*, 19:597. See Scaglia's architectural analysis, "Disegno," 203ff.

21. For the story of the gradual brutalization of the Frederick statue between 1557 and 1877, see Willemsen, *Triumphtor*, 33–40, and Shearer, *Renaissance*, 24–29. A drawing of the statue before its head was lost appears in Seroux d'Agincourt, *Histoire de l'art par les monuments. IV. Sculpture, IIe Partie* (Paris, 1823), pl. 27, 4.

22. For the enthroned statue of Charles of Anjou attributed to Arnolfo di Cambio, see A. M. Romanini, *Arnolfo di Cambio e lo "stil novo" del gotico italiano* (Florence,1980), 159ff., pl. 160; also Willemsen, *Triumphtor*, pl. 42.

23. See note 17. The inscription, also reproduced in Sannelli's *Annali*, reads "Quam miseros facio quos variare scio."

24. Regarding literature produced at court under Frederick's patronage, see C. H. Haskins, "Latin Literature under Frederick II," *Speculum* 3 (1928), 150ff., who discusses the secular character of these varied works as well as the deliberate use of Roman phraseology.

25. See note 32. The Neapolitan historian Francesco Daniele commissioned the sculptor Tommaso Solari and the intaglist Battista Bertiolo to copy the head of the Frederick statue, c. 1781. See Willemsen, *Triumphtor*, pls. 34–37, for photographs of these works. See figure 4.1 for a cast of the Solari head, now in the Museo Provinciale Campano, Capua.

26. Kowalski, *Augustalen*, fig. 12(d).

27. Horace, *Odes*, Book IV, Ode V, 5 (Loeb Classical Library, New York, 1929, 302). Siragusa, *Liber*, 100ff.

28. Willemsen, *Triumphtor*, 43.

29. Kantorowicz, *Frederick*, 685ff.

30. Scaglia, "Disegni," 208, fig. 6.

31. See C. A. Willemsen, ed., *De arte venandi cum avibus* (Leipzig, 1942) and *Zeit der Staufer*, vol. 1:cat. no. 824, vol. 2:pls. 616, 617, regarding a thirteenth-century illustrated copy of the manuscript (Rome, Biblioteca Apostolica Vaticana, Pal. lat. 1071).

32. C. A. Willemsen, "Die Bauten Kaiser Friedrichs II. in Süditalien," in *Zeit der Staufer*, vol. 3, 145, figs. 37, 38.

33. *Zeit der Staufer*, vol. 1:cat. no. 890, vol. 2:pl. 663.

34. H. P. L'Orange and A. von Gerkan, *Der spätantike Bildschmuck des Konstantinsbogens*, Berlin, 1939, 167–81, pls. 3–5, 40, 41, regarding the Hadrianic hunt *tondi* and the related *Sol* and *Luna* medallions.

35. H. Oesterley, ed., *Gesta Romanorum* (Berlin, 1872, 1963 reprint), 349–50. The relevant lines are as follows: "imperator iste est dominus noster Ihesus Christus . . . In qua porta sculpta est imago domini nostri Ihesu Christi cum duobus collateralibus, i.e. cum Maria matre Ihesu et Johanne evangelista,".

36. Horace, *Carmen Saeculare* (Loeb Classical Library, New York, 1929) 351–357.

37. L'Orange and von Gerkan, *Konstantinsbogens*, 174.

38. Ibid., 174–81.

39. See note 17. "Cesaris imperio regni custodia fio."

40. Shearer, *Renaissance*, 24, 77; Willemsen, *Triumphtor*, 48.

41. Kantorowicz, *Frederick*, 532. Shearer and Willemsen concur; see note 32.

42. See note 17. "Intrent securi qui querunt vivere puri, Infidus excludi timeat vel carcere trudi." These inscribed captions and that surrounding the female head of *Custodia*/Capua are also reproduced in a c. 1500 manuscript in the Nationalbibliothek, Vienna. See Willemsen, *Triumphtor*, pl. 104, and Shearer, *Renaissance*, fig. 60, for reproductions of the relevant folio.

43. Willemsen, *Triumphtor*, 49–55 and pl. 50–68, for additional views.

44. Powell, *Liber Augustalis*, book 3, title 94 (70), 152.

45. *Zeit der Staufer*, vol. 1: cat. no. 848, pl. 627.

46. The Solomonic associations of Henry's lion throne are noted in *Zeit der Staufer* 1:647.

47. C. A. Willemsen and D. Odenthal, *Apulien. Land der Normanner Land der Staufer* (Cologne, 1958), pls. 39, 60, respectively Troia Cathedral and the Abbey of Venosa.

48. Powell, *Liber Augustalis*, xx.

49. Willemsen, *Triumphtor*, 59ff, pl. 71–81.

50. The famous progeny is the arch in Naples of Alfonso V of Aragon. See Willemsen, *Triumphtor*, 29 and G. L. Hersey, *The Aragonese Arch at Naples, 1443–1475* (New Haven and London, 1973) 17, 23, 31.

51. As quoted in Kantorowicz, *Frederick*, 359, "manifestare ea quae sunt sicut sunt," Frederick's stated intention in writing his manual of falconry, *De arte venandi cum avibus*, a factual treatise based on his years of nature observation. *V. supra*. n. 31.

52. Kantorowicz, *Frederick*, 425ff., 454ff.; Huillard-Bréholles, *Historia Diplomatica*, 1:761.

53. Kantorowicz, *Frederick*, 421ff.

54. Ibid., 437.

55. Ibid., 514.

5. Deconstruction and Reconstruction in Poussin's Decoration of the Grande Galerie of the Louvre

1. Christiane Aulanier, *Histoire du palais et du musée du Louvre* (Pairs, 1948), vol. 1, *La Grande Galerie au bord de l'eau*, 4–5; Anthony Blunt, "Long Gallery," *Burlington Magazine* 93 (1951), 369ff. and 94 (1952), 31; Anthony Blunt and Walter Friedlander, eds., *The Drawings of Nicolas Poussin: A Catalogue Raisonné* vol. 4, *Studies for the Long Gallery, The Decorative Drawings, The Illustrations to Leonard's Treatise, The Landscape Drawings* (London, 1963), in collaboration with John Sherman and Richard Hughes-Hallett, 11ff.; Doris Wild, "Nicolas Poussin et la décoration de la Grande Galerie du Louvre," *La Revue du Louvre* 16 (1966), 77ff.; H. W. van Helsdingen, "Notes on Two Sheets of Sketches by Nicolas Poussin for the Long Gallery of the Louvre," *Simiolus* 5, nos. 3/4 (1971), 172ff.; Natalie and Arnold Henderson, "Nouvelles recherches sur la décoration de Poussin pour la Grande Galerie," *La Revue du Louvre* 29 (1978), 225ff.

2. Blunt, "Long Gallery," 93 (1951), 370. For Foucquières, see Wolfgang Stechow, "Drawings and Etchings by Jacques Foucquier," *Gazette des Beaux-Arts* 34 (1948), 419ff.

3. Jacques Thuillier, "Pour un 'Corpus Poussinianum,'" *Colloques Nicolas Poussin*, ed.

André Chastel (Paris, 1960), 2:63, 71; Anthony Blunt, *Nicolas Poussin*, Bollingen Series 35, no. 7 (New York, 1967), 158−60; Charles Jouanny, ed., *Correspondance de Nicolas Poussin*, Société de l'Historie de l'Art Français, nouvelle period 5 (Paris, 1911; reprint, Paris, 1968), 183−84, nos. 76−77.

4. Blunt, "Long Gallery," 94 (1952), 31ff; Francis J. B. Watson, *The Choiseul Box* (Oxford and London, 1963), 2ff.

5. Henri Sauval, *Histoire et recherche des antiquités de la ville de Paris* (Paris, 1724; reprint, Westhead, 1966), 2:42ff (for the 1648 date, see Blunt's introduction). Roland Fréart de Chambray, *Parallèle de l'architecture antique et de la moderne* (Paris, 1650), 4ff.; Giovanni Pietro Bellori, "Nicolo Pussino," *La Vite de'pittori, scultori et architetti moderni* (Rome, 1672; reprint in Jacques Thuillier, *Poussin* [Novara, 1969], 63ff.

6. Sauval, *Histoire*, 2:43.

7. Sauval, *Historie*, 2:44; Chambray, *Parallèle*, 34; Bellori, "Nicolo Pussino," 68.

8. Blunt, 4:11−24; Anthony Blunt and Walter Friedlander, eds., *The Drawings of Nicolas Poussin: A Catalogue Raisonné*, vol. 5, *Drawings after the Antique, Miscellaneous Drawings, Addenda* (London, 1974), 121−22.

9. Chambray, *Parallèle*, 34.

10. Bellori, "Nicolo Pussino," 68.

11. Hans Peter L'Orange and Armin von Gerkan, *Der spätantike Bildschmuck des Konstantinbogens* (Berlin, 1939), 5−8; for example, in Giovanni-Battista Marliani, *Le antichità di Roma*, 1st ed. (1560; rev. ed. 1620), 156, and Roberto Paribeni, *Optimus Princeps: Saggio sulla storia e sui tempi dell'imperatore Traiano* (Messina, 1926-1927), 2:78−79.

12. Poussin was particularly aware of the problems of size and cost: see Jouanny, *Correspondance de Nicolas Poussin*, 144−45, no. 51; Blunt, "Long Gallery," 93 (1951), 374; John Rupert Martin, *The Farnese Gallery* (Princeton, 1965), 162−64; Guilio Briganti, *Pietro da Cortona o della pittura Barocca* (Florence, 1962), 81ff. For Poussin's views on ceiling decoration, see Carl Goldstein, "Poussin's Letter to De Noyers," *Burlington Magazine* 108 (1966), 233, and "Studies in 17th Century French Art Theory and Ceiling Painting," *Art Bulletin* 47 (1965), 177ff. For a discussion of the implications of Poussin's decoration in the context of seventeenth century Roman illusionism, see Irving Lavin, *Bernini and the Unity of the Visual Arts* (New York and Oxford, 1980), 45n.80.

13. The standard biography of Trajan is Paribeni, *Optimus Princeps*. For representations in the visual arts, see H. van der Wall, *Iconclass: An Iconographic Classification System* (Amsterdam, Oxford, New York, 1980), vols. 8−9, 98B, 219, and esp. Giacomo Boni, "Leggende," *Nuova Antologia di lettere, scienza, ed arti* 126, no. 210 (1906), 3ff.; Arturo Graf, *Roma nella memorie e nella immaginazioni del medioevo*, 3d rev. ed. (Turin, 1923), 374−402; Eugene Muntz, *Les Légendes du Moyen Age dans l'art de la Renaissance: La Légende de Trajan* (Paris, 1924); Jean Seznec, "Diderot and 'The Justice of Trajan,'" *Journal of the Warburg and Courtauld Institutes* 20 (1957), 106ff.

14. J. L. Guez de Balzac, *Le Prince* (Paris, 1631), 15; see F. E. Sutcliffe, *Guez de Balzac et sons temps, littérature et politique* (Paris, 1959), 185ff.

15. *Éloges et discours sur la triomphante réception du roi en sa ville de Paris après la réduction de Rochelle* (Paris, 1629), 80.

16. The literature on imperial revivals and related themes is vast. For a useful summary of the literature and exemplary analysis of the use of these ideas in political art, see Loren Patridge, "Divinity and Dynasty at Caparola: Perfect History in the Room of the Farnese Deeds," *Art Bulletin* 50 (1978), 494ff., esp. 528−30. For the association of the French monarchy with imperial ideal, see Robert Folz, *Le souvenir et la légende de Charlemagne* (Paris, 1950), 114−47, 203−462, and *L'Idée d'empire en Occident du Ve au XIVe siècle* (Paris, 1953), 135−45.

17. Robert W. Scheller, "Imperial Themes in the Art and Literature of the Early French Renaissance: The Period of Charles VII," *Simiolus* 12, no. 1 (1981), 5−69; Volker Hoffman, "*Donec totum impleat orbem:* symbolisme impériale au temps du Henri II," *Bulletin de la Société de l'Histoire d'Art Français* (1978), 29−42; Frances Yates, *Astraea: The Impe-*

rial Theme in the Sixteenth Century (Harmondsworth, 1977), 121–47, 208–14, with further bibliography.

18. Pliny the Younger, *Panegyric to Trajan*, sec. 81, 1–2; Francois Perrier, *Icones et segmenta illustrium e marmore tabularum quae Romae adhuc extant* (Rome and Paris, 1645), pl. 35. For Bellori's authorship of the inscriptions, see Kenneth Donohue, "Giovanni Pietro Bellori," *Dizionario biografico degli Italiani*, 7:787.

19. For pietas and *fortitudo-virtue-victoria* as coupled virtues in Roman imperial ideology, see M. P. Charlesworth, "Pietas and Victoria," *Journal of Roman Studies* 33 (1943), 1–10; for these virtues in Trajanic Art, see Karl Fittschen, "Das Bildprogram des Trajansbogen in Benevent," *Archäologische Anzeiger* 87 (1972), 785–86, pl. 32; for Justice, Fortitude, and Piety as the preeminent virtues of the French monarch, see Michael Tyvaert, "L'Image du roi: légitimité et moralités royales dans les histoires de France au XVIIe siècle," *Revue d'histoire moderne et contemporaine* 21 (1974), 531–34, and Jacques Hennequin, *Henri IV dans les oraisons funèbres ou la naissance d'une légende* (Paris, 1977), 117, 191.

20. L'Orange and von Gerkan, *Konstantinbogens*, 172–74. Four drawings after the *tondi* and seven after prints depicting the column have been attributed by Blunt to Poussin; for the drawings after the prints of the column, see Blunt 5:36–38, nos. 328–35, and after the *tondi*, see Blunt 5:30–31, nos. 307–10. While the attribution of the drawings after the column seem secure, the *tondi* drawings are less certain. The pen work seems too unbroken and insensitive to depth, the use of red chalk, although typical of early Poussin drawings, seems inconsistent with the proposed date of the early 1640s. Indeed, the drawings seem closer in style to Poussin's Italian contemporaries, like Mola; for example, Richard Cocke, *G. B. Mola* (Oxford, 1972), pls. 9 and 10, dated to 1641–1642. For earlier drawings after the *tondi* and the column, see Bernhard Degenhart and Annegrit Schmitt, "Ein Musterblatt des Jacopo Bellini mit Zeichnungen nach der Antike," *Festschrift Luitpold Dussler* (Munich, 1972), 139ff., and R. Chevallier, "Dessins de 16ème siècle de la colonne Trajane dans une collection parisienne, contribution à l'histoire des formes et des idées," *Bulletin de la Société Nationale des Antiquaires de France* (1977), 130ff.

21. Giulio Romano used a similar device in his Sala degli Stucchi, where depictions of Mars and Hercules represent *fortitudo*, a virtue expressed in the narrative scenes of the rest of the decoration based on the Column of Trajan; see Egon Verheyen, *The Palazzo del Té in Mantua: Images of Love and Politics* (Baltimore, 1977), 35–36. Malcolm Campbell (*Pietro da Cortona at the Pitti Palace: A Study of the Planetary Rooms and Related Projects* [Princeton, 1977], 146ff.) points to a similar system, although Cortona's *istorie* are not historical but allegorical; see also Charles Dempsey, "Review of Malcolm Campbell's *Pietro de Cortona at the Pitti Palace*," *Art Bulletin* 61 (1979), 141–144. For the interaction of allegorical and narrative elements in the column reliefs, see Per Gustaf Hamberg, *Studies in Roman Imperial Art with Special Reference To the State Reliefs of the Second Century* (Uppsala, 1945), 110ff., and Richard Brilliant, *Visual Narratives: Storytelling in Etruscan and Roman Art* (Ithaca and London, 1984), 90–123.

22. Ibid., 110–11.

23. Julius Held, *The Oil Sketches of Peter Paul Rubens* (Princeton, 1982), 78ff:, *Charles Le Brun, 1619–1690*, exh. cat. (Versailles, 1963), 109ff.

24. Above all in Poussin's *Letter on the Modes*: see Blunt, *Poussin*, 225–27; Wilhelm Messerer, "Die Modi im Werk von Poussin," *Festschrift Luitpold Dussler* (Munich, 1972), 335–56. See Rudolf Wittkower, "The Role of Classical Models in Bernini's and Poussin's Preparatory Work," *Studies in Western Art*, Vol. 3, Acts of the Twentieth International Congress of the History of Art (Princeton, 1963), 41ff.; Oskar Batschmann, "Poussin's *Narziss und Echo* im Louvre: Die Konstruktion von Thematik und Darstellung aus den Quellen," *Zeitschrift für Kunstgeschichte* 42 (1979), 31ff. and *Dialektik der Malerei von Nicolas Poussin* (Zurich, 1982), 45.

25. Marc Bloch, *Les Rois Thaumaturges* (Strasbourg, 1924), 360.

26. Henderson and Henderson, "Nouvelles recherches," 224; Joseph Forte, "Politi-

cal Ideology and Artistic Theory in Poussin's Decoration of the Grande Gallerie of the Louvre" (Ph.D. diss., Columbia University, 1982).

27. Biographies of Roman emperors are relatively rare subjects for the decoration of princely galleries in the sixteenth and seventeenth century despite numerous admonitions of theoreticians to employ these themes. Among those Poussin would have known are the decoration of the Sala di Costantino by Giulio Romano and Francesco Penni and the *modelli* for the tapestries of the *Life of Constantine* by Rubens; see Rolf Quednau, *Die Sala di Costantino im Vatikanischen Palast: zur Dekoration der beiden Medici-Päpste Leo X und Clemens VII*, Studium for Kunstgeschichte, 13 (Hildesheim and New York, 1979); and for the Constantine tapestries, see Julius Held, *The Oil Sketches of Peter Paul Rubens* (Princeton, N.J., 1982), 63ff. The only known example of the use of casts of reliefs of the Column of Trajan for stucco decorations is Giulio Romano's *Sala di Stucchi* in the Palazzo del Té, Mantua, see Frederick Hartt, *Giulio Romano* (New Haven, 1958), 145ff.

28. For example, in Alberti, *De re aedificatoria*, 9: 6; G. B. Armenini, *De veri precetti della pittura* (Ravenna, 1587), 3: 8; Antoine de Laval, *Peintures convenables aux basiliques et palais du roi* (Moulins, 1600), 1–3. For a similar biographical decoration see Campbell, *Pietro da Cortona at the Pitti Palace*, 146–53.

29. Jacques Derrida, *On Grammatology*, trans. Gayatri Chakravoity Spivak, (Baltimore, Md. 1977), 43ff. For a sensible introduction to Derrida and to poststructuralist thought, see Christopher Norris, *Deconstruction: Theory and Practice* (London, 1982).

30. Blunt, *Poussin*, 354–63.

31. For the unities of time and of place, see Rensselear Lee, *Ut Pictura Poesis: The Humanistic Theory of Painting* (New York, 1967), 12ff.

32. Jacques Derrida, *Speech and Phenomena, and Other Essays on Husserl's Theory of Signs*, trans. David B. Allison (Evanston, Ill., 1973), 18ff.

33. For the idea of the competent audience or reader, see Terry Eagleton, *Literary Theory: An Introduction* (Minneapolis, 1983), 74–88 and in painting, Norman Bryson, *Vision and Painting: The Logic of the Gaze* (New Haven and London, 1983), 133–62.

34. Karl Lehmann-Hartleben, *Trajanssäule: Ein römisches Kunstwerk zu Beginn der Spätantike* (Berlin and Leipzig, 1926), 51ff.; Brilliant, *Visual Narratives*, 90–108, notes the difficulty of seeing the original column and then proceeds to posit a hermenutic based on clear legibility.

35. L'Orange and von Gerkan, *Konstantinbogens*, 5ff.; Brilliant, *Visual Narratives*, 120–23.

36. Held, *Oil Sketches of Rubens*, 95–96.

37. For disparate modern interpretations that support my view of the ambiguity of the theme see Held, *Oil Sketches of Rubens*, 89–95.

38. Leo Tolstoy, *War and Peace*, trans. L. A. Maude, Great Books of The Western World, 51:342, 447, 465.

39. Roman Schnur, *Individualismus und Absolutismus. Zur politischen Theorie vor Thomas Hobbes, 1600–1640 (Berlin, 1963).*

6. "Venetia": The Figuration of the State

This paper was originally published in David Rosand, ed., *Interpretazioni Veneziane: Studi di storia dell'arte in onore di Michelangelo Muraro* (Venice, 1984), 177–96.

1. See Gaetano Cozzi, "La ventura di Alessandro III a Venezia nel dibattito religioso e politico tra il '500 e il '600," *Ateneo Veneto* 15 (1977), 119–32; for the ceremonial and iconographic aspects of the theme, see the contributions of Lina Padoan Urban, "La Festa della Sensa nelle arti e nell'iconografia," *Studi veneziani* 10 (1968), 291–353, esp. 291–311, and Edward Muir, *Civic Ritual in Renaissance Venice* (Princeton, 1981), 103–19. Further relevant bibliography on aspects of the myth of Venice will be found in David Rosand, *Painting in Cinquecento Venice: Titian, Veronese, Tintoretto* (New Haven and London, 1982),

239–40 passim. To that bibliography should be added Wolfgang Wolter's important monograph, *Der Bilderschmuck des Dogenpalastes: Untersuchungen zur Selbstdarstellung der Republik Venedig im 16. Jahrhundert* (Wiesbaden, 1983), for the pictorial representation of the events of 1177, see esp. 164–81, and, for the representation of *Venetia*, 236–46.

2. Petrarch, *Epistolae seniles*, 4: 3. In his *Venetia* of 1581 Francesco Sansovino quotes part of this passage in Italian translation: "La quel lettera . . . descrivendo la qualità di Venetia in quel tempo, mi è piaciuto di mettere in questo luogo, non Latina come egli scrisse, ma fatta Volgare, si come ella stà, per intelligenza d'ogni uno, & è questa, dopo l'introduttione d'essa lettera.

L'Augustissima Città de i Veneti, la quale hoggi è casa di libertà, di pace, & di giustitia, rifugio de buoni. Solo Porto de legni conquassati dalle tempeste in ogni parte, delle guerre, & delle tirannidi, à coloro, che desiderano di viver bene. Città ricca d'oro, ma più ricca di fama. Potente di facultà, ma molto più potente di virtù. Fondata su saldi marmi, ma più saldamente stabilita sul saldo fondamento della concordia civile. Cinta dall'onde salse, ma difesa da più salsi consigli,"

Venetia città nobilissima et singolare, ed. Giustiniano Martinioni (Venice, 1663), 407–8. On Sansovino, see Paul F. Grendler, "Francesco Sansovino and Italian Popular History, 1560–1600," *Studies in the Renaissance* 16 (1969), 139–80.

A full English translation of Petrarch's letter is available in David Thompson, ed., *Petrarch, A Humanist Among Princes: An Anthology* (New York, Evanston, and London, 1971), 197–203. On Petrarch in Venice, see Fritz Saxl, *A Heritage of Images: A Selection of Lectures by Fritz Saxl*, ed. Hugh Honour and John Fleming (Middlesex and Baltimore, 1970), 43–56, as well as several of the contributions to the volume *Petrarca, Venezia e il Veneto*, ed. Giorgio Padoan (Florence, 1976): Lino Lazzarini, "'Dux ille Danduleus'. Andrea Dandolo e la cultura veneziana a metà del Trecento" (pp. 123–56); Michelangelo Muraro, "Petrarca, Paolo Veneziano e la cultura artistica alla corte del doge Andrea Dandolo" (pp. 157–68); and Guido Perocco, "Il Palazzo Ducale, Andrea Dandolo e il Petrarca" (pp. 169–77).

3. *The Commonwealth and Government of Venice. Written by the Cardinall Gaspar Contareno and translated out of Italian into English by Lewes Lewkenor* (London, 1599), 2. Contarini's Italian version read: "Ma quasi tutti gli huomini di piu polito, et acuto ingegno si stupiuano di questa nuoua ragione del sito della città: talmente opportuna ad ogni cosa, che sono usati, ch'ella sia piu tosto fabrica de gli Dei, che opera, & trouato de gli huomini," *La repvblica e i magistrati di Vinegia, libri* 5 (Venice, 1548), 3v.

On Contarini and his book, see Felix Gilbert, "The Date of the Composition of Contarini's and Giannotti's Books on Venice," *Studies in the Renaissance* 14 (1967), 172–84; see also J. G. A. Pocock, *The Machiavellian Moment: Florentine Political Thought and the Atlantic Republican Tradition* (Princeton, 1975), 272–330, Chapter 9: "Giannotti and Contarini: Venice as Concept and as Myth."

4. James Howell, *S.P.Q.V. A Survay of the Signorie of Venice, of Her Admired Policy, and Method of Government, &c.* (London, 1651), 55. The locution suggests that Howell's source was probably *The Garden of Pleasure* "done first out of Italian into Englishe by James Sandford" in 1573: "Venetia, chi non ti vede, non ti pretia: Venice, he that doth not see thee, doth not esteeme thee." Shakespeare's source, however, may have been John Florio's *Firste Fruites* (1578) (or his *Second Fruites*, 1591): "*Venetia, chi non ti vede, non ti pretia, ma chi ti vede ben gli costa.* Venise, woo seeth thee not, praiseth thee not, but who seeth thee, it costeth him well"; see the New Variorum edition of *Love's Labour's Lost*, ed. Horace Howard Furness (Philadelphia, 1904), 150–51, 351–57. See also Frances A. Yates, *John Florio: The Life of an Italian in Shakespeare's England* (Cambridge, 1934), 334–36. According to Horatio F. Brown, the saying first appeared in the early sixteenth century, printed in the *Dieci tavole*, ten broadsides of collected Venetian proverbs (*Studies in the History of Venice* [London, 1907], 2: 161). Already by 1542, the date of Andrew Borde's *The First Boke of the Introduction of Knowledge*, some version of the proverb had reached England: "Who-

soever that hath not seene the noble citie of Venis hath not sene the beewtye and ryches of thys worlde" (cited by Z. S. Fink, "Venice and English Political Thought in the Seventeenth Century," *Modern Philology* 38 [1940–41] 156).

5. Francesco Sansovino, *Delle cose notabili che sono in Venetia, libri* 2 (1556; Venice, 1583), 57. On the Loggetta, see Manfredo Tafuri, *Jacopo Sansovino e l'architettura del '500 a Venezia*, 2d ed. (Padua, 1972), 72–80, and Deborah Howard, *Jacopo Sansovino: Architecture and Patronage in Renaissance Venice* (New Haven and London, 1975), 28–35. On architecture as a presentation of state, see Manfredo Tafuri, "'Sapienza di stata' e 'atti mancati': Architettura e tecnica urbana nella Venezia del '500," in *Architettura e utopia nella Venezia del Cinquecento*, exh. cat. (Venice, 1980), 16–39.

6. For a recent study of state iconography in the medieval commune, with full bibliography, see Jonathan B. Riess, "Uno studio iconografico della decorazione ad affresco del 1297 nel Palazzo dei Priori a Perugia," *Bollettino d'arte* 66 (1981), 43–58.

7. See Wolfgang Wolters, *La scultura veneziana gotica, 1300–1460* (Venice, 1976), 46–47 and cat. no. 49. Although the roundel has occasionally been dated as late as ca. 1420, Wolters argues for a much earlier date, before 1355, the year of the death of Filippo Calendario, to whom he attributes the work. Furthermore, Wolters suggests that the Ducal Palace relief served as the model for the two similar reliefs of Giustizia and Fortezza on the façade of the Palazzo Loredan on the Riva di Ferro, which can be dated to 1365 (ibid., cat. no. 98). See also Wolters, *Der Bilderschmuck*, 236–37.

8. Wolters, however, has denied that this *Venecia* is in fact a Justice figure or derived from that virtue. Arguing that Francesco Sansovino's comment (*Venetia città nobilissima*, 326: "scolpito di mezzo rilievo una Giustitia in una Lunetta") is a careless cinquecento misreading inspired by the experience of the Loggetta relief, Wolters suggests instead that the Venecia with a sword basically stands for the idea of "Buon Governo." For its imperial aspect he adduces Albertino Mussato's declaration, "Venetia mari dominatrix Adriatici" and the victory over Zara in 1346 that assured Venice's control of the Adriatic.

9. For Jacobello del Fiore's painting, see Sandra Moschini Marconi, *Gallerie dell'Accademia di Venezia. Opere d'arte dei secoli XIV e XV* (Rome, 1955), cat. no. 26. For the Porta della Carta and the Bon workshop, see Anne Markham Schulz, *The Sculpture of Giovanni and Bartolomeo Bon and their Workshop*, Transactions of the American Philosophical Society 6, no. 3 (Philadelphia, 1978), 7, 9, 32–49. On the medieval personification of Justice, see Adolf Katzenellenbogen, *Allegories of the Virtues and Vices in Medieval Art* (London, 1939) and Ernst H. Kantorowicz, *The King's Two Bodies: A Study in Mediaeval Political Theology* (Princeton, 1957), 97–143 passim.

10. On the Ducal Palace, its significance and role in the iconography of Venice, see Rosand, *Painting in Cinquecento Venice*, 127–29, 277–78, with further references, and Wolters, *Der Bilderschmuck*.

11. Sansovino, *Venetia città nobilissima*, 337: "Su le cui cime dalla parte di Piazza si vede vna Venetia più alta che il naturale, con lo scettro in mano, & dalla parte del canal grande vna giustitia, scolpite l'vna & l'altra da Alessandro Vittoria."

An interesting and relatively early variant on this iconography occurs on the central bronze pedestal by Alessandro Leopardi, set up in Piazza San Marco in 1505. There the figure of Venetia/Giustitia appears rather as a triumphant Judith carrying the head of Holofernes—anticipating the similar figure frescoed on the Fondaco dei Tedeschi—and accompanied by an elephant, symbol of Forza. This is illustrated in Rosand, *Interpretazioni Veneziane*, fig. 17; see also Wolters, *Der Bilderschmuck*, p. 241. On the elephant, see Millard Meiss, *Mantegna as Illuminator* (New York, 1957), 8–12.

12. Girolamo Bardi, *Dichiaratione di tvtte le historie, che si contengono ne' quadri posti nuouamente nelle Sale del Scrutinio, & del gran Consiglio del Palagio Dvcale della Republica di Vinegia* (Venice, 1587; reprinted 1606). On the program of the redecoration, see Wolfgang Wolters, "Der Programmentwurf zur Dekoration des Dogenpalastes nach dem Brand vom 20. Dezember 1577," *Mitteilungen des Kunsthistorischen Institutes in Florenz* 12 (1966), 271–318; Wolters, *Der Bilderschmuck*; and Staale Sinding-Larsen, *Christ in the*

Council Hall: Studies in the Religious Iconography of the Venetian Republic, Acta ad archaeologiam et artium historiam pertinentia, Institutum Romanum Norvegiae, 5 (Rome, 1974).

13. Bardi, *Dichiaratione di tvtte le historie* (ed. 1606), 46.

14. Ibid., 45v.

15. For representations of Dea Roma, see Cornelius C. Vermeule, *The Goddess Roma in the Art of the Roman Empire* (Cambridge, Mass., 1959). On the general theme of Venice as a new Rome, see D. S. Chambers, *The Imperial Age of Venice, 1380–1580* (London, 1970), 12–30, chapter 1: "Another New Rome?"); also Wolters, *Der Bilderschmuck,* 265–68.

16. See Sansovino, *Venetia città nobilissima,* 4: "Singolare parimente, perche in vn tempo medesimo hebbe, & l'origine sua, & la sua libertà. . . . La qual libertà non le fu mai turbata, & ciò per la forma del suo eccelso gouerno. Consiosia che temperato di tutti i modi migliori di qualunque spetie di publica amministratione, & composto à guisa di harmonia, proportionato, & concordante tutto à se stesso, è durato già tanti secoli, senza seditione ciuil senz'armi, & senza sangue fra i suoi Cittadini, inuiolabile, & immaculato; lode veramente unica di questa Città, della quale non può gloriarsi, ne Roma, ne Athene, ne Cartagine, ne qual si voglia altra Republica, che sia stata presso à gli antichi di maggior grido." On the harmonic theme in this discourse, see Ellen Rosand, "Music in the Myth of Venice," *Renaissance Quarterly* 30 (1977), 511–37.

17. See Robert Weiss, "La medaglia veneziana del Rinascimento e l'umanesimo, in *Umanesimo europeo e umanesimo veneziano,* ed. Vittore Branca (Florence, 1963), 339. The medal is illustrated in George F. Hill, *A Corpus of Italian Medals of the Renaissance before Cellini* (London, 1930), 1:4, no. 11; vol. 2: pl. 1. See also Giovanna De Lorenzi, *Medaglie di Pisanello e della sua cerchia,* exh. cat., Museo Nazionale del Bargello (Florence, 1983), no. 1; Wolters, *Der Bilderschmuck,* 238–39.

18. Charles Yriarte, *Venise* (Paris, 1878), 261; Hill, *A Corpus of Italian Medals,* 1:108, no. 410; vol. 2, pl. 77. On Foscari's grandest contribution to the monumental iconography of Venice, see Debra Pincus, *The Arco Foscari: The Building of a Triumphal Gateway in Fifteenth Century Venice* (New York and London, 1976).

19. Here we need only mention the figure of Florentia, who appears in Medicean iconography beginning in medals of Cosimo "Pater Patriae." On the imagery of the Florentine republic, see Donald Weinstein, "The Myth of Florence," in *Florentine Studies: Politics and Society in Renaissance Florence,* ed. Nicolai Rubinstein (London, 1968), 15–44, with further references.

20. On Guariento's monumental fresco, executed during the dogato of Marco Cornaro (1365–1368), see especially Sinding-Larsen, *Christ in the Council Hall,* 45–56, 65–66; see also Francesca Flores d'Arcais, *Guariento* (Venice, 1965), 72–73, for further bibliography. For Petrarch's impact on the political self-consciousness of Venice, see note 3 above.

21. Quoted from Patricia H. Labalme, *Bernardo Giustiniani, A Venetian of the Quattrocento* (Rome, 1969), 267; see also chapter 10, "History of the Origin of Venice," 247–304. For a review of the earlier, prehumanistic historiographic traditions, see Antonio Carile and Giorgio Fedalto, *Le origini di Venezia* (Bologna, 1978), esp. 19–123, part 1: "Le origini di Venezia nella tradizione storiografica," with further bibliography.

22. Sandra Moschini Marconi, *Gallerie dell'Accademie di Venezia. Opere d'arte del secolo XVI* (Rome, 1962), cat. no. 73; see also Wolters, *Der Bilderschmuck,* 63–64.

23. This basic structure, further transformed, appears in a drawing in Berlin once attributed to Pordenone, (illustrated in Rosand, *Interpretazioni Veneziane,* fig. 12; see Charles E. Cohen, *The Drawings of Giovanni Antonio da Pordenone* [Florence, 1980], 129, with earlier references): flanked by St. Sebastian and St. Roch, the Madonna and Child are seated upon a throne supported by two lions. Here the traditional identification of the Virgin as *Sedes Sapientiae* and of Venice as Vergine are reunited (if only by implication), each reinforcing the other even as it draws new expressive capabilities from it. Compare the function of the enthroned St. Mark as a figure of Venice in Titian's altarpiece from Santo Spirito in Isola (David Rosand, *Titian* [New York, 1978], 68, and Rosand, *Painting in Cinquecento Venice,* 69–70).

24. See Sinding-Larsen, *Christ in the Council Hall*, 55–56, 174–75.

25. In general on the political significance and function of this figure in the Renaissance, see Frances A. Yates, *Astraea: The Imperial Theme in the Sixteenth Century* (London and Boston, 1975), esp. 29–87, "Queen Elizabeth I as Astraea." See also Kantorowicz, *The King's Two Bodies*, 101n.41, and 111–12n.73, on the transformations and exchanges of the Virgo Astraea and the Virgin Mary, Iustitia, and Ecclesia, in the twelfth century.

26. Cited by Sinding-Larsen, *Christ in the Council Hall*, 155.

27. Giovandomenico Roncale of Rovigo, in Francesco Sansovino, *Delle orationi recitate a principi di Venetia nella loro creatione da gli ambasciadori di diverse città* (Venice, 1562), 48, quoted by Sinding-Larsen, *Christ in the Council Hall*, 140. It is one of the great merits of Sinding-Larsen's study that he has introduced the rich body of panegyric literature that, precisely for being so commonplace, establishes the thematic leitmotifs of Venetian self-glorification, as well as attesting to the scope of that propaganda. See also Staale Sinding-Larsen, "L'immagine della Repubblica di Venezia," in *Architettura e utopia*, exh. cat., 40–49.

28. Sansovino, *Venetia città nobilissima*, 323.

29. *The Pilgrimage of Arnold von Harff, Knight . . . , 1496–1499*, trans. Malcolm Letts (London, 1946), 59. Further on the iconography of this celebration, note 1 above.

30. Thomas Coryat, *Coryats Crudities* (London, 1611), 158.

31. Ibid., 278–79.

32. Ibid., 290.

33. The English appreciation of Venice, which received early impetus from Lewkenor's translation of Contarini in 1599 (see note 3 above), may be said to culminate in Wordsworth's elegy "On the Extinction of the Venetian Republic," which was published in 1807; the tradition is then revived with heroic and creative nostalgia in the literary and practical efforts on behalf of the Serenissima undertaken by Ruskin. For the purely political tradition, see Fink, "Venice and English Political Thought," 155–72; William Bouwsma, "Venice and the Political Education of Europe," in *Renaissance Venice*, ed. J. R. Hale (London, 1973), 445–66; Brian Pullan, "The Significance of Venice," *Bulletin of the John Rylands University Library* 56 (1974), 443–62; and Pocock, *The Machiavellian Moment*, 383–400 passim. See also Eco O. G. Haitsma Mulier, *The Myth of Venice and Dutch Republican Thought in the Seventeenth Century* (Assen, 1980).

34. Howell, *S.P.Q.V.*, 1. For an early modern appreciation of Howell and his response to Venice, see Arthur Livingston, "James Howell e la città vergine," *Fanfulla della Domenica* no. 20 (Rome, May 19, 1912). The theme was soon repeated in James Harrington's *Oceana* (1656): "To come unto experience, *Venice*, notwithstanding that we have found some flaws in it, is the only Commonwealth, in the make wereof, no man can find a cause of dissolution; for which reason wee behold her (albeit she consist of men that are not without sin) at this day with one thousand years upon her back, for any internal cause, as young, as fresh, and free from decay, or any appearance of it, as shee was born, but whatever in nature, is not sensible of decay by the course of a thousand years, is capable of the whole age of nature; a Commonwealth rightly ordered, may for any internal causes be as immortal, or longlived as the World" (ed. S. B. Liljegren [Heidelberg, 1924], 185–86).

35. See Sinding-Larsen, *Christ in the Council Hall*, 55, 218, pl. 99b.

36. Father Richard Lamoureux has been preparing a study of the image of Venice especially in relation to Rome.

37. For the interdict of Pope Paul V and the Venetian response, see William J. Bouwsma, *Venice and the Defense of Republican Liberty* (Berkeley and Los Angeles, 1968), and Gaetano Cozzi, *Paolo Sarpi tra Venezia e l'Europa* (Turin, 1979).

38. See the references cited in notes 33 and 37, above.

39. *Coryats Crudities*, 199.

40. Ibid., 199–200.

41. Ibid., 200.

42. Bardi, *Dichiaratione di tvtte le historie*, 45v, illustrated in Rosand, *Interpretazioni Ve-*

neziane, fig. 6. For the ceiling of the Sala del Maggior Consiglio, see Wolters, *Der Bilderschmuck*, 275–87.

43. *Coryats Crudities*, 200.

44. Ibid. See Bardi, *Dichiaratione di tvtte le historie*, 45v, illustrated in Rosand, *Interpretazioni Veneziane*, fig. 7, and Wolters, *Der Bilderschmuck*, fig. 285.

45. Howell, *S.P.Q.V.*, 32.

46. Giovanni Nicolò Doglioni, *Venetia trionfante et sempre libera* (Venice, 1613), p. vi:

<div align="center">

INCERTI AVTHORIS
DE EADEM VRBE.
Aut Venus à Venetis sibi fecit amabile nomen,
Aut Veneti Veneris nomen, & omen habent.
Orta maris spuma fertur Venus, & Venetorum
Si videas vrbem, creditur orta mari.
Iuppiter est illi genitor, sed Mars pater huic est;
Mulciberi coniunx illa, sed ista maris.
Complet amat, hunc numquam debet amare Venus.

</div>

47. Cited by Antonio Medin, *La storia della Repubblica di Venezia nella poesia* (Milan, 1904), 20, 387–88.

48. Ibid. In his *Regulae artificialis memoriae*, Bernardo Giustiniani imagined "a beautiful lady to represent Venice, who shot arrows into a crowned serpent which represented the enemy" (Labalme, *Bernardo Giustiniani*, 59).

49. London, British Museum, Add. Ms. 21463, fol. 1. Illustrated in Rosand *Interpretazioni Veneziane*, fig. 13, and Wolters, *Der Bilderschmuck*, fig. 247. See Giordana Mariani Canova, *La miniatura veneta del Rinascimento* (Venice, 1969), cat. no. 1, p. 141.

50. Paolo D'Ancona, *The Schifanoia Months at Ferrara* (Milan, 1955), 35–37, pls. 13–15. See Edgar Wind, *Pagan Mysteries in the Renaissance* (Harmondsworth, 1967), 84, 89.

51. Illustrated in Rosand, *Interpretazioni Veneziane*, fig. 16. Aloïse Heiss, *Les médailleurs de la Renaissance: Venise et les Vénitiens du XVe au XVIIe siècle* (Paris, 1887), 190, no. 21; Hill, *A Corpus of Italian Medals*, 1:129, no. 489; vol. 2, pl. 91. I am grateful to Father Lamoureux for bringing this medal to my attention.

52. The height of Renier's career was evidently his election as "podestà e capitano" of Rovigo on April 3, 1527: see *I diarii di Marino Sanuto*, ed. Rinaldo Fulin et al. (Venice, 1879–1903), 44: cols. 420, 422.

53. Zelotti's girdled nude Venice may be compared with the Venus figures of Veronese's frescoes in the Villa Barbaro at Maser, in the so-called Stanza di Bacco and Stanza del Tribunale d'Amore.

54. See Juergen Schulz, *Venetian Painted Ceilings of the Renaissance* (Berkeley and Los Angeles, 1968), cat. no. 35, pp. 97–99. Daniele Barbaro's role as an iconographer is discussed at length by Inge Jackson Reist, *Renaissance Harmony: The Villa Barbaro at Maser*, (Ph.D. diss., Columbia University, 1985).

55. I have discussed this aspect of Venetian iconography in "Venezia e gli dei," in *"Renovatio Urbis": Venezia nell'età di Andrea Gritti (1523–38)*, ed. Manfredo Tafuri (Rome, 1984) 201–215.

56. Howell, *S.P.Q.V.*, opp. title page:

<div align="center">

Upon the Citty and Signorie of VENICE.
Could any State on Earth Immortall be,
Venice by Her rare Goverment [*sic*] is She;
Venice Great Neptunes Minion, still a Mayd,
Though by the warrlikst Potentats assayed;
Yet She retaines Her Virgin-waters pure,
Nor any Forren mixtures can endure;
Though, Syren-like on Shore and Sea, Her Face
Enchants all those whom once She doth embrace;

</div>

Nor is ther any can Her bewty prize
But he who hath beheld Her with his Eyes:
 These following Leaves display, if well observd,
 How She so long Her Maydenhead preservd,
 How for sound prudence She still bore the Bell;
 Whence may be drawn this high-fetchd parallel,
Venus and Venice are Great Queens in their degree,
Venus is Queen of Love, Venice of Policie.

7. *Political and Social Themes in Late Eighteenth Century British Images of India*

1. Pierre Legendre, *Notre epopée coloniale* (Paris, 1900).

2. Thomas Daniell and William Daniell, *Oriental Scenery* (London, 1795–1808), part 1, 1795; part 2, 1797; part 3, 1799; part 4, 1801; part 5, 1803; part 6, 1807; the last twelve plates of part 3 were published in 1808. On the publishing history of *Oriental Scenery*, see John Roland Abbey, *Travel in Aquatint and Lithography* (London, 1956–57), no. 420.

3. On the price of *Oriental Scenery*, see Abbey, *Travel*, no. 420. For a detailed itinerary of the Daniells' travels in India, see Thomas Sutton, *The Daniells: Artists and Travellers* (London, 1954). Also on the Daniells, see Martin Hardie and Muriel Clayton, "Thomas and William Daniell: Their Life and Work," *Walker's Quarterly*, nos. 35–36, (1932); and the following works by Mildred Archer: "Picturesque India with the Daniells," *Connoisseur* (March, 1963), 171–75; "The Daniells in India," *Country Life* (Jan. 23, 1958), 150–151; "The Daniells in India and their Influence on British Architecture," *Journal of the Royal Institute of British Architects* (Sept., 1960), 439–44; *The Daniells in India, 1786–1793*, exh. cat. (Smithsonian Institution, Washington, D.C. 1962); "India Revealed: Sketches by the Daniells," *Apollo* (Nov., 1962), 689–92; "British Painters of the Indian Scene," *Journal of the Royal Society of Arts* 115 (Oct., 1967), 867–79; *Drawings in the India Office Library*, 2 vols. (London, 1969). For a listing of British artists who traveled to India, see William Foster, "British Artists in India, 1760–1820," *Walpole Society* 19 (1931).

4. Sutton, *The Daniells: Artists and Travellers*, 92. Part 1 of *Oriental Scenery*, 1795, is "respectfully dedicated to the Honourable Court of Directors of the East India Company."

5. On the political history of India, see Thomas George Percival Spear, *Oxford History of India* (Oxford, 1965) part 3, *The Oxford History of Modern India, 1740–1947*.

6. Letter-press, part 4, plate 11, *Jag Deo and Warrangur, Hill Forts in the Barramahal*; part 4, plate 12, *Rycotta in the Barramahal*; part 4, plate 13, *Verapadroog in the Barramahal*. A separate letter-press pamphlet accompanied each part of *Oriental Scenery*; no other text (save titles) was bound with the plates. My quotations from the letter-press will not be foot-noted when the part and plate number of the image under discussion clearly identify the particular letter-press description cited.

7. Letter-press, part 6, plate 7, *Sankry Droog*.

8. Letter-press, part 6, plate 23, *The Rope Bridge at Sirinagur*.

9. For general attitudes regarding cities and natural scenery in the eighteenth century on the Grand Tour, see the most popular guide book of the period, Thomas Nugent, *The Grand Tour*, 3d ed., 4 vols. (London, 1778). Also see Camillo von Klenze, *The Interpretation of Italy during the Last Two Centuries* (Chicago, 1907).

10. John Henry Grose, *A Voyage to the East Indies* (London, 1757), 291.

11. On ruins and their associations, see Rose Macaulay, *Pleasure of Ruins* (New York, 1967). On the fascination with ruins in the late eighteenth and early nineteenth centuries, see Robert Rosenblum, *Transformations in Late Eighteenth Century Art* (Princeton, 1967), chap. 3.

12. On British depictions of and attitudes toward the "noble savage" of the South Seas, see Bernard Smith, *European Vision and the South Pacific 1760–1850* (Oxford, 1969), 1–116.

13. F. G. Stephens, *Dante Gabriel Rossetti* (London, 1894), 8n.1.

14. Letter-press, part 4, plate 11, *Dhuah Koonde.*

15. Thomas and William Daniell, *Antiquities of India . . . taken in the Years 1790 and 1793* (London, 1800), 37, nos. 19–20. This is a reduced version of parts of *Oriental Scenery*, with engraved plates. Thomas Daniell was a member of the Asiatick Society.

16. William Hunter, "Some Account of the Astronomical Labours of Jayasinha, Rajah of Ambhere, or Jayanar," *Asiatick Researches* 5 (1798), 210.

17. See Archer, "The Daniells in India and their Influence on British Architecture," 439–44.

8. Political Implications of the Houses of Parliament

1. For all this, see the book on which this essay so heavily leans: M. H. Port, ed., *The Houses of Parliament* (New Haven and London, 1976), 5ff., 16ff., 20ff., 30ff.

2. Phoebe B. Stanton, "The Collaboration Renewed: Barry and Pugin," in *Houses of Parliament*, ed. Port, 55.

3. Stanton, "Collaboration Renewed," 53ff.

4. "The Old English Domestic Architecture," *Quarterly Review* 45 (1831), 480.

5. "Old English Domestic Architecture," 473.

6. John N. Summerson, *Architecture in Britain, 1530–1830* (Baltimore, 1954), fig. 61.

7. Archibald Alison, "The Birth of British Architecture," *Edinburgh Magazine* 40 (1836), 238.

8. George L. Hersey, *Architecture, Poetry and Number in the Royal Palace of Caserta* (Cambridge, 1983), fig. 5.2.

9. Ibid., fig. 1.3

10. Port, *Houses of Parliament*, 20ff., 312.

11. Ibid., 232.

12. *Westminster Review* 22 (1835), 163ff.

13. Port, *Houses of Parliament*, 1.

14. Allan Braham, *The Architecture of the Enlightenment* (Berkeley, 1980), 87ff.

15. Stefan Muthesius, *The English Terraced House* (New Haven and London, 1982), 156.

9. The Arts in Early Post-Revolutionary Russia: The Posters of Vladimir Mayakovsky

1. The Russian realist movement in painting, known as the *peredvizhnichestvo*, was founded in 1863. It liberated Russian painting from conventional tradition and gave Russian art a new identity. It emerged in the period of reform of the 1860s, itself initiated by Czar Alexander II (1855–1881), and lasted until a few years after his assassination. The movement established the autonomy of the artist outside of state supervision. Ironically, from the 1890s to 1917 the artists, or the *peredvizhniki*, became the official, government-sanctioned school of Russian painting, which reflected conservative Russian nationalism. During the period following 1932, it was resurrected by Stalin and fashioned into the prototype for Positive Socialist Realism, imposed on all Soviet painters. For an excellent account of realist art in Russia see, E. Valkenier, *Russian Realist Art* (Ann Arbor, 1977).

2. The 1979 exhibition *"Paris-Moscou"* shown at the Pompidou Center in Paris was devoted entirely to the arts of this period.

3. For more details see G. H. Roman's article in this volume, chapter 10.

4. These included N. Miakovsky, Y. Shaporin, A. Alexandrov, and M. Steinberg, some of whom taught or influenced D. Shostakovich and S. Prokofiev; for a comprehensive study, see S. D. Krebs, *Soviet Composers and the Development of Soviet Music* (New York, 1970).

5. The most famous dancer of the revolution was not a Russian but the American Isadora Duncan. New dance forms and choreography emphasizing modern music were the mainstay of the Ballet Russe, composed of Russian artists who had not moved to Eu-

rope. Stravinsky, Bakst, Nijinsky, and many others under the direction of Diaghelev began their innovations in Russia but felt that they could reach a wider audience in the West.

6. From among a dozen film directors of this period the names of V. I. Pudovkin and S. Eisenstein stand out as the most prominent, not only in Russia but the world. Pudovkin's *Mother* and Eisenstein's *October* (*Ten Days That Shook the World*) and *Battleship Potemkin* are among the greatest revolutionary propaganda films ever made.

7. Moscow and Petrograd (old St. Petersburg, changed to Petrograd during the First World War and Leningrad after the death of Lenin) were firmly controlled by the Bolsheviks.

8. Symbolists such as V. Ivanov, A. Bely, acmeists like N. Gumilyov, and O. Mandelshtam, imagists like Marengof, and scores of other fiery poets and writers, such as I. Erenburg and M. Gorky, contributed to the formation of revolutionary literature. Some of these were Russians who had returned home following the revolution with the expressed purpose of contributing to this new flowering of free expression.

9. For an excellent study of revolutionary film posters, see M. Constantine and A. Fern, *Revolutionary Soviet Film Posters* (Baltimore, 1974).

10. In 1918 Moscow became the capital and attracted a large number of young artists who enthusiastically gathered and discussed various projects. Art became life itself and they created a new style of art suited for their new state, called constructivism or productive art. Art was to serve the state and the people—hence posters and other advertisements were not degrading but necessary in disseminating the message of the revolution.

11. The Russian futurists replaced the symbolists as the main force of the avant-garde. Futurism was founded in Italy by F. Marinetti in 1909 as a rejection of traditional aesthetic and cultural values.

12. The Russian Telegraph Agency was founded on September 7, 1918, and operated until January 1935.

13. For an excellent study of landlord and peasant in prerevolutionary Russia, see G. T. Robinson, *Rural Russia under the Old Regime* (Berkeley, 1960).

14. A. Denikin, A. Kolchak, and P. Wrangel were counterrevolutionary leaders who fought the Bolsheviks during the civil war. For more details and an excellent study of the Bolshevik Revolution and subsequent formative years (1917–1926), see E. H. Carr's monumental studies, *The Bolshevik Revolution, 1917–1923*, 3 vols. (London, 1950–1953); *The Interregnum, 1923–1924* (London, 1954); and *Socialism in One Country, 1924–1926*, 3 vols. (London, 1958–1964).

15. It was easier for composers such as Prokofiev and Shostakovich to remain productive during this period; filmmakers also continued to remain active. Composers of the written word had a much more difficult time, some like Ehrenburg, K. Simonov, A. Tolstoi, F. Gladkov, and M. Sholokhov either conformed or sincerely espoused the "proletarian" school of writing.

16. A. Blok died a broken man in 1921; S. Esenin committed suicide in 1925; M. Tsvetayeva committed suicide in 1941; the great poetess A. Akhmatova and B. Pasternak were constantly harassed; scores of others were imprisoned and were only rehabilitated during the Khrushchev era.

17. J.-A. Bédé and W. B. Edgerton, eds. *Columbia Dictionary of Modern European Literature* (New York, 1980), 527.

10. Tatlin's Tower: Revolutionary Art and Life in Russia

1. Nikolai Punin. *Pamiatnik tret'ego internatsionala: Proekt V. E. Tatlina* [The monument to the Third International: a project by V. E. Tatlin], (Petersburg: IZO Narkompros [Fine Arts Division of the People's Kommissariat of Enlightenment], 1920), n.p.

2. Vladimir Tatlin. "Nasha predstoiashchaia rabota" [The work ahead of us], *Ezhednevnyi byulleten VIII-go sezda Sovetov* [Daily Bulletin of the Eighth Congress of Soviets] 13 (1921), 11.

3. Ibid. The term "constructivism" was coined by Alexei Gan in 1920 in a lecture on art delivered to the Moscow branch of the Institute of Artistic Culture (IINKhUK), but the style had been more or less determined in the late teens.

4. This information was related to the author in an interview in Leningrad during the fall of 1978.

5. Viktor Shklovsky, quoted in Troels Andersen, *Vladimir Tatlin* (Stockholm: Moderna Museet, 1968), 7.

6. *V. I. Lenin on Literature and Art* (Moscow-Paris-London-Chicago: Progress Press, 1970), 222–23.

7. Vladimir Mayakovsky, "Prikaz armii iskusstv" [Order to the army of the arts]. *Iskusstvo kommuny* [Art of the Commune] 1 (1918), 1.

8. See I. Rostovtseva, "Uchastie khudozhnikov v organizatsii i providenii prazdnikov 1 Maia i 7 Noiabria v Petrograde v 1918 godu" [The participation of artists in the organization and planning of celebrations of the First of May and the Seventh of November] in *Agitatsionno-massovoe iskusstvo pervykh let Oktiabria: Materialy i issledovdniia* [Agitational-mass art of the first years of October: Materials and researches], E. A. Speranskaya et. al (Moscow: Gosizdat [State Publishing Agency], 1971), 39.

9. René Fülop-Miller, *The Mind and Face of Bolshevism: An Examination of Cultural Life in Soviet Russia*, trans. F. Flint and D. Tait (London and New York: G. P. Putnam's Sons, 1927), 148–49.

10. See John Elderfield, "The Line of Free Men: Tatlin's 'Towers' and the Age of Invention," *Studio International* 916 (1969), 162–67.

11. Punin, *Pamiatnik tret'ego internatsionala*.

12. El Lissitzky, quoted in Andersen, *Vladimir Tatlin*, 65.

13. Leo Shestov, *All Things Are Possible*, trans. S. S. Koteliansky (New York: Robert M. McBride, 1920), 241.

11. Modernists and Proletarian Music: The Composers' Collective of the Early 1930s

1. Mike Gold, "Toward an American Revolutionary Culture," *New Masses* (July, 1931), 13.

2. Mike Gold, "What a World," *Daily Worker* (Oct. 19, 1933), 5.

3. "Workers Music," *New Masses* (July, 1931), 13.

4. *Red Song Book* (New York: Workers Music Library Publishers, 1932), 3.

5. "Foreword," *Workers Song Book* (New York: U.S.A. Section of the International Music Bureau, 1934). Given the variety of musical personalities represented in the Collective, it would have been virtually impossible for a common musical style to have emerged from this "free and vigorous clash" of compositional points of view, even with a common political purpose.

6. Industrial Labor Defense.

7. Aaron Copland, "Workers Sing!" *New Masses* (June 12, 1934), 28.

8. Carl Sands, "A Program for Proletarian Composers," *Daily Worker* (Jan. 16, 1934), 5.

9. The doctrine of Socialist Realism was first articulated by Maxim Gorky and Andrei Zhdnov at the First All-Union Congress of Soviet Writers in the summer of 1934. The new artistic expression was intended to emerge from the daily lives and experiences of the people. Works of art were supposed to inspire through their presentation of the familiar in easily understood forms and styles.

10. Mike Gold, "Change the World," *Daily Worker* (June 11, 1934), 5.

11. Lan Adomian, "What Songs Should Workers' Choruses Sing?" *Daily Worker* (Feb. 7, 1934), 5.

12. Cowell was one of fifty-three signatories to a statement of support for the presidential candidacy of William Z. Foster in 1932. Foster ran on the Communist party ticket. This statement was later expanded into broader attack on the two major political parties

in *Culture and Crisis: An Open Letter to the Writers, Artists, Teachers, Physicians, Engineers, Scientists, and Other Professional Workers of America* (League of Professional Groups for Foster and Ford, 1932).

13. Henry Cowell, "Useful Music," *New Masses* (Oct. 29, 1935), 26.

14. Michael Gold, "Change the World!" *Daily Worker* (Oct. 17, 1935), 5.

12. Rockefeller Center: The Success of the Architecture and the Failure of the Art Program

1. For the building history, see C. H. Krinsky, *Rockefeller Center* (New York, 1978), 22–100, with bibliographical citations on pp. 214–15. See also A. Balfour, *Rockefeller Center, Architecture as Theater* (New York, 1978), 3–56, and M. Tafuri in G. Ciucci et al., *The American City* (Cambridge, Mass., 1979), 389 ff.

2. The firms were: Corbett, Harrison & MacMurray; Hood, Godley & Fouilhoux; and Reinhard & Hofmeister.

3. For Hood as the one who made this suggestion, see J. R. Todd, *Living a Life*, ed. W. P. Vogel (New York, 1947), 119. Wallace K. Harrison, in conversations with me and others, remembered that he had been the first to think of a connection with the "radio group."

4. Todd, *Living a Life*, 126–27.

5. Balfour, *Rockefeller Center*, 137–80, illustrates most of the works discussed here and quoted from Alexander's thematic program. The program and correspondence, memos, and other material are in the Rockefeller Family Archives, especially Box 94, Theme and Decoration file.

6. The Rivera story is given in B. Wolfe, *The Fabulous Life of Diego Rivera* (New York, 1963); Diego Rivera (with B. Wolfe), *Portrait of America* (New York, 1934), 21–32, 40–47. The Rockefeller Family Archives hold copies of the correspondence. A draft of Rivera's first reply, drafted by Ben Shahn, is in Shahn's papers at the Archives of American Art, microfilm roll D 147, s.v. R.

7. Rockefeller Family Archives, Box 94, Theme and Decoration file.

13. A Battle of Wills: How Leni Riefenstahl and Frank Capra Fought A War with Film and Remade History

1. L. Jacobs, ed., *The Documentary Tradition: From Nanook to Woodstock* (New York, 1971), 70.

2. P. Taylor, "Propaganda in International Politics, 1919–1939," in *Film and Radio Propaganda in World War II*, K. R. M. Short (Knoxville, 1983), 17–20. Taylor tries to make a case for a coordinated propaganda effort between the two world wars. It's true that Hitler and Mussolini could hardly have won over their respective countries without adequate means of persuasion, yet most examples, even Taylor's, are drawn from the years after 1934.

3. G. Infield, *Leni Riefenstahl: The Fallen Film Goddess* (New York, 1976), 3–10, 38–199. Riefenstahl's glowing treatment of black and oriental athletes in her later film, *Olympia*, would do the same, while lulling the suspicions of those outside the Reich who had begun to believe that nazism was actively (instead of just rhetorically) racist.

4. F. Capra, *The Name above the Title: An Autobiography* (New York, 1971), 326–53.

5. Ibid., 328–31.

6. "By twentieth-century standards of humanism and democracy, the films insinuate that only the strong and the muscular, the chosen and the elite, can lead and win. *Triumph* depicts the individual as an unidentified part of a regimented mass, and implies that emotion is superior to reason," R. Barsam, "Leni Riefenstahl: Artifice and Truth in a World Apart," in *Nonfiction Film: Theory and Criticism*, 252.

7. E. Barnouw, *Documentary: A History of the Nonfiction Film* (London, Oxford, and

New York, 1974), 154–62. For a good summary of the contrasting rationales of German, Russian, British, and American war films, see pp. 139–72.

8. Ibid.

9. Infield, *Leni Riefenstahl*, 70.

10. Barsam, "Leni Riefenstahl," 253–54.

11. Infield, *Leni Riefenstahl*, 81.

12. Ibid., 82.

13. D. B. Hinton, *The Films of Leni Riefenstahl* (Metuchen, N.J., and London, 1978), 50.

14. A most thorough treatment of these sequences, including a reconstruction of how Riefenstahl's editing contrasts with the historical order of events, and a comparison with her later films, such as *Olympia*, is to be found in Hinton, *Films of Leni Riefenstahl*, 27–110.

15. "This speech is most important as a character study of Hitler himself. A cool, composed Hitler that has so far been seen throughout the film gives way to an intensely animated Hitler, whose excitement feeds on itself. His gestures become dramatic, interpretative flourishes and his facial expressions those of a seasoned actor. The editing . . . does a masterful job of conveying the mounting excitement of the event. The crowd's enthusiasm increases almost in direct proportion to Hitler's, and the alternation of shots shows this reciprocal relationship. . . . Whenever Hitler makes a point that arouses a great cheer from the audience, there is always a cut to the audience. At one point the enthusiasm . . . becomes so great that Hitler cannot continue, and the camera trains itself on the agitated Hitler waiting to resume speaking" (Hinton, *Films of Leni Riefenstahl*, 53).

16. Ibid., 44.

17. Ibid., 39.

18. Infield, *Leni Riefenstahl*, 101.

19. For an analysis of *Triumph*'s psychology, including its mythological opening and featuring Hitler as All-Father Odin, see Siegfried Kracauer's classic and unsurpassed description in his *From Caligari to Hitler: A Psychological History of the German Film* (Princeton, NJ, 1947). It is interesting to compare this analysis with that of Frank Capra in his autobiography, *Name above the Title*, 328. A sample: "The music crashed out its Götterdämmerung to the gods of freedom; the supernal specter touched down on an airport runway; glided to a full stop; then—silence." "Magically, a plane door opened; its mystic frame dark with mystery. Then, god the spirit materialized into god the Führer—uniformed, resplendent, stigmatic with swastikas."

20. Capra, *Name above the Title*, 328.

21. For Murrow's London broadcasts, see A. Kendrick, *Prime Time: The Life of Edward R. Murrow* (Boston, 1969), 173–242; for Shirer's wartime experience, see his *End of a Berlin Diary* (New York, 1947); his *Berlin Diary* (New York, 1941); or his *The Rise and Fall of the Third Reich* (New York, 1981).

22. J. Grierson, "The Nature of Propaganda," in Barsam, *Nonfiction Film*, 31–41.

23. H. Kline, "Films without Make-Believe," in Jacobs, *Documentary Tradition*, 148–57.

24. Ibid.

25. L. Jacobs, "The Military Experience and After," in Jacobs, *Documentary Tradition*, 182–88.

26. H. F. Hardy, "British Documentaries in the War," in Jacobs, *Documentary Tradition*, 205–10.

27. Ibid.

28. P. Dunne, "The Documentary and Hollywood," in Barsam, *Nonfiction Film*, 160.

29. For a full description of this process, see R. Elson, "Time Marches on the Screen," Barsam, *Nonfiction Film*, 95–113.

30. M. Farber, "Education for War," *New Republic* (May 31, 1943), 234.

31. Capra, *Name above the Title*, 335–36.

32. All quotations are taken directly from the soundtrack.

33. See D. Culbert, "'Why We Fight': Social Engineering for a Democratic Society at War," in Short, *Film and Radio Propaganda*, 173–91, for a most thorough analysis of the entire series.

34. Ibid.

35. Capra, *Name above the Title*, 335.

36. U.S. Congress, Senate *Congressional Record*, 78th Congress, 1st sess., Feb. 8, 1943, pp. 674–76. Senator Holman was furious at the Capra appropriations, claiming the "Why We Fight" series to be part of Roosevelt's push for a fourth term.

37. Culbert, "Social Engineering for a Democratic Society," 189.

14. Making the Invisible Visible: The Roots of an Original Magic Language

1. William Butler Yeats, "Long-Legged Fly."

2. "To Posterity," in *Selected Poems of Bertolt Brecht*, trans. H. R. Hays (New York and London, 1947), 173.

3. A. Hauser, *The Social History of Art*, vol. 3 (New York, 1958), 166.

4. Dylan Thomas, "In My Craft or Sullen Art."

5. J. Rothenberg, ed., *Technicians of the Sacred: A Range of Poetries from Africa, Asia, and Oceania* (New York, 1968), 361.

6. Hauser, *Social History of Art*, 168.

7. Rothenberg, *Technicians*, 361.

8. Hauser, *Social History*, 166.

9. H. Gregory, *The Poems of Catullus* (New York, 1956).

Contributors

BERNARD APTEKAR is a New York–based artist working in the medium of large scale painting. He also teaches painting and design at New York City Technical College, and he lectures frequently on artistic theory and practice at colleges throughout the Northeast. He recently mounted a major exhibition of his own work entitled *Art and Politics* at SUNY Stony Brook.

JACQUELINE AUSTIN is literary and media critic for the *Village Voice* and the *New York Times*. Her reviews of books and films have appeared in numerous newspapers, magazines, and collections of critical essays. She is also the author of a novel about life in Vienna during World War II, entitled *Hermann*.

KENNETH BENDINER is Associate Professor of Art History at the University of Wisconsin at Milwaukee. He is the author of the forthcoming book *Introduction to Victorian Painting*. He has also written extensively on English art of the eighteenthand nineteenth centuries, and French, German, and Italian art of the nineteenth century.

GEORGE BOURNOUTIAN is a specialist in Russian and Transcaucasian history of the nineteenth and twentieth centuries. He has taught in the History Department at the University of California in Los Angeles and in the Department of Middle Eastern Studies at Columbia University, where he was also Assistant Director of the Russian Institute. He is the author of *Eastern Armenia in the Last Decades of Persian Rule*.

RICHARD BRILLIANT is Professor of Art History at Columbia University. He is a leading authority on the art of Greece and the Roman Empire. His books include *Gesture and Rank in Roman Art*, *Arts of the Greeks*, *Roman Art*, and most recently *Visual Narratives in Etruscan and Roman Art*.

DAVID CASTRIOTA is Assistant Professor of Art History at Duke University. His work focuses on stylistic and iconological aspects of the decorative arts in antiquity. He is the author of a forthcoming book-length study of the religious-political imagery of the Augustan Altar of Peace in Rome and the annotator of a forthcoming English translation of Alois Riegl's *Stilfragen*.

209

JOSEPH FORTE is Associate Professor of Art History at Sarah Lawrence College. His specialties include Italian Renaissance drawings and French painting of the seventeenth century. He has published articles on the art of Raphael and especially on the strategies of political imagery in seventeenth century French art.

GEORGE L. HERSEY is Professor of the History of Art at Yale University. He is an acknowledged expert in Renaissance architectural iconography and British architecture in the nineteenth century. His books include the *Aragonese Arch at Naples*, *Pythagorean Palaces*, and *High Victorian Gothic*.

CAROL HERSELLE KRINSKY is Professor of Art History at New York University and current president of the Society of Architectural Historians. A leading scholar in the study of modern architecture, she is the author of the definitive monograph on Rockefeller Center and, most recently, *The Synagogues of Europe: Architecture, History, and Meaning*.

JILL MEREDITH is a specialist in the field of Italian medieval sculpture and architecture. She is currently photo archives consultant for the J. Paul Getty Center for the History of Art and the Humanities.

EDITH PORADA is Professor Emeritus of Art History at Columbia University. She is the foremost expert in the study of ancient Near Eastern art today. She has written numerous books and articles on the cylinder seals of ancient Mesopotamia. Her books include the *Corpus of Ancient Cylinder Seals*, *The King of Assyria*, and most recently her new edition of *The Art of Ancient Iran*.

GAIL HARRISON-ROMAN is Assistant Professor of Art History at the Harriman Institute of Columbia University. She is a specialist in Russian avant-garde art and its political and social implications. She has published articles on the work of Rodchenko, *Agit-Prop*, and the machine aesthetic in Soviet Russia.

DAVID ROSAND is Professor of Art History at Columbia University. He is a leading specialist in Venetian painting and graphics of the sixteenth century and their relation to the humanism of the Italian High Renaissance. He is the author of *Painting in Cinquecento Venice* and *Titian, His World and Legacy*.

BARBARA L. TISCHLER is Assistant Professor in The History Department at Barnard College. She is a cultural historian and trained musician whose work focuses on music as a reflection of the social, political, and economic developments of nineteenth and twentieth century America. She has explored these themes in journal articles and the recent book, *Musical Modernism and American Cultural Identity*.

Index